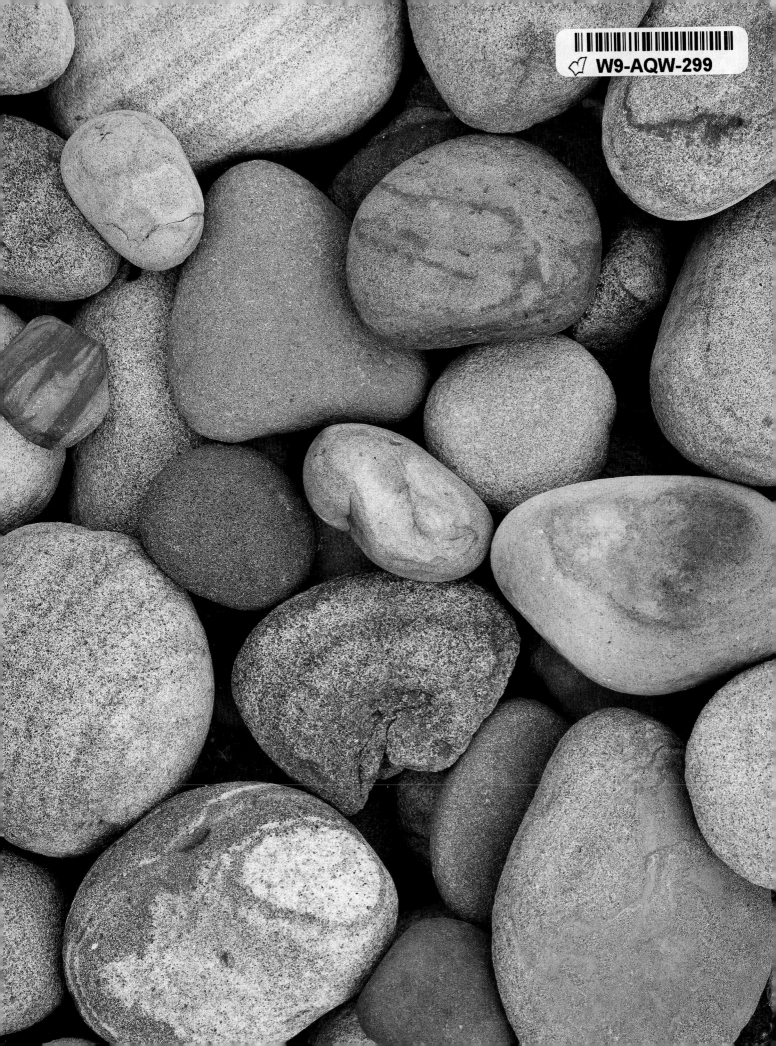

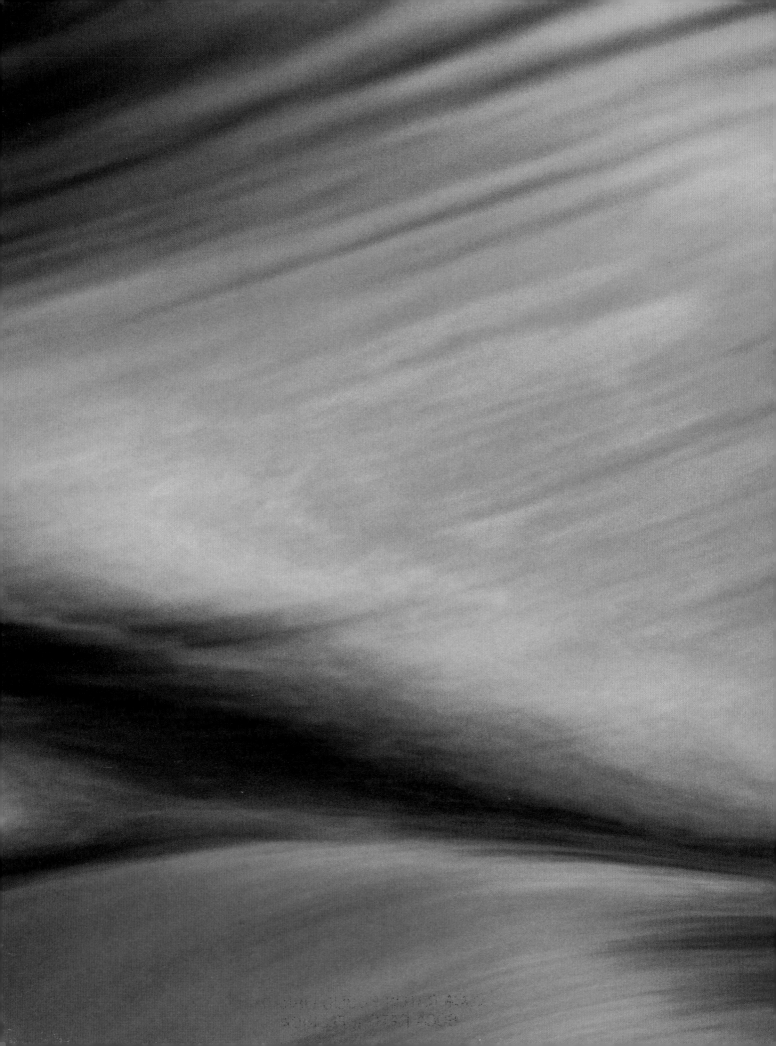

Creative Nature & Outdoor Photography

REVISED EDITION

BRENDA THARP

AMPHOTO BOOKS

AN IMPRINT OF THE CROWN PUBLISHING GROUP
New York

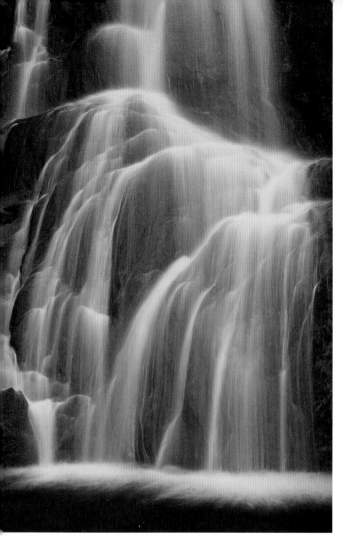

TO JED—FOR ALWAYS BEING THERE, AND FOR SHARING
IN THE JOY OF PHOTOGRAPHY

Published in the United States by Amphoto Books,
an imprint of the Crown Publishing Group,
a division of Random House, Inc., New York.
www.crownpublishing.com
www.amphotobooks.com

AMPHOTO BOOKS and the Amphoto Books logo are trademarks of Random House, Inc.

A previous edition of this work was published in the United States by Amphoto Books,
an imprint of the Crown Publishing Group, a division of Random House, Inc., New York, in 2003.

Library of Congress Cataloging-in-Publication Data is available from the Library of Congress.

Library of Congress Control Number: 2009931352

ISBN 978-0-8174-3961-3

Printed in China

Design by Lauren Monchik

10 9 8 7 6 5

Revised Edition

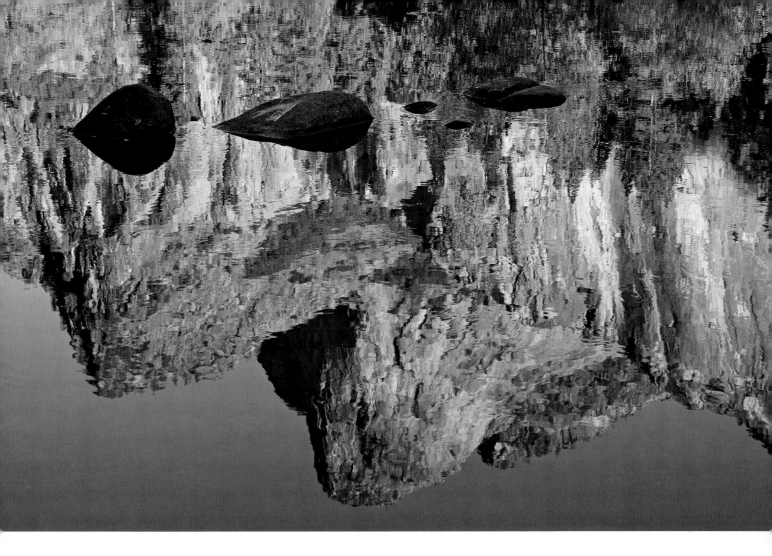

ACKNOWLEDGMENTS

This book would not be possible without the success of the first edition, so I'd like first to thank the thousands who purchased it, especially those who are using it as a teaching guide for their own classes. Thanks, too, to the students who attend my workshops and allow me to share my passion for photography. Thanks to Lewis Kemper, Ben Willmore, and Jack Davis, just to name a few, for being key players in helping me get on the digital track and to grow as a digital photographer and artist.

I am so grateful to Victoria Craven for seeing the potential of my idea and commissioning the original book, and to Julie Mazur for inviting me to revise it to reflect the industry shift into digital photography. Many thanks also to Carrie Cantor, my project editor, and to the book's designer, Lauren Monchik, for their creative efforts in producing a great revision to this book.

My deepest gratitude goes to my family and friends for their encouragement and ongoing support. Thank you for continuing to cheer me onward as I pursue my dreams.

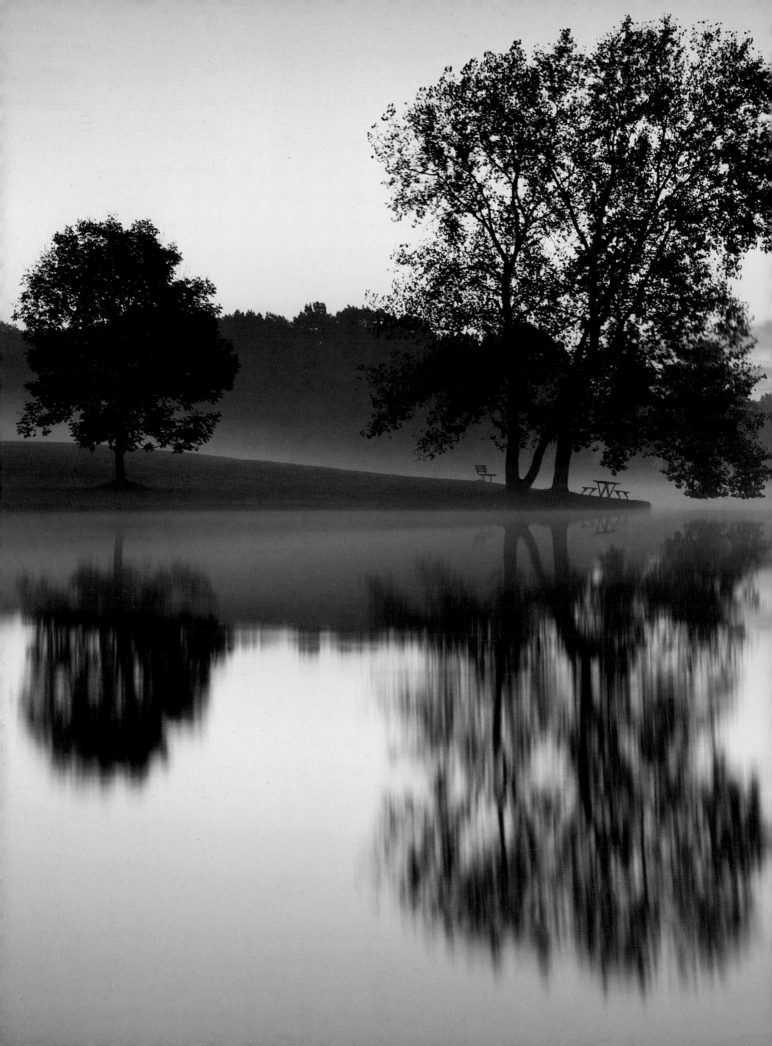

CONTENTS

INTRODUCTION

"A great photograph is a full expression of what one feels about what is being photographed in the deepest sense, and is, thereby, a true expression of what one feels about life in its entirety."
—ANSEL ADAMS

"WHAT ARE YOU TRYING TO SAY WITH THIS photograph?" Someone asked me this question many years ago at a photography workshop, and it is still the driving force behind my photography. The question hovers in my subconscious with every image I pursue, and it influences every action I take to create a photograph. To me, "What are you trying to say with this photograph?" is the most fundamental of all questions regarding creative photography.

Nature and outdoor photographers want to share the beauty of a landscape, the drama of light, and the action of wildlife. Travel photographers want to share the faces of a culture, a slice of daily life, and a sense of place. Photojournalists want to share the moment or emotional situation before them. We're all really after the same thing: to create images that express what we see, feel, and experience in the world around us. Whether we are aiming for artistic interpretation or realism, the common goal is to make our photographs as creative and expressive as possible.

Why then, do so many images fail to convey what the photographer really saw or experienced? They are side-of-the-road or edge-of-the-crowd snapshots, static records of what was seen.

LEAF, ZION NATIONAL PARK, UTAH. *When I saw this leaf, the pattern reminded me of an aerial view of canyons and tree-topped mesas. To keep some sense of place, I included the red sand that is typical of the area. 90mm tilt shift lens, f/16 at 8 seconds with polarizing filter.*

BELOW: SNOW-COVERED BERRIES, UTAH. *A fresh snow in the Wasatch Mountains of Utah provided a great opportunity for pictures.* 70–200mm lens at 200mm, f/6.3 at 1/30 sec.

OPPOSITE: NINE PIPES NATIONAL WILDLIFE REFUGE, MONTANA. 24–105mm lens at 36mm, f/16 at 1/8 sec.

Those photographs don't move us—they don't invite us in to explore the visual scene or to experience the moment. Usually, the photographer approached the scene as a removed observer, and the results showed that. No matter what you're photographing, if you're not feeling connected with what you're seeing, viewers won't engage with the final picture. Ansel Adams once said, "There is nothing more useless than a sharp photograph of a fuzzy concept." When you aren't clear about what you want to say with the photograph, the resulting visual message may say noth-

ing. At best, it may only communicate the facts in a less-than-exciting way.

If you want to photograph more creatively, you'll need to begin looking at the world differently. Engage the great outdoors with a sense of awe and wonder. Crawl on your belly in meadows and climb mountains to new heights; touch the trees; smell the flowers; feel the wind. When you make photographs from the perspective of your experiences, your photographs will be much more compelling.

If you view life through the filter of your experiences, you'll see the world uniquely. If you want to make awe-inspiring images, decide now that you'll have as many awe-inspiring experiences as possible. Look at the world with curiosity and wonder, and you'll see many great things. Then draw from your own creative well of experiences when you make your photographs.

As a child, I spent a lot of time outdoors with my family. We hunted for fossils in Pennsylvania and canoed on the Delaware River. We hiked Mount Washington in New Hampshire, picked wild blueberries in New York, and played at the Jersey shore. I developed a love for the outdoors and a respect for the fragile beauty of my world. Those experiences created the filters through which I view the world, and they built the foundation of my passion: to share that view through my photographs.

Yet even with a deep connection to the outdoors, my early pictures were horrible interpretations of what I saw! For all the passion I had, I lacked the technical understanding of how to get my vision onto film. My understanding of design, perspective, and color were also very rudimentary. Determined to change that, I began attending workshops. My photographs quickly became better technically, yet there was still something missing in many of them. Searching for some magical technique, I enrolled in a workshop with Sam Abell, a *National Geographic* photographer, who is now a legendary instructor. When Sam

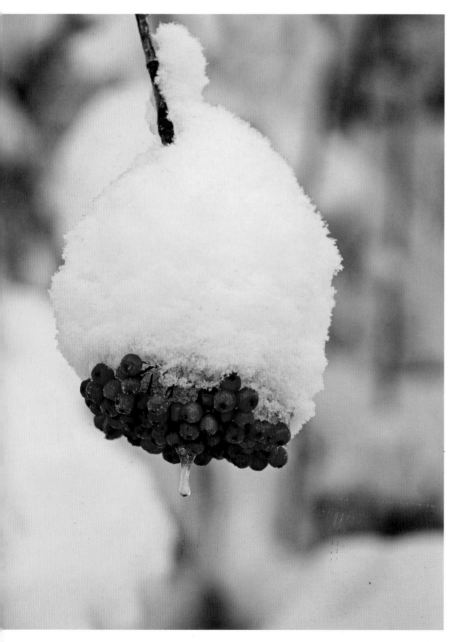

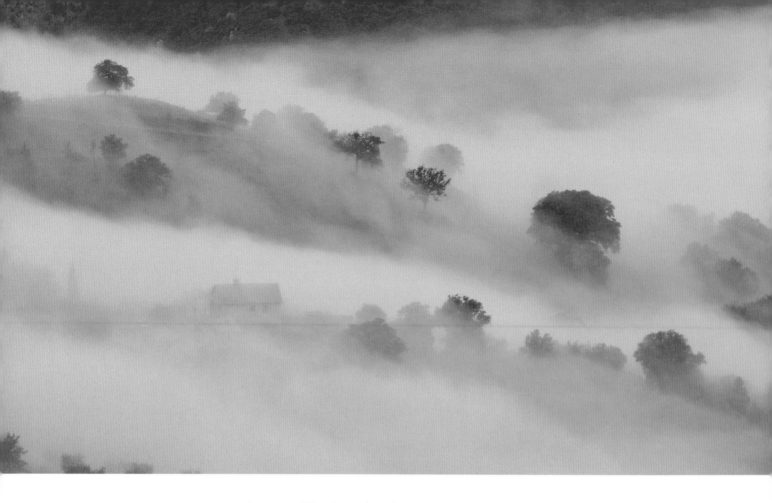

reviewed my portfolio, he said, "These are
nothing more than postcards; they don't
communicate the real experience of being
there."

Ouch! Thinking back on it, the
photographs were pretty mundane. Sam
challenged my "bystander approach" and
encouraged me to become more involved
in the photograph. I learned a valuable
lesson that week: In those pictures,
I was missing. After that epiphany, I
ended the week with some very good
images. I continued to photograph
after the workshop, but the results were
inconsistent—my photos were either great
or pretty bad! I hadn't quite broken my old
habits, so I enrolled in more workshops,
studied books on art, photography, and
the creative process, and made many more
photographs. I learned how to use the
tools—cameras, lenses, and flashes—to
express my vision. More important, I
learned about the art of seeing and how
my feelings about a subject affected my
vision of it.

With the shift into digital
photography by so many, for a time I was

worried that the fundamental reason
people photographed might be lost. So
many of us, myself included, got swept
up in the technical issues of pixels, file
formats, and storage. And then there was
the concern about proper processing of
our digital images. "Workflow" became
the buzzword, even when we didn't
understand what that really meant!
Those on the leading edge of the digital
wave rode it and published articles and
DVDs on workflow, processing RAW
files, and every other technique out
there today. It was truly overwhelming
for many photographers. My students in
workshops would complain that they felt
lost and confused about all the technical
jargon. And so my workshops changed to
accommodate some of those needs. But
fundamentally, I refused to depart too
much from what I believe in—that despite
whatever technical prowess we develop,
our pictures are only great if we start
with a solid concept of what we want to
say and apply these techniques to express
that. While there are software programs
that claim to turn your pictures into

"works of art" with their unique effects, the picture still has to start out with a good composition. Even though I am now photographing only with a digital camera, my primary focus and intent have not changed.

This book addresses the aesthetic aspects of photography, covering technical aspects as well in the chapters on light and special techniques. It isn't really a beginner's book; however, even a beginning photographer can learn the aesthetics before mastering the technical. Because art and technique overlap, I do discuss some essentials of the craft—understanding light, creating visual depth with perspective and lenses, and composition—and how they relate to making expressive outdoor images. For example, the chapter on composition is not just about proper placement of the subject; it also discusses other key elements: dominance, balance, proportion, and color.

The goal of the book is to teach you how to use light, design, composition, and other creative techniques to make photographs that go beyond the ordinary. Along with these fundamental topics, you'll also learn how to use motion, mood, and color to make your images more expressive. You'll be shown ways to create abstract photographs and artistic effects—both in-camera and by applying selected software applications that I have found fun and useful. Finally, and most important, I hope you'll discover what it means to capture the essence of your subject.

The text, along with the visual exercises, will help you develop your own creativity, but the book requires some effort. Read the section on design and learn how shapes, patterns, and lines enhance your photographs, then go out and look for those design elements. Study the sections on perspective and composition, and apply those ideas to create unique viewpoints and make clean, uncluttered visual statements. The concepts in this book can make a profound difference in your photography, but success lies in their application.

You may be asking if it's possible to learn to see more creatively. The answer is a resounding yes. Creativity is nothing more than a combination of inspiration, visual perception, and imagination, along with some technical skill. You can learn how to discover all of these qualities within yourself. Seeing light, utilizing design, and creating good compositions can all be learned. All it takes is a little effort to absorb the ideas covered in this book, a willingness to ask, *what if?*, and the courage to act on your curiosity. Always remember that while craft and art are important, it is the creative vision that makes the difference between an ordinary shot and a great photograph. This realization alone will push you into the realm of creative photography.

It is my sincere hope that this book will provide you with the tools you need to develop your vision and that it will serve as a guide in your discovery of personal creativity. The information I provide here is the foundation and springboard for your experimentation. Step up to the line and be willing to participate in the learning process by reading and doing the exercises. Open your mind, your eyes, and your soul to what's around you, and share what you see through your photographs.

LEARNING TO SEE

"What you see is real, but only on the particular level to which you've developed your sense of seeing. You can expand your reality by developing new ways of perceiving."
—WYNN BULLOCK

THE SUCCESS OF ANY PHOTOGRAPH RELIES UPON these key ingredients: great light, a dynamic composition, good visual design, and an interesting moment. I don't always succeed in getting all of them in one picture, but when I do it's exhilarating. This accomplishment motivates me to keep honing my vision, my sense of design, and my timing.

The effectiveness of a photograph depends entirely upon the photographer. You decide whether the light is right for your subject and whether it is interesting. You select the point of view, design the composition, and choose the appropriate camera settings. Before you do anything, however, you must intuitively answer the question, "What do I find interesting about the scene or subject?" It is not enough to say, "I like the trees." Why do you like the trees? Maybe you love their pattern or how the light creates tree shadows on the hillside. In precisely identifying what you find interesting—for whatever the reason—you clarify your vision, a key part of the process of making memorable images.

Equally important is articulating how you feel about your subject and what it means to you. One day, I was teaching a workshop at Point Reyes National Seashore, and my group headed for the beach. The winds were fierce, and the students were reluctant to have their cameras sandblasted while photographing. But I was not willing to

SANDSTONE, UTAH. 100mm lens, f/16 at 1/15 sec.

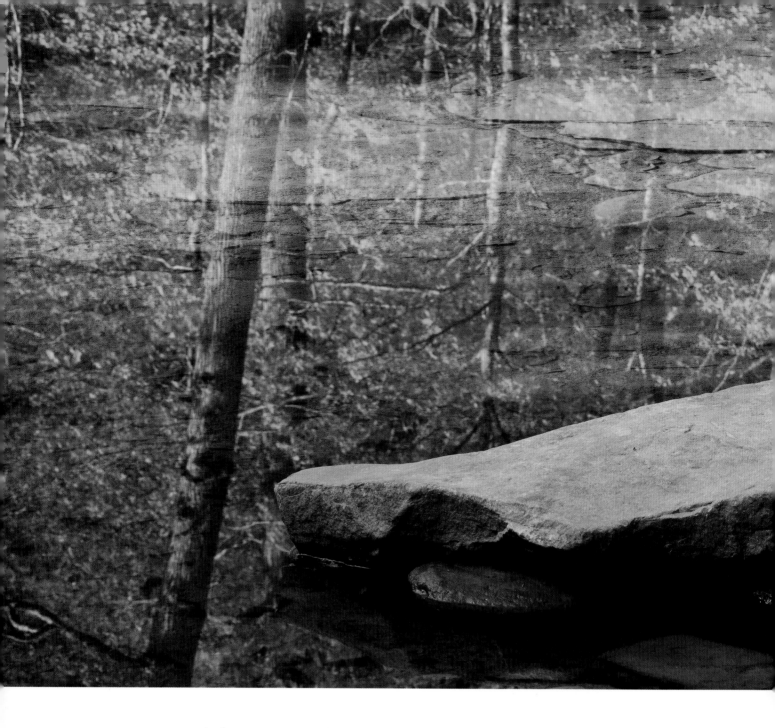

bail out. I went onto the beach and discovered that the blowing sand grains were at about knee height. If we didn't get lower than that, we could photograph—provided we could steady our tripods in the gusts. So we began to explore. The wind had scoured the beach and piled up the grains of sand, sorting by weight and creating great erosion patterns. It reminded me of Bryce Canyon in miniature and created an interesting abstract photograph full of texture.

Once you've identified what interests you and how you feel about it, you have the basis for all the actions and decisions you'll make to create the photograph. You'll choose the equipment, as well as the creative tools of light, composition, color, and perspective, based on what you want to say. Many years ago, I learned the value of making a checklist for creating a photograph. I still use one, although it's now an intuitive process. Each question relates to concepts or equipment:

- What do I want to be dominant in the scene?
- What do I want in the frame, and what can I eliminate?

each one from the perspective of what you want to express with your photograph. If you want to show the vastness of the desert, you should not choose a telephoto lens. Similarly, if you want to show the texture of a landscape, you most likely won't lie down on the ground to achieve your point of view. Using a list may sound like a way to stifle creativity, but, surprisingly, the opposite is true. After a short while, a written checklist becomes a mental list, and then simply an intuitive feeling.

To achieve a level of skill at handling your camera equipment intuitively, you need to practice daily, like a musician. Carry your camera everywhere. Even if you can't make quality images, for lack of time or due to other limitations, practice working with the camera and your lenses. Master your camera's controls, and know and understand its features. Learn which way a lens rotates to focus closer. Know how to compensate exposure on your camera quickly, how to switch between auto-focus and manual focus and between aperture and shutter speed priority modes, and how to change the focus points quickly. Master the fundamentals of photography so you'll no longer need to be fussing over what shutter speed or lens to use when the world is showing you its magic. The camera should be a conduit for creativity, not a technical block.

To develop visual skills, you need to constantly look at the things around you. It would be wonderful to be able to stop and take time to photograph whenever you see something interesting, but that's not always possible. Make it a daily practice to at least see and compose, if only mentally. Not only will you improve and stimulate your photographer's eye, but you'll also improve the quality of your day as you see beautiful and interesting things. Look at the day with awe and wonder; it's a present for us to appreciate and share.

REFLECTIONS, OZARK NATIONAL FOREST, ARKANSAS 70–200mm lens at 135mm, $f/22$ at 1/10 sec.

- Where do I need to be for the best angle of view?
- How much depth of field do I want or need?
- Do I need a slow or fast shutter speed?
- Would a tripod help?
- What's the range of light?
- What's the color of the light?
- Would a filter help?
- Is there a creative technique that would better express my vision?

With each answer, you build your creative image. Although many of these questions relate to technical issues, answer

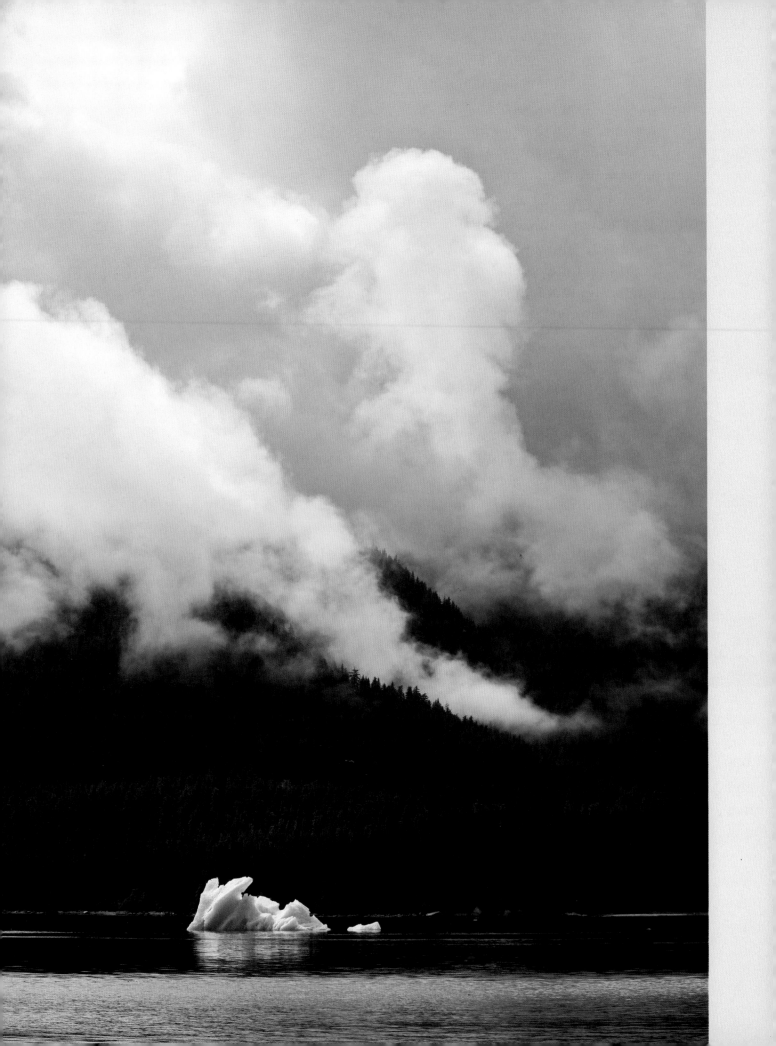

LIGHT: THE ESSENTIAL ELEMENT

"Light makes photography. Embrace light. Admire it. Love it. But above all, know light. Know it for all you are worth, and you will know the key to photography."
—GEORGE EASTMAN

LIGHT IS THE ESSENTIAL RAW MATERIAL OF ALL photographs. Light defines a subject, expresses a mood, and sometimes enhances a moment. By its very definition, photography is "writing with light." Ruth Bernhard referred to light as the "drawing pen for photographers." To do this "writing," outdoor and nature photographers rely heavily on available light. What this really means is that you head out into the field hoping that great light is available! Light is different every day, all day; in some places, it's different every moment as clouds move overhead. This changeability is the magic of light.

If people aren't responding to your photographs, perhaps it's time to take a good look at the light in them. An image that lacks the right light for the subject or scene usually lacks visual impact and usually doesn't garner any "oohs" and "aahs" from your viewer—unless they, too, don't know the difference.

STORM LIGHT OVER FREDERICK SOUND, ALASKA. *I loved how the light was striking the clouds and the icebergs, and the way the clouds swept down over the mountains. Light in Alaska can be so mood-evoking.* 100–400mm lens at 140mm, $f/7.1$ at 1/640 sec.

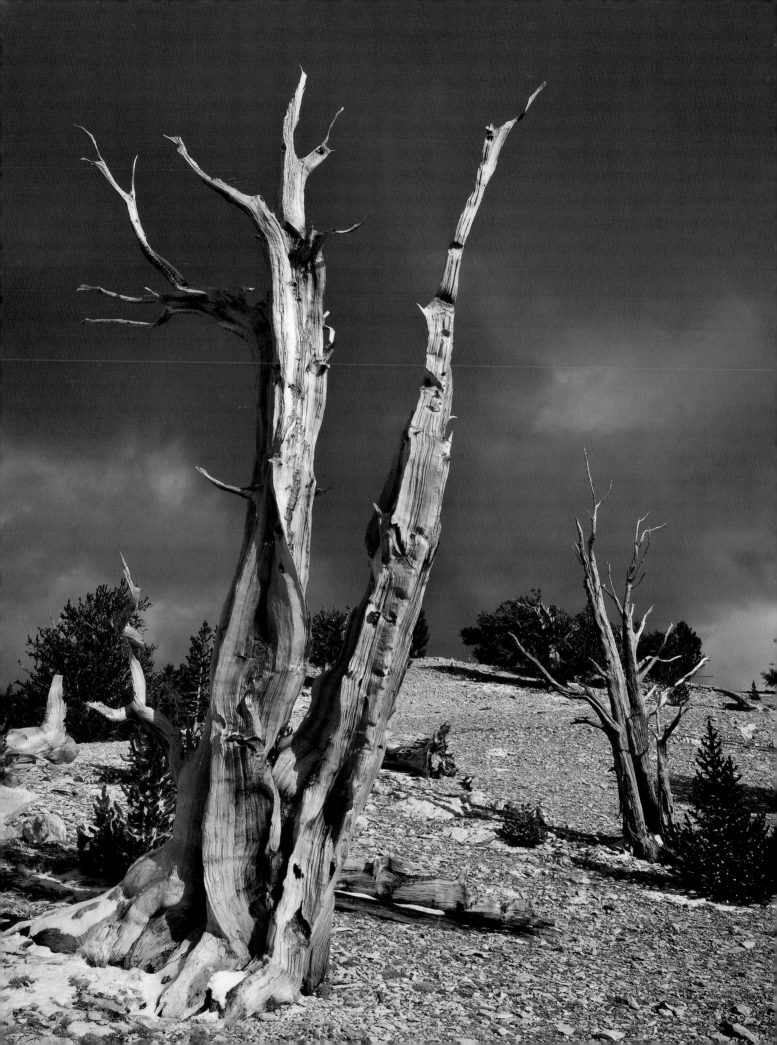

Photographers have long considered early morning and late afternoon to be the best times to photograph outdoors. Light at other times, the consensus has it, is "bad light," so there's no need to take out the camera. Yet Ernst Haas, a master color photographer, once said, "There is no such thing as bad light. There is just light." If you reconsider how you define light, you'll find his statement is true. Rather than define light as "bad" or "good," think instead of "appropriate light." With creativity and resourcefulness, you can make great photographs any time of day using the idea of "appropriate light." Although I prefer the warm light and longer shadows that occur in the morning or afternoon for my landscapes, I also search for photographic opportunities during midday. Whether you're photographing a landscape, a flower, or a castle, there is an appropriate light that will bring out the best attributes of your subject. So, actually, the best time to photograph is whenever the light is right for your subject.

For example, sunlight doesn't shine into many streets in European villages until midmorning, so I use the even light of open sky in the mornings to photograph details of doorways and gardens. Midday is the best time to photograph in the slot canyons of Arizona, where the light streams in from above and bounces off the walls. I can plan to be in the desert for sunrise and then head into the canyon when the sun is too harsh for the landscape.

OPPOSITE: BRISTLECONE PINE TREE IN STORM LIGHT, CALIFORNIA. *A stormy day left snow on the ground and dark threatening clouds on the horizon. But the clearing storm allowed for sunlight to break through the clouds and highlight the weathered trees.* 24–105mm lens at 24mm, f/18 at 1/60 sec.

BELOW: EL CAPITAN IN CLEARING STORM, YOSEMITE NATIONAL PARK, CALIFORNIA. *Just as Ansel Adams did, I continually search for drama in the light of Yosemite.* 70–200mm lens at 100mm, f/11 at 1/25 sec.

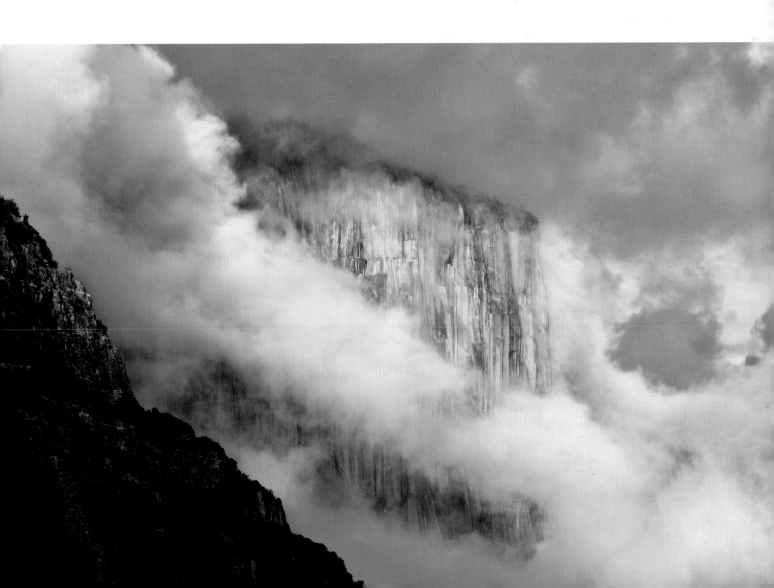

HOW THE CAMERA "SEES" LIGHT

RHODODENDRON, CALIFORNIA. *These rhododendron blossoms looked great to the eye—but horrible when I downloaded the file to review. Too much contrast. But when the sun moved, and light became diffused from shade, all the details were visible in the blossoms, and the colors were better, too.* RIGHT: *70–200mm lens at 165mm, f/0 at 1/125 sec.* LEFT: *70–200mm lens at 165mm, f/9 at 1/25 sec.*

Have you ever heard yourself saying, "Well, the light looked better than it does on the print," or, "It wasn't great light, but I made the image anyway"? It's easy to fall into the habit of thinking that the light will somehow magically be transformed as it is recorded. Yet the difference between how we see and how a camera "sees" light is substantial. Most digital sensors can only record a usable range of about 5 *f*-stops of light before they lose detail. However, the human eye perceives about 11 to 14 *f*-stops between the brightest highlight and the deepest shadow. Because the pupil is constantly opening and closing as it scans a scene, the eye will perceive detail in each area it views.

This is a large disparity between what we are able to see and what the camera can record. Depending upon the range of light and dark values in your scene (known as tonal contrast), you may lose detail in the shadows if you expose for the highlights, and you may lose detail in the highlights if you expose for the shadows. It's no wonder that you don't always get what you think you'll get! Digital sensors record no detail for pixels that are too overexposed. And no detail translates to nothing, *nada*, when it comes to ink going down on the paper in a print. Known as *clipping the highlights*, it's a situation that has become dreaded by digital photographers.

You can learn to recognize what conditions might be too high in contrast for the sensor by learning how to evaluate your histogram.

As you read on, this concept will become clearer.

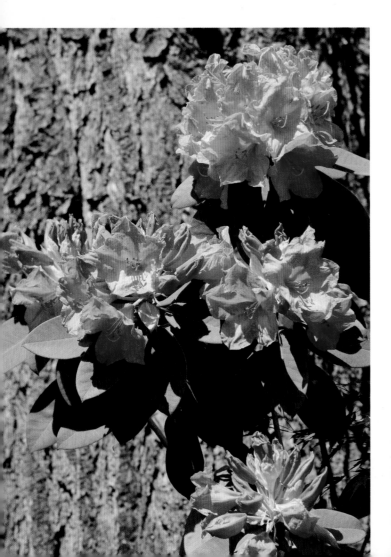
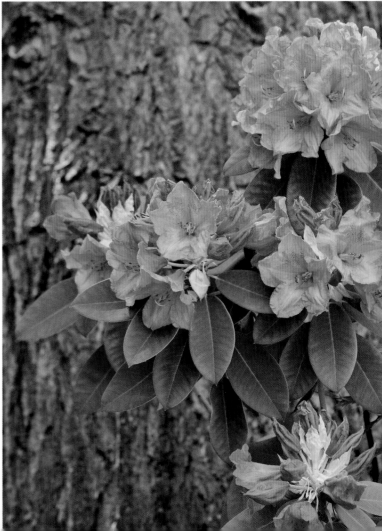

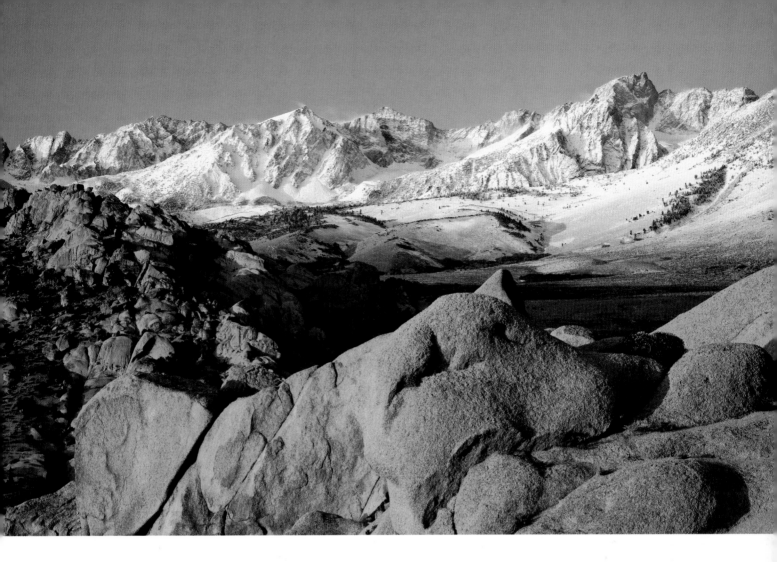

THE CHARACTERISTICS
OF NATURAL LIGHT

SUNRISE, BUTTER-
MILK ROCKS, BISHOP,
CALIFORNIA. *Sunrise
created a soft warm glow that
skimmed the surface of the rock
formations in the valley and
illuminated the Sierra Range.
I love natural light when it's
this beautiful. With the first
dusting of snow for the season,
the mountains were stun-
ning.* 24–105mm lens at
67mm, f/16 at 1/3 sec.

Light has several significant characteristics:
quality, quantity, direction, and color.
I can't overstate the impact these
characteristics have on your photographs.
Photographers who don't understand the
characteristics of light usually produce
images that lack drama or emotion. Those
who learn how to work with light will
make infinitely better photographs. Not
only will they illuminate their subjects
well, they will also convey light's emotional
symbolism.

Natural light can be *specular* or *diffuse*.
Both come from a specular source, the sun.
When nothing stands between the sun and
the subject, the light is direct and produces
sharply defined edges on objects. Specular
light creates bright highlights and deep

shadows, known as tonal contrast. Since
the sensor cannot record too extreme a
range of contrast, photographing in strong
specular light can present a challenge.
Light that is refracting off an object in
full sun reduces the color saturation, and
bright highlights and deep shadows create
a contrast that is considered "busy" and
hard on the eyes as they try to read the
details in the shadows and highlights of
the picture.

From an emotional perspective,
specular light is bold and aggressive.
Direct sunlight represents energy, vitality,
and heat, so it doesn't make sense to
photograph certain subjects in strong
sunlight. For example, you wouldn't be
able to capture the delicate color and

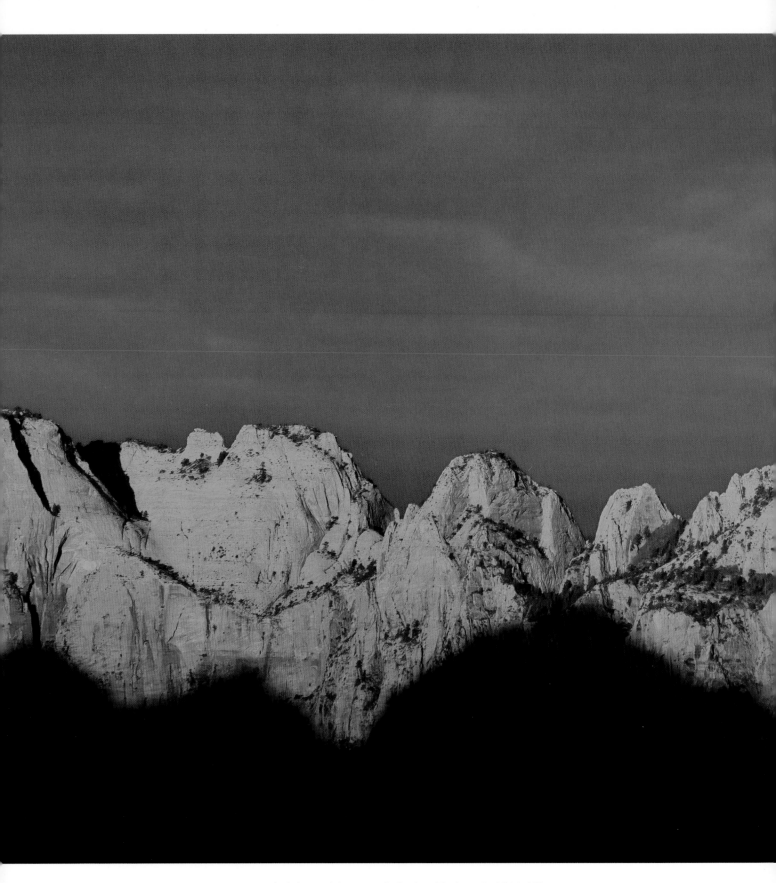

SUNRISE, ZION NATIONAL PARK, UTAH. *As the sky began to lighten, I saw clouds—lots of clouds—and it didn't look like there would be much of a sunrise. I had gotten up to hike a mile-long trail in the total darkness, to be in place for the best light. But I've learned to wait it out, and on this morning that paid off. The sun blazed across the face of the rocks of Zion without striking the clouds above. The result was this incredible contrast between the dark and stormy sky and the sweet light on the cliffs. It lasted only a few seconds, but long enough for me to get one or two exposures of it. 70–200mm lens at 97mm, f/16 at 1/3 sec.*

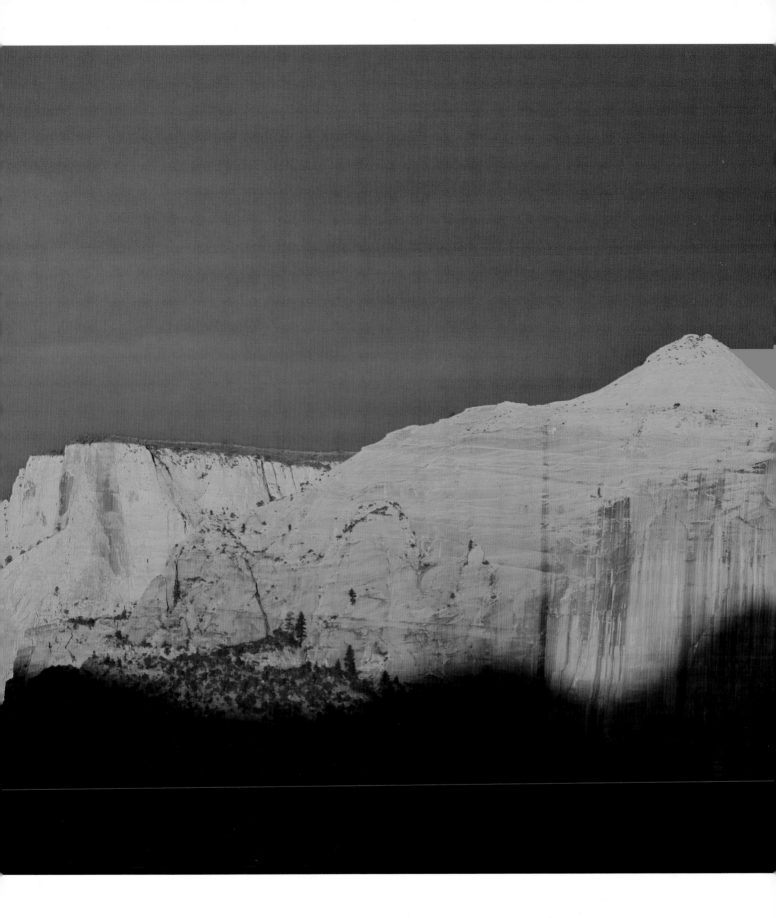

OPPOSITE, TOP: REDBUD TREES, GREAT SMOKY MOUNTAINS NATIONAL PARK, TENNESSEE. *A colleague refers to the diffused light of an overcast or foggy day as "quiet" light. It's very appropriate light for photographing in the forest. These delicate redbud blossoms would not show up well in sunlight. I needed the even light of the cloudy day to bring out all the fine details. 70–200mm lens at 155mm, f/16 at 1 second.*

OPPOSITE, BELOW: ENDICOTT ARM, INSIDE PASSAGE, ALASKA *This day was an incredible journey past steep hillsides of rock and fir. The fog expressed the mood of a majestic place. 100–400mm lens at 400mm, f/7.1 at 1/400 sec.*

details of a blossom in strong sunlight, but you could capture the drama of strong sunlight breaking through storm clouds.

Diffuse light, often called soft light, is sunlight that has been run through a filter of cloud layers, smoke, fog, marine haze, or materials like silk or nylon. Light beams from the sun hit this diffusion layer and scatter. Light coming from several directions at once, rather than a single direction, lowers tonal contrast. With the range of brightness compressed, the transition from highlight to shadow is much more gradual. As a result, colors appear richer, and you can record areas of highlight and shadow more successfully. Commonly called "quiet light," diffuse light will enhance the delicate details of a flower, but it may make a landscape dull and uninteresting. Diffuse light is emotionally nonassertive. It quiets the spirit and suggests peacefulness. Yet it can also suggest danger, as it does in the ominous skies that precede a storm.

In my workshops I am surprised to notice how many students will start to pack up their cameras at the first signs of cloudy or overcast skies. Most outdoor photographers exult over the cheerfulness of a sunny day, but when the weather turns "bad," you need to don rain gear and pack more memory cards. Intimate details and moody landscapes await those who venture out with an adventurous spirit into the diffuse light that often accompanies fog, mist, and rain.

Although diffuse light is generally better for macro and intimate views, and specular light is usually more effective for landscapes, this is not a hard-and-fast rule. Every photographic situation is unique. What matters is that the light is right for what you want to photograph.

As an exercise, photograph the same scene, or object, on a sunny day, a rainy day, and a cloudy day, and compare the results. Study them, and you'll learn how different qualities of light affect your subject and which type of light is the most evocative for that subject.

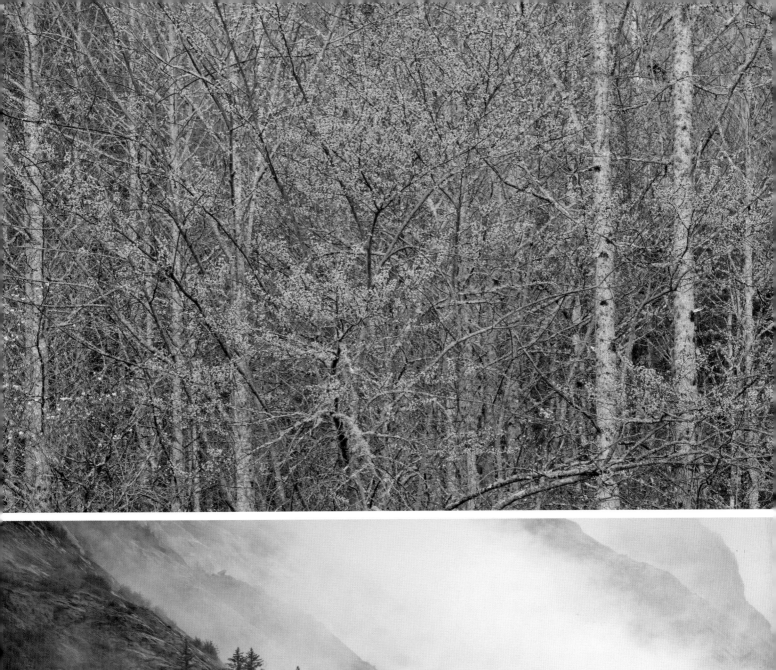
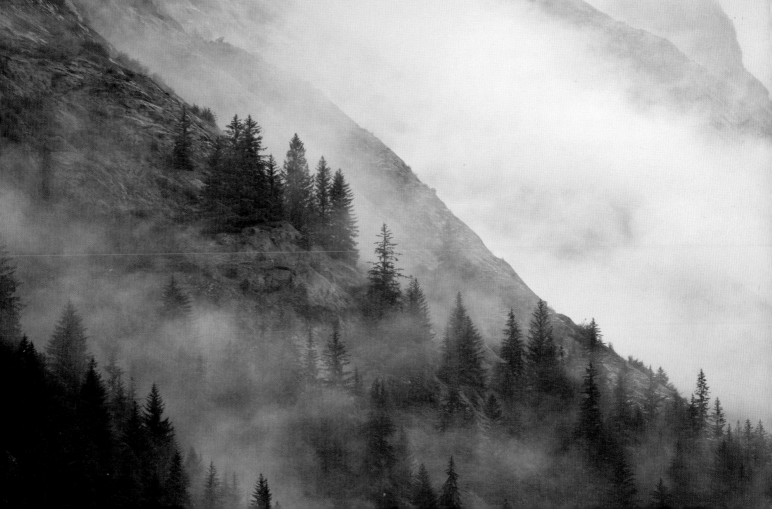

THE DIRECTION OF LIGHT

The direction of the light is constantly changing throughout the day as the sun shifts position in the sky. In the middle of the day, when the sun is overhead, you essentially have *top light*. Have you ever noticed how a midday scenic or portrait in full sun is usually not very exciting? Top light from the sun often has extreme contrast, puts shadows in the wrong places, and is the least flattering of all the possible light directions.

Front light, when light is hitting the front of your subject, can be similarly boring. Many years ago, the rule was to photograph with the sun over your shoulder. And look at those photographs! When light comes from over your shoulder, straight on to your subject, the shadows that give dimension to an object and depth to a scene are often eliminated.

Without dimension, the photograph is flat, and so is your viewer's response.

Front light is in effect even when the sun is at your back and low in the sky. When you face east at sunset, the landscape may be filled with rich golden hues. But just because the color of the light is wonderful, the direction of light is not necessarily the best for your subject. A mountain will still look better when illuminated by a little more sidelight than front light. A city illuminated by the last rays of sunlight, however, may look great, because of the reflected light off the buildings. Pay attention to the direction of that light and use it to your advantage. For most nature and outdoor photography, sidelight and backlight usually provide the most pleasing results when photographing in sunlight.

NAVAJO SANDSTONE, ARIZONA. *Strong late-afternoon sidelight created wonderful shadows and texture and warmed up the already rich colors of these red rock formations.* 16–35mm lens, ƒ/16 at 7/10 sec.

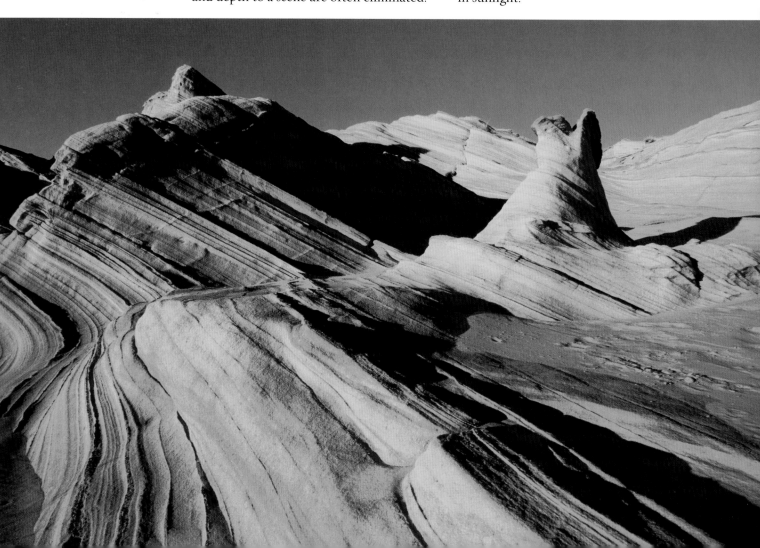

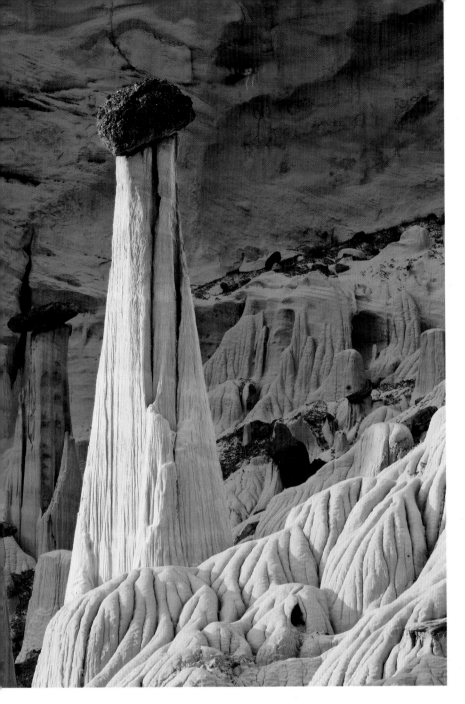

LAKE POWELL, UTAH. *The sidelight really brought out the texture and the form in this fragile, hardened, and very unusual mud formation— called a hoodoo—with capstone. 70–200mm lens at 100mm. f/22 at 1/15 sec.*

Professional outdoor photographers often use *sidelight* to give a feeling of dimension to a landscape and help define the form of objects. Painters "saw the light" centuries ago when they used sidelight to give their work dimension. Photographers can use sidelight the same way. The low angle of sun in the early morning or late afternoon produces great sidelight for landscapes, bringing out the form of objects and any texture that might be present.

Most obvious in the morning or afternoon, sidelight occurs any time your subject is struck by light at an angle. A vertical canyon wall can be sidelit at high noon. Even though the light is coming from overhead, it is skimming down the surface of the wall, producing the effect of sidelight.

Backlight, light coming from behind your subject, is one of the most dramatic kinds of light. It's great for silhouettes and for capturing the rim light on backlit cactus spines, a human's hair, and animal fur.

In landscapes, backlight can accentuate such atmospheric conditions as fog, rain, haze, mist, and smoke. In close-up details, as the sun pours through translucent objects, such as petals, leaves, or seedpods, backlight creates a wonderful glow.

Of the three directions of light, backlight is the trickiest type of light to meter correctly. When pointed toward your subject in the sun, your camera will suggest a reading that takes into account the bright sun and sky around it. This results in an underexposed picture, with your subject as silhouette. If you do want a silhouette, but with a properly exposed background, take a reading just to the left or right of the sun without the sun in the frame, lock in that exposure, if you're not in manual mode, and recompose the scene.

For translucent backlit subjects, spot-meter off the part of the object that is glowing—for example, the leaf surface—and adjust your meter according to whether it's a light or dark tonal value. Experiment with exposures and check your LCD for the results until you get what you want from the situation.

Early morning and late afternoon are great times to photograph backlit scenes, with the golden light creating a feeling of warmth, energy, even nostalgia. However, with the low angle of the sun, you may get light shining directly onto the front element of the lens, which can cause lens flare. Filters can also cause flare as the light bounces off the front lens element and reflects back off the inside of the filter.

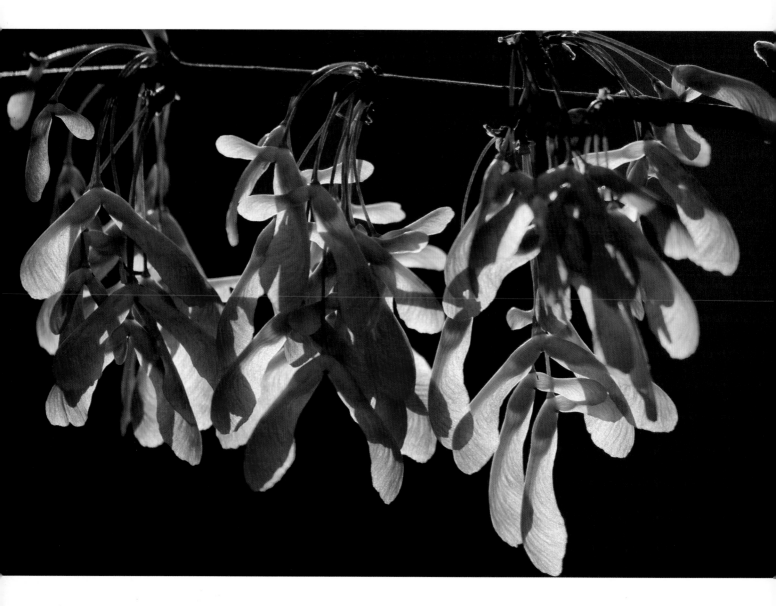

MAPLE SEEDLINGS, TENNESSEE. *I noticed these maple seedlings glowing in the sunlight that had just popped up over the ridge. I stood on a bench to position them against a dark part of the hill to emphasize the backlight.* 100–400mm lens at 365mm. f/6.3 at 1/200 sec.

To reduce flare in these circumstances, remove all filters and use a lens hood.

Because of the way sensors are designed, digital experts have come to realize that you get more information in the upper half of the pixels for your sensor. By exposing so that the histogram favors the right side the graph, while not overexposing any highlights, you'll record more information in the upper half of your sensor's pixels and have more information to work with in the image-processing phase. This is commonly referred to as *exposing to the right*. Yet, doing this means that instead of using the meter reading you got, you may have to deliberately overexpose from that reading. So much for our discussion on *correct* exposure! You can see where traditional metering concepts don't work if you follow this "shift to the right" method. My cameras typically give me a histogram that is shifted to the right when I overexpose by +1/3 to +2/3 stops. See the resources section for links to Web sites with articles on this topic. There are also numerous books that discuss histograms and exposure. For newer digital photographers, just work to keep your exposure within the walls of the histogram by choosing your exposure settings carefully.

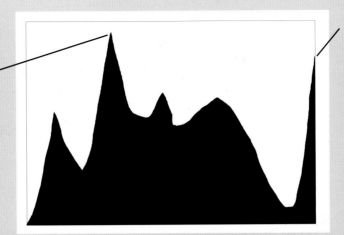

This shows you have a lot of pixels in the same tonal range

This shows you are overexposing, or clipping the highlights

This histogram shows that we have a scene with good tonal range, except for the spike on the right side. With it running up the side of the histogram, in simple terms, we have most likely lost the detail in those highlights. If it was just touching but not spiking up the right side, the exposure would have worked out pretty well.

understanding your histogram

No matter how you arrive at your exposure, the proof of correct digital exposure will be in the histogram. Put this book down, and go turn on histogram view mode in your cameras, and don't turn it off—ever! You should live and die (photographically speaking) by the histogram. It tells you whether your exposure is within the range of what the sensor can record. You can use it to evaluate how to adjust your settings for a better exposure.

I even use my histogram as a compositional tool. If I have a large area that is bright or dark, I will evaluate whether that is hurting the overall picture and may reframe to eliminate troublesome areas. I have my camera set to have the histogram pop up right after exposing. I can always cycle through the modes to view the picture large if I need to, but it's the exposure that I want a quick confirmation on when working.

In my workshops, especially those for beginners, we sometimes refer to the histogram as the "hysteria-gram." That usually gets a major laugh from the group. Most beginners are a little hysterical about how to decipher the histogram and know they are getting a good exposure, so they just look at the picture on the back. *You cannot trust your LCD on the camera.* Most likely, you turn the brightness level up on the LCD to see it better when outdoors. So how can you evaluate an exposure looking at that brighter screen? Once you get the basics understood, the histogram is the only way to confirm your exposure is good.

If you're overexposing the highlights too much, the histogram will show you this. (Your camera might even have a highlight warning feature that blinks on and

off in areas that are too overexposed.) The histogram represents 256 tonal values across the graph, from total black on left to total white on right. It shows the spread of recorded information over the entire tonal range. When the data runs off the right or left side of the graph, spiking up the edge, you are "clipping" highlights or shadows, and you've likely lost detail in them. If, however, the histogram is just touching the side, it may not be critical. For example, if highlights are small, such as sparkles on water or dew on grasses, it's not an issue, because to expose properly for them would mean gross underexposure for the rest of the picture. Tall spikes in the graph tell you that you have a lot of pixels in that particular tonal value. Spikes in the middle areas are not a problem, but spikes up the right side indicate that you've lost detail, and if that area is a significant portion of your picture, this is not a good thing. Spikes that go up the left side of the histogram show that you've lost detail in the shadows; but, generally, shadows are less important than highlights, in terms of retaining detail, unless they comprise a large area of your picture.

The goal is to get a histogram that doesn't run off either the right side or the left side of the graph. A bell curve is the "perfect" histogram, but when was the last time you saw one of those on your LCD? In the real world, most histograms won't look like that. That's okay, as it usually means that you have contrast in your scene, which is generally better than lack of contrast. Just try to keep the range of exposure within the graph when possible and not have it spike on either side.

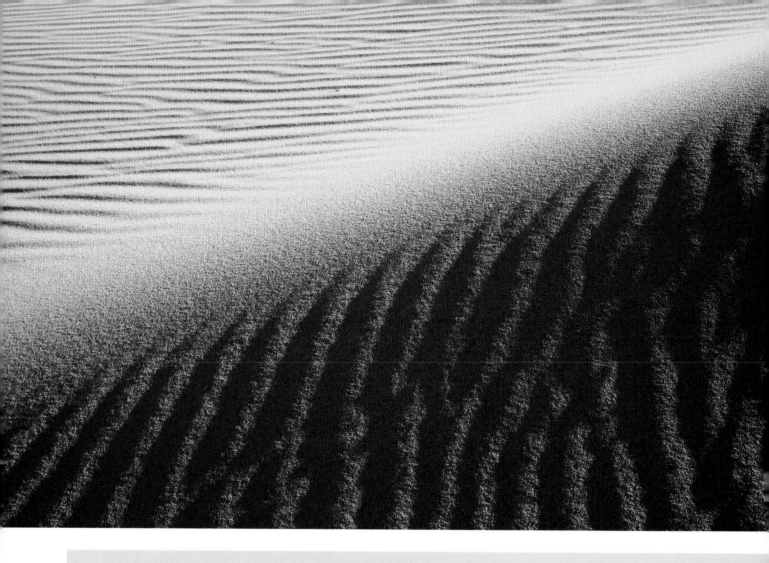

metering in a nutshell

Ideally, we should all be able to look at a scene and know what shutter speed and aperture combinations will give us the correct exposure. The more you can see a scene in certain light and say, "f/11 at 1/125," the faster you can respond to capturing that scene. Photographers who can do this know how to "read" light from learning how the camera reads light. But many photographers today simply rely on the meter in the camera. While today's camera meters are very accurate, there are conditions under which the camera's meter reading may still be incorrect. Since all light meters in cameras are calibrated to read 18 percent reflectance of light from the scene—the equivalent of middle-tone, or neutral gray—both darker than middle-tone and lighter than middle-tone scenes are rendered as middle-tone. The moral here is that if you don't want medium-gray snow or medium-gray black bears, you'll need to compensate by overexposing or underexposing from that meter reading.

In general terms, you'll add light to light scenes and subtract light from dark scenes by compensating from the meter reading.

Of course, all of this is relative to the effect you want. Sometimes, a slightly underexposed image of a foggy scene evokes a certain somber mood that you might want, and a slightly overexposed scene can render a pastel effect. So it's not always the technically correct exposure but rather the creative exposure that you want, as long as you're not overexposing or underexposing large important areas of the scene too much.

On a scene that is stationary and repeatable, you can make adjustments and take another picture. But you can't do this with events or where fleeting moments are occurring, so it's important to understand how to get a good overall exposure on the first try, by knowing how to meter accurately. For a complete understanding of exposure, I recommend Bryan Peterson's *Understanding Exposure, 3rd Edition*.

DEATH VALLEY
NATIONAL PARK,
CALIFORNIA. *The low angle
of morning light skimmed across
the surface of this dune, creat-
ing a wonderful light/shadow
relationship, and bringing out the
texture at the same time. 70–
200mm lens at 80mm,
f/20 at 1/5 sec.*

BACKLIT ASPEN TREES,
BISHOP, CALIFORNIA.
*This was a tricky lighting situa-
tion, as the trees were in sun but
the wall behind them was not.
The leaves on the aspen were too
small to spot-meter on easily, so
I used evaluative metering. But
because the amount of light and
dark in my viewfinder was fairly
equal in terms of overall propor-
tion, I only had to underexpose
by -0.3 to get a good exposure.
70–200mm lens at
200mm with 1.4x, f/16 at
1/40 sec.*

THE COLOR OF LIGHT

TUSCANY, ITALY.
*Mornings often bring mist to
the valleys in central Tuscany.
On this particular morning we
found a special scene. The color
of the light was a great mix of
cool and warm hues in that
predawn hour. Moments like
this are the reason I get up very
early and get out there with
my camera. 70–200mm
lens at 165mm, f/16 at 2
seconds.*

You don't need to be a scientist, but knowing a few basics about the color temperature of natural light can help you make better outdoor photographs.

All natural light has a certain color that results from the way light rays travel through the atmosphere. Full midday light (white light) is about 5,500 degrees on the Kelvin scale, the standard for measuring the *color temperature* of light. By comparison, the color of sunrise will measure between 2,900 and 3,400 degrees Kelvin, and twilight will measure about 10,000

to 12,000. The lower the number, the warmer and redder the light; the higher the number, the cooler and bluer the light. Warm light is easy to see in the hues of a good sunrise or a glowing campfire. Cool light is easy to see in the deep blue of twilight. It's the many variations between these extremes that are most difficult for the human eye to discern, because the brain corrects for color shifts, just like Auto White Balance does on a digital camera.

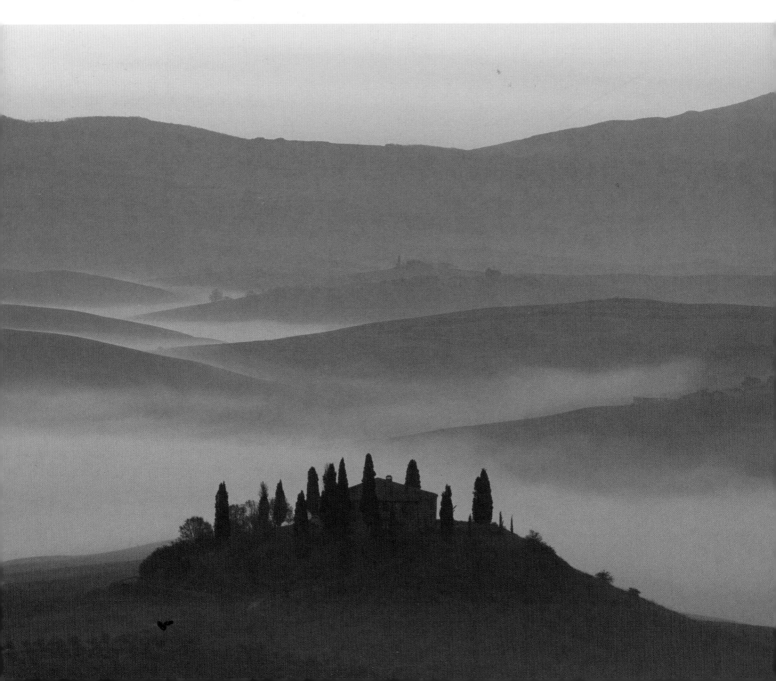

RIGHT: MISTY DAWN, MAINE. *This is a favorite lake of mine near Camden, Maine. I loved how the blue light of dusk added a feeling of tranquility to the misty scene.* 70–200mm *lens at* 78mm, *f*/13 *at* 1/5 *sec.*

BELOW: BRISTLECONE PINE AT SUNSET, WHITE MOUNTAINS, CALIFORNIA. *I knew a spot where I could get the last rays of the sunset striking the bristlecone pine trees. The reddish-orange light created a great color contrast of the tree against a cobalt blue sky.* 24–105mm *lens at* 35mm, *f*/16 *at* 1/13 *sec.*

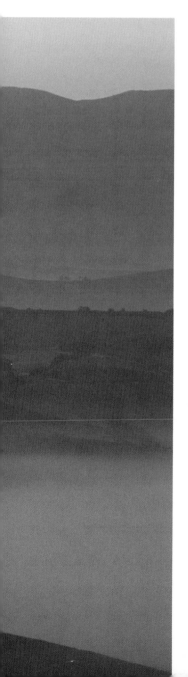

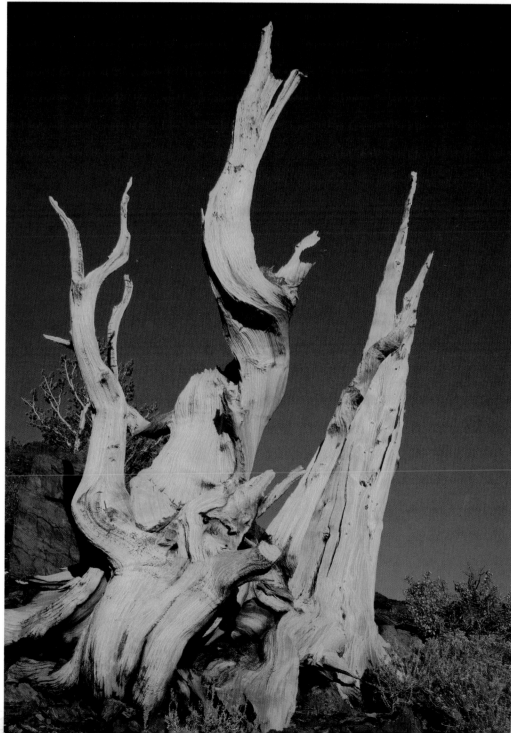

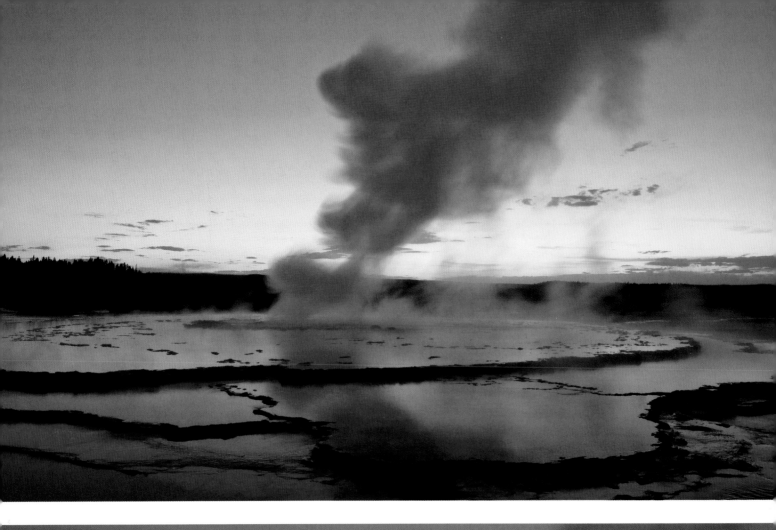

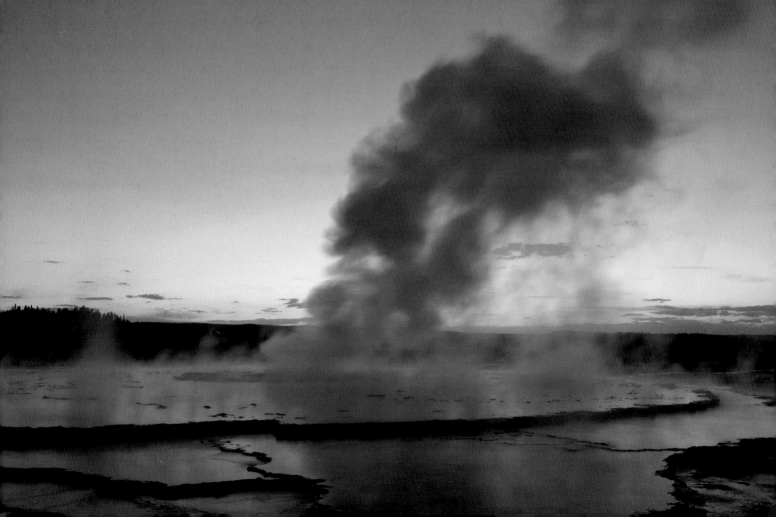

GIANT GEYSER, YELLOWSTONE NATIONAL PARK, WYOMING. *For these two pictures, I simply changed my white balance setting. The sunset had gone flat, and twilight was not yet rich enough, but with the camera set on Tungsten, I was able to create a nice twilight effect by adding to the blue light already in the scene. 24–105mm lens at 27mm, f/14 at 1/2 sec.* TOP: White Balance set to Tungsten. BOTTOM: White Balance set to Daylight.

Why is it so important to learn about the color of light, when a digital camera can automatically white balance? In some cases, the actual color of the light may be making the picture more interesting, and if you let the camera take over color control, you might be losing the effect. Auto White Balance (AWB) neutralizes the color of the light it reads based on daylight parameters built into the camera, so if the light is "cool," it will warm it up some, and if it's "warm," it will cool it down some. If the coolness of a foggy morning is what you want to show, AWB may ruin the effect by warming up that cool light too much. By learning to recognize the color of the light in a situation, you can make creative decisions in the field that will improve your picture. You can also use that awareness later when you process the file to get the color of the overall light to be what you remembered.

The color of light affects the color of objects in your photograph. The cool blue light of an overcast day will drain the rich hues of yellows, oranges, and reds of autumn leaves, so your forest scene may end up looking dull. A quick white balance change to Cloudy will help that. There are times when the color of the light is a strong warm hue, at sunrise or sunset, and yet the effect on your scene may not be so wonderful. The orange light of sunrise will make a field of blue flowers look "muddy." You're mixing colors like paint in this instance, and white balance settings can't really improve the flowers without changing the color of the light in the whole scene and potentially negating the warmth of your sunrise. So if you want a field of blue lupine to look accurate for the flowers, you'll need to wait until the color of the light is a little more neutral, usually about 45 to 60 minutes after sunrise.

setting your white balance

Your camera offers a variety of white balance settings to correct the color temperature of light. How do you decide which to use? First, it's important to note the difference between photographing in RAW or JPEG mode. If in JPEG, changes made in-camera are incorporated into the camera's processing of that JPEG, and the resulting file has the color correction embedded in it. You won't need to correct it later in the computer, thus protecting the JPEG from potential degradation with additional manipulation. If in RAW mode, the setting is somewhat irrelevant, as you can safely modify it later when processing the file. However, for new photographers, I still suggest setting it in-camera, as this teaches you to pay attention to the color of the light, part of mastering the craft of photography.

As to which setting to use, it's pretty straightforward. When you're under cloudy conditions, set the white balance to Cloudy; when in shade, set it to Shade,

and so on. You could also choose to use Auto White Balance (AWB), and 95 percent of the time it will be fine, but if you learn to see the color of light, you'll be more aware of when AWB may not be the best choice. I use Daylight, which applies no color correction, and modify it later in the computer.

Understanding how white balance settings affect your camera's response to different color temperatures will give you one more creative tool. With a little practice, you can train your eye to see subtle variations of color temperature. The key is to remember what conditions or times of day produce a particular color of light. Sunrise and early mornings are typically warmer, midday light is fairly white or neutral, and afternoons and sunsets are warm again. Cloudy, rainy days tend to have a cool, bluish cast to them. Open shade has a deeper blue cast. High altitudes (above 4,000 feet) are cooler than you think, even at sunset.

MODIFYING THE LIGHT WITH FILTERS

Because color correcting the light can be done with digital camera settings, I don't have to carry all the filters I used to have in my bag. I like that! It leaves more room for other accessories. But there are still some filters that digital photographers need to carry to modify the light in a scene.

POLARIZING FILTERS

The most essential filter for me now is a polarizing filter. Both digital and film users need polarizing filters. These wonderful filters reduce the glare from the atmosphere on sunny days to deepen blue skies and create strong contrast between the sky and clouds. They also reduce glare from wet or shiny surfaces, producing more saturated colors. Polarizing filters work best when used at a 90-degree angle to the light source, typically the sun. Light waves normally vibrate in all directions. Polarizing filters eliminate the scattered light and only allow the light that vibrates along one plane to reach the camera. This reduces glare and increases contrast. If you're working with morning or afternoon light coming from the side, your scene will have maximum polarization. But with wide-angle lenses, your sky will be polarized unevenly, an effect that many don't like in landscapes.

Polarizing filters are also great in the forest, as they minimize reflective glare from wet leaves, rocks, and mosses. By reducing surface glare, they allow you to see into tide pools and shallow ponds. I use my polarizer more under these circumstances than I do on a sunny day!

GRADUATED NEUTRAL DENSITY FILTERS

Unless you know how to use the gradient tool well in Photoshop, or how to blend different exposures together with various computer techniques, you'll need these filters to balance the light in many situations. Using a filter, you can see the effect immediately, and that means less time spent at the computer to fix the picture later. And not everything is easily fixed by the editing software.

Graduated neutral density (ND) filters allow you to compress the range of light in a situation that is normally too extreme for the camera to record. You'll most often use these filters when photographing landscapes or seascapes in which the sky is too bright when you get a good exposure for the land or sea.

They come in various densities that are equivalent to f-stops, such as a 2-stop (.6 ND). If you are just learning to use graduated ND filters, a 3-stop (.9 ND) is a good choice, as RAW files can usually manage a 2-stop difference with little problem. The 4 x 6–inch rectangular filters that fit in a holder are the best style, as they allow you room to shift the line of gradation in the composition when you put your horizon higher or lower in the frame.

The easiest and fastest way to use a graduated ND filter is to match the gradation line on the filter with the "line" between the light and dark areas of your scene. With soft-step filters, though, it's not always easy to see the filter's line, even when the lens is stopped down. Here's a tip to make it easier: Fold a 4 x 6–inch piece of paper in half so it's 4 x 3 inches. Place it over the top edge of the filter and place the filter in the filter holder on the lens. When you look through the viewfinder, you will very easily see where the line is on the filter as you adjust it up or down. Soft-step graduated filters, which have a feathered line, are more forgiving, making placement not as critical as with hard-step filters.

OTHER FILTERS AND ACCESSORIES

I use various other filters to enhance color or add special effects. One particular filter

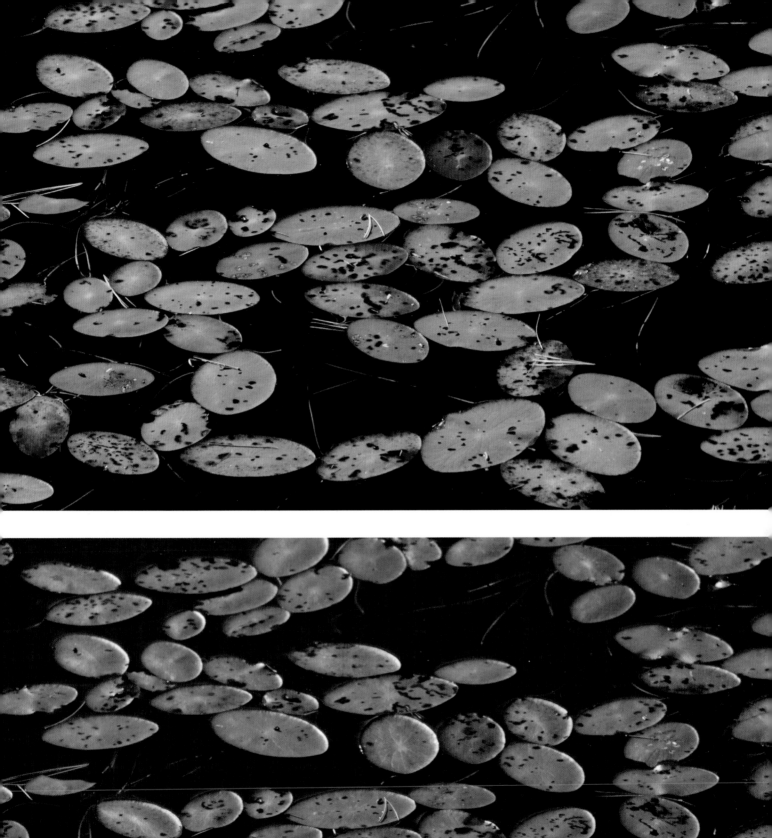
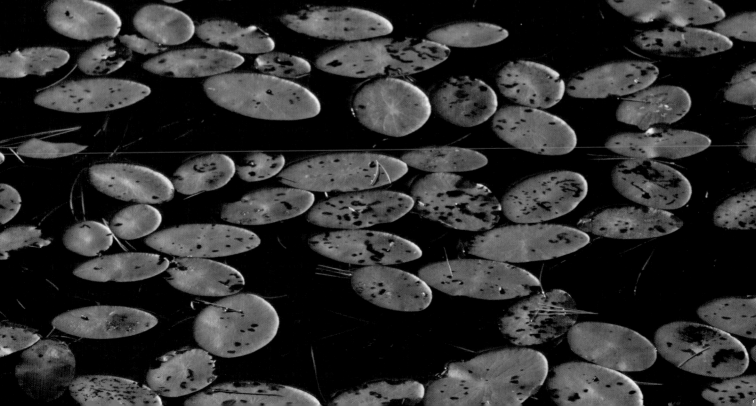

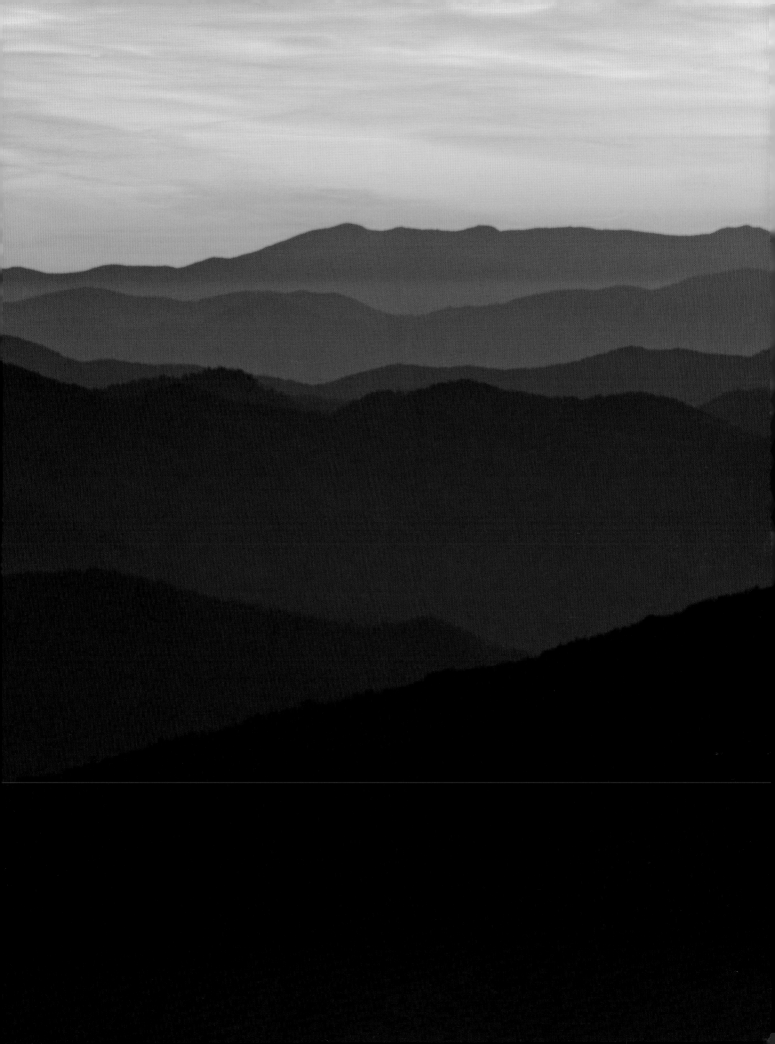

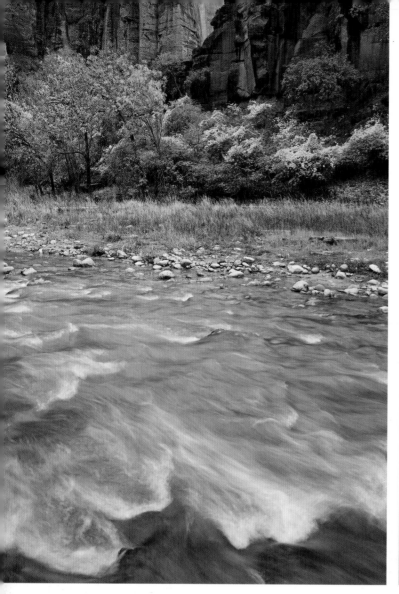
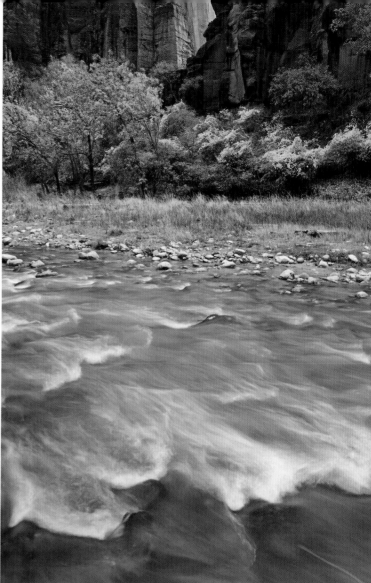

PREVIOUS SPREAD: GREAT SMOKY MOUNTAINS NATIONAL PARK, TENNESSEE. *Using a 3-stop graduated filter, I was able to capture the rich hues of the sky while not totally silhouetting the ridgelines. I placed the filter over the sky portion and used evaluative metering to make the exposure. 70–200mm lens at 280mm with 2x teleconverter, f/10 at 2 seconds.*

that is invaluable to me is Singh-Ray's Variable ND filter, which, when rotated, adds from 2 to 8 stops of density. It's great for slowing the shutter speed down in bright situations. I've used it for coastal scenes when I want the wave action to be very soft and blurred, as well as for midmorning images of white-water rafting and other action events, to create artistic interpretations of the motion.

Outdoor photographers don't have total control over the *quality* of the light, but you can use accessories to modify it. If you want to do macro photography and can't wait for an overcast day, make your own diffuse light by placing translucent fabric between the sun and the subject. Diffusers are available as ready-made discs that fold up with a twist of the wrist. I never leave home without mine.

What if you have strong sunlight and don't want to alter the quality of the light yet need to balance the contrast? You have two options: You can use reflectors to bounce light in to the shadows, to compress the range of light, or you can use your flash in "fill" mode. In outdoor photography, the key to successful "fill" using a reflector or flash is to make it appear as natural as possible. Reflectors are easier, because you see the fill light with your eyes before making the picture. With flash, you have to review the LCD. Yet they both serve a purpose with outdoor photographers.

Your fill light should always be less than the main light source—for example, the sun. Silver and gold reflectors are pretty intense, creating a strong, somewhat harsh light that may be too much for

nature scenes. White reflectors are less intense and neutral in color. But there are combinations called "soft gold" for example, that reduce the intensity a bit.

With flash, you'll need to control the quantity of light. For easiest and best results, you'll need a programmable flash that talks with your camera. You'll simply set your flash compensation to the negative side of the scale, something like -1 or -1 2/3, and the camera and flash "talk" to determine the exposure. To know where to start, do a quick test in full sun, using all the minus settings for flash compensation, and choose what looks natural to you. That setting will then be a starting point for future pictures in sunlight needing fill-flash, although you might make a slight adjustment for the particular situation.

The quality of the light from flash is similar to that of the sun—i.e., specular, creating hard edges, harsh light, and deep shadows (when used in full flash mode). Compensating with less light doesn't change the quality. You'll need to *diffuse* the light from the flash, because if any shadow edges do show in your picture, it will appear unnatural. There are a variety of accessories to help you do that. My favorite for its effect, price, and size is Sto-Fen's Omni Bounce. Digital has made it easy to practice using your flash and review the results. If you learn how to set your flash correctly for natural-looking fill light, you can create very pleasing results.

All of these are great tools to help modify or control the light, once you have learned the characteristics of natural light. The more practice you get in the field, the more you'll develop your ability to see light and to previsualize the scene or subject under different lighting conditions. Learn how to recognize the best light for the situation, and you can use the magic of light to enhance your photographs.

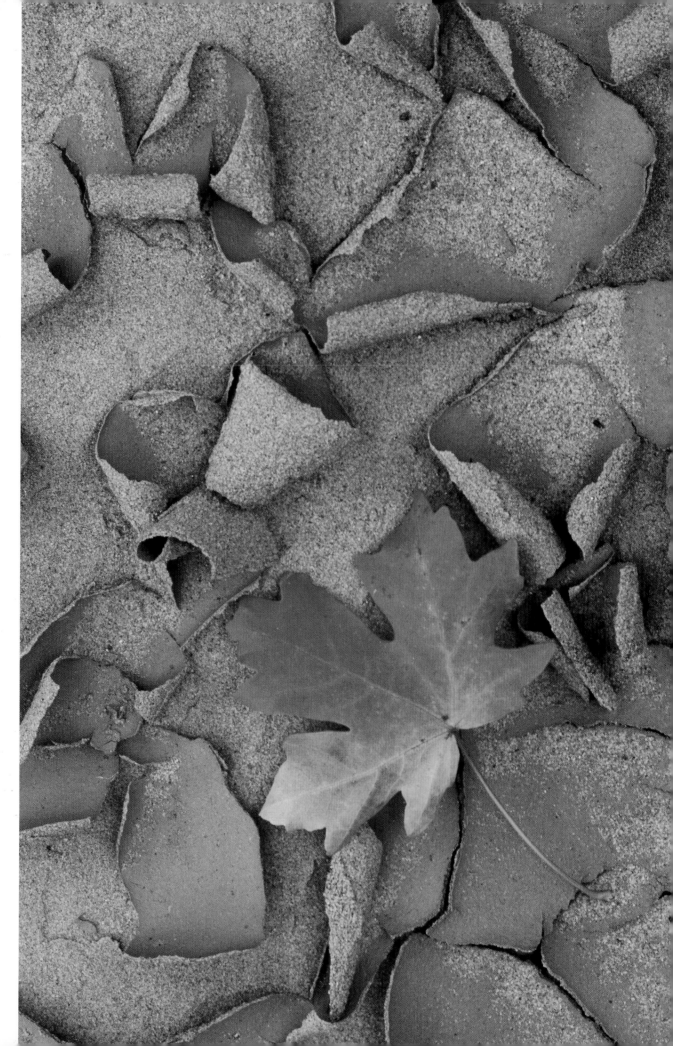

BIGTOOTH
MAPLE LEAF IN
WASH, ZION
NATIONAL
PARK, UTAH.
*I diffused this scene
with a translucent
disc. When I put
the disc up close
to the subject, the
light got stronger,
yet remained dif-
fuse, creating a soft
directional glow to
the light.* 100mm
macro lens, f/16
at 1 second.

high dynamic range

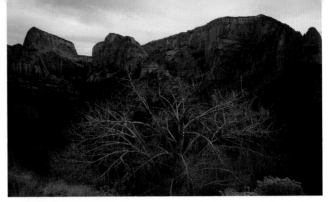

If you have scenes in which the range of contrast is extreme in any area of the picture, you can now solve that problem using a technique called High Dynamic Range (HDR). This computer process takes the different exposures you've made and combines them into one file that, with just a few manual adjustments, gives you a natural-looking, well-exposed picture from a high-contrast situation. This technique works best when there is little or no movement between exposures, as it "stacks" the pictures together when it does its computing, and movement can cause blurring in that area in the final picture.

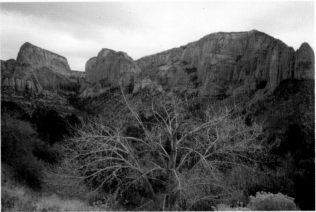

Photoshop has a built-in HDR feature, but I prefer Photomatix, which is both a Photoshop plug-in and an external software application.

For this scene from Zion National Park, I made three exposures. I made my first exposure as dark as I needed, just to where highlights were no longer clipping. Then, I exposed +1 and +2 stops for the other two exposures, not caring about the overexposed highlights in those, but wanting to bring in shadow detail. (You can do as many as six exposures, if you need to, on a scene with a lot of exposure range.) I then combined them using Photomatix and, with a few adjustments to the combined file, created the finished natural-looking result.

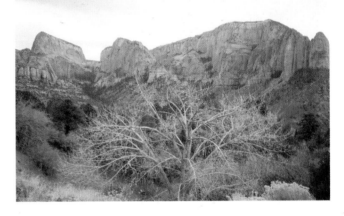

KOLOB CANYON, ZION NATIONAL PARK, UTAH.
TOP: 24–105mm lens at 24mm, *f*/11 at 1/15 sec.
SECOND FROM TOP: 24–105mm lens at 24mm, *f*/11 at 1/8 sec.
THIRD FROM TOP: 24–105mm lens at 24mm, *f*/11 at 1/4 sec.
BOTTOM: Merged file; no exposure available.

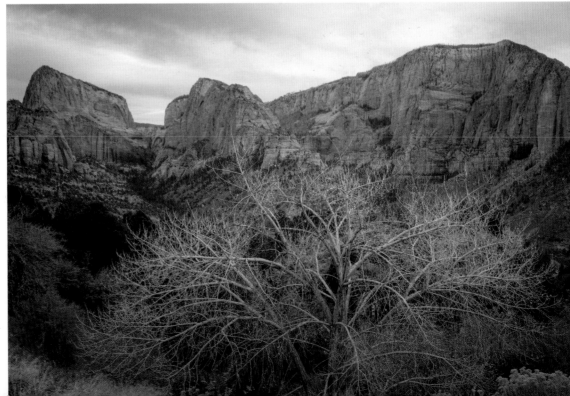

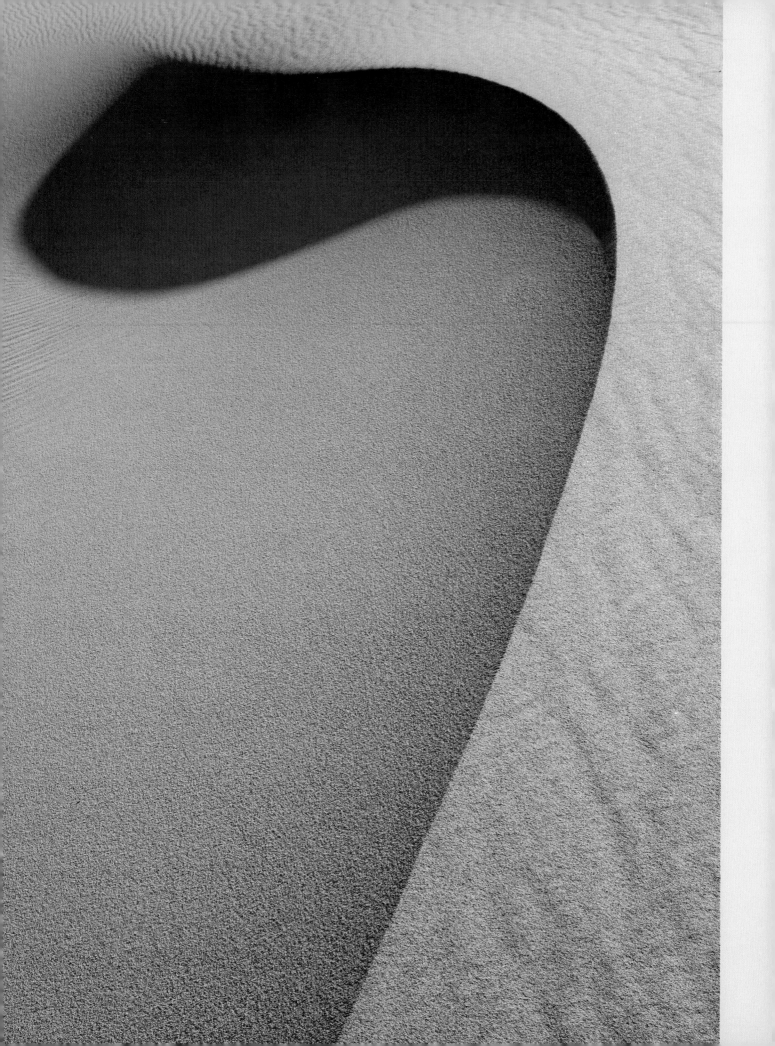

VISUAL DESIGN

*"If you think of effective visual expression as your goal . . .
then good visual design is the craft that makes it possible."*
—FREEMAN PATTERSON

THE SUCCESS OF A PLAY DEPENDS IN PART UPON A WELL-designed set that creates a pathway for the movement of the actors and establishes a tone, or mood. Photographs also need a well-designed "set," where line, shape, form, pattern, texture, and perspective are the essential elements that come together to create an appealing image. Each element carries a symbolic value and has unique attributes. For example, lines can be aggressive or passive; patterns can be dizzying or organized. This symbolism comes from our deep association with objects.

Most photographers haven't really thought about the elements of design in their pictures. They consider the objects simply as objects, not as lines or shapes or patterns. You must have a deeper perception to see visual design elements in the world. After reading this chapter, I hope you'll look at the world around you differently. If you incorporate some of these design elements in your photographs, your images will have more visual impact, whether they are close-up details, landscapes, or action images. Remember, each element contributes to building your "set," so every one of them is important.

SAND DUNE, DEATH VALLEY NATIONAL PARK, CALIFORNIA. *The curved line of this dune's crisp edge and the play of light and shadow drew my attention. I framed it vertically to emphasize the line and let it draw the viewer through the scene. 24–105mm lens at 50mm, f/20 at 1/5 sec.*

LINE

Lines are the most prevalent design element, defining shapes, clarifying divisions between areas, and visually leading us places. Lines bring structure to a photograph and possess visual strength. There are really only two types of lines: straight and curving. Straight lines have a sense of purpose, taking you directly to and from areas in the scene. Curving lines create a more relaxed trip through a photograph, like taking a drive on a winding road.

Like all design elements, lines contain powerful symbolism. Smooth, curving lines can be sensual or tranquil. Jagged, zigzag lines suggest tension and can represent danger. Straight lines convey rigidity and structure (and are usually man-made). Straight lines can be horizontal, vertical, or oblique, and each direction evokes an emotional response. Lines also carry visual weight—a thin line has less impact than a thick line.

Lines powerfully direct the eye. Magazine and book designers often use this fact, consciously positioning images with lines to visually move you toward the edge of the page and onto the next one. Lines can be a great addition to a photograph, but they can also divide an image or take the viewer places you don't want them to go. It's important to recognize the significance of lines and to learn how to use them well in a photograph.

HORIZONTAL LINES

A straight horizontal line, such as the line defining the horizon where the ocean or a wheat field meets the sky, imparts a calm, stable feeling and can convey the breadth of a place if unbroken. The shoreline of a lake or pond, the line of trees at the base of a mountain range, and the rows of flowers in a commercial farm can all be considered horizontal lines.

You can deliberately use horizontal lines to create photographs that express a calm, pastoral mood. However, a horizon or strong horizontal line running through the middle of the frame can divide the photograph too equally, and the resulting visual stasis can make the photograph overly calm. Try placing any horizontal lines just above or below the section of the scene you want to emphasize. And consider framing your scene vertically to reduce the eye's travel along the line. This can make it more dynamic.

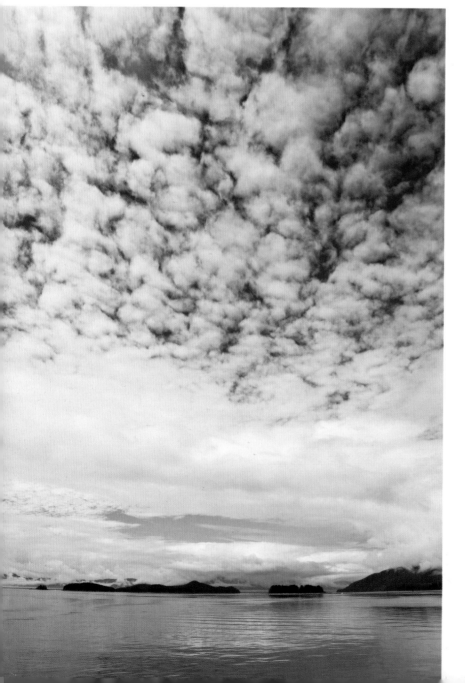

RIGHT: REFLECTIONS AT DAWN, BIRCH POINT, MAINE. *Since the mud patterns reflecting the colors of dawn were my subject, I chose to keep the horizon and distant trees out of the frame—except in the reflection. The dark line of trees creates a slight horizon line, but placed high in the frame, it keeps this picture dynamic.* 24–105mm lens at 70mm, f/16 at 1/2 sec.

BELOW: ROWS OF LAVENDER IN PROVENCE, FRANCE. *The lavender region of Provence is a visual design paradise, with lines, textures, and patterns everywhere. Positioning myself at a slight angle to the rows, I used the lines of this field to gently draw the viewer across the frame and into the background.* 70–200mm lens at 200mm, f/22 at 1/20 sec.

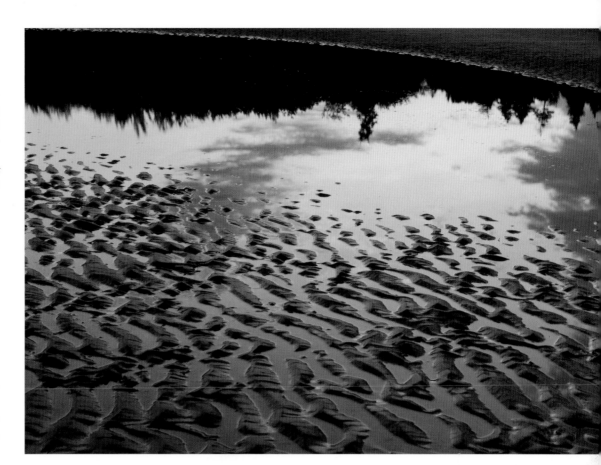

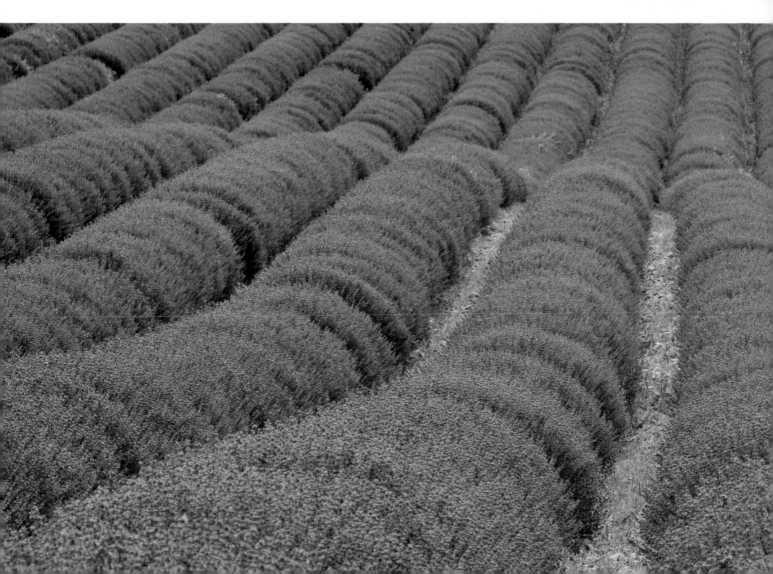

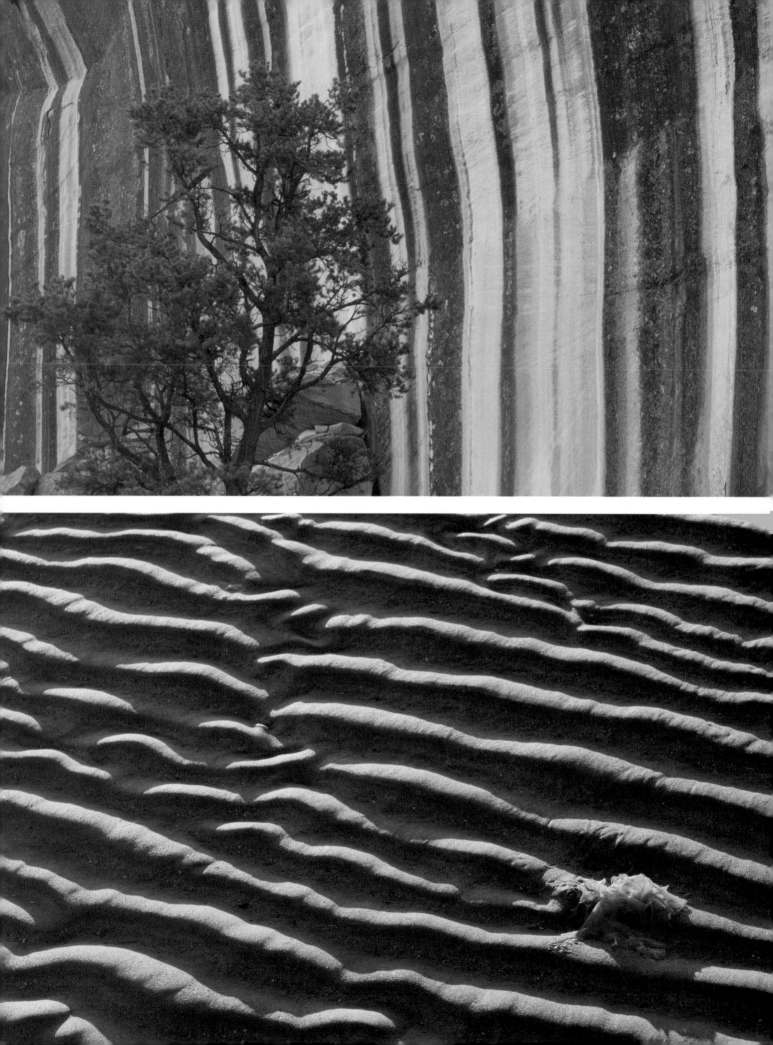

VERTICAL LINES

Vertical lines possess more energy than horizontal lines. A person usually seems more energetic when standing up than when lying down, and for that matter, so does a grizzly bear. Nature doesn't create truly vertical lines all that often, but trees, cattails, flower stalks, and waterfalls, are some vertical lines that can add impact to a composition. Man-made vertical lines—those of columns, bridge towers, lighthouses, and flagpoles, for example—exist everywhere and can add energy and strength to a picture.

Vertical lines are assertive and direct. They impart a sense of height to a composition, which we interpret as power, order, and strength. An orderly line-up of people often suggests power. A towering redwood tree certainly imparts a sense of strength, as can a slender blade of grass—provided you compose your image to emphasize the blade's vertical orientation. Like a horizontal line, a vertical line will produce visual stasis if it divides a photograph too uniformly. For a more interesting photograph, try composing an image so a vertical subject is off-center.

OBLIQUE AND DIAGONAL LINES

Oblique lines express more energy than horizontal or vertical lines, and they move the eye through a scene more rapidly. They represent movement because they look like vertical lines that are falling over. Visual tension develops because the line has been "knocked" out of a balanced state. The resulting instability stimulates the eye and brain. All of this can translate into a more exciting photograph. The steep switchbacks on a hillside create strong oblique lines in a landscape, giving the scene a more dynamic energy. The slope of a dune possesses more tension than a flat sea of sand. The angles in architecture make a building appear strong and powerful. Even the letter Z has an energy to it, and it is the oblique line connecting the two short horizontal lines that creates that energy.

Because oblique lines are so aggressive, they can dominate or even interfere with your composition. An oblique line that touches the top or bottom of the frame and one side of it can slice off a section of the image. And an oblique line that cuts

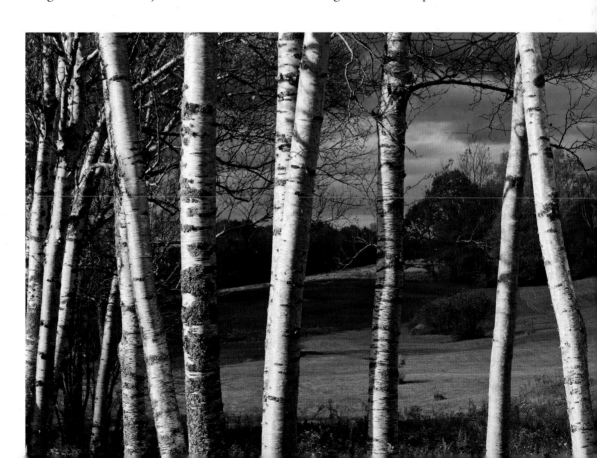

through from corner to corner, known as the only true diagonal line in the frame, divides the frame into equal parts and imparts the same static result you get when you equally divide a photograph vertically or horizontally. Oblique lines can be fantastic design elements in your photograph, but like any line, they demand thoughtful incorporation.

CURVING LINES

Mother Nature didn't make too many straight lines, at least not perfectly straight ones. A curved branch, a meandering river, the shapes of flower blossoms, and the human form are all examples of objects that contain curving lines. These curves convey gentleness and sensuality. We move through an image easily when traveling along a line that curves. The movement is peaceful and unhurried, evoking a feeling of going with the flow. When architects want to emulate nature, and soften the overall look, they incorporate curving lines into their design.

If you want to create images that are restful, and yet have movement, try incorporating curving lines. To make a curving line effective in your photograph, allow enough space for the curve to unfold, to swing back from one direction to another, and possibly to undulate through your scene. Cropping too tightly can prevent the curve of a line from developing, and cutting off the curve of the line with the frame's edge can interrupt the fluid movement of the line.

Here's an assignment to try: Spend a day looking for lines in the world around you. You can choose one type of line, or look for all types. Whichever you select, create interesting compositions in which the line is the subject, making full use of the attributes of that type of line. Finally, photograph images that use lines to lead the eye to your subject or through the scene. In the process, you'll learn to see lines everywhere and to incorporate them to create dynamic photographs, and you'll come to understand the power of lines as an important design element.

WINDING ROAD, TUSCANY, ITALY. *This undulating and curving road invites you to meander slowly through the countryside.* 70–200mm lens at 200mm, *f*/16 at 1/30 sec.

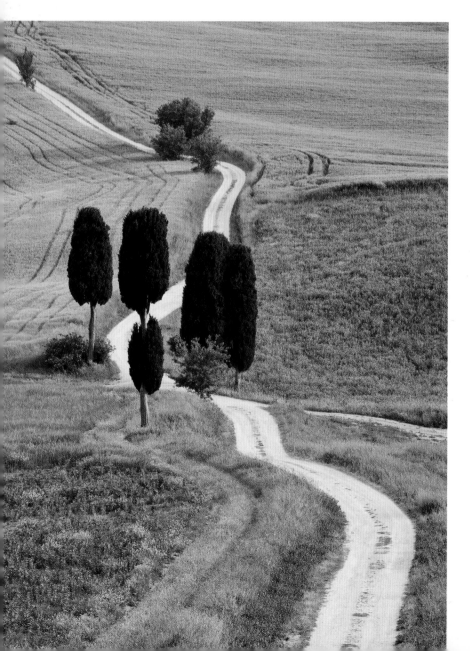

OPPOSITE: SWIRLING SANDSTONE, ARIZONA. *The angles and curving lines in the foreground pull you in to the scene, and the lines in the background pull you in from left to right.* 24–70mm lens at 30mm, *f*/16 at 1/100 sec.

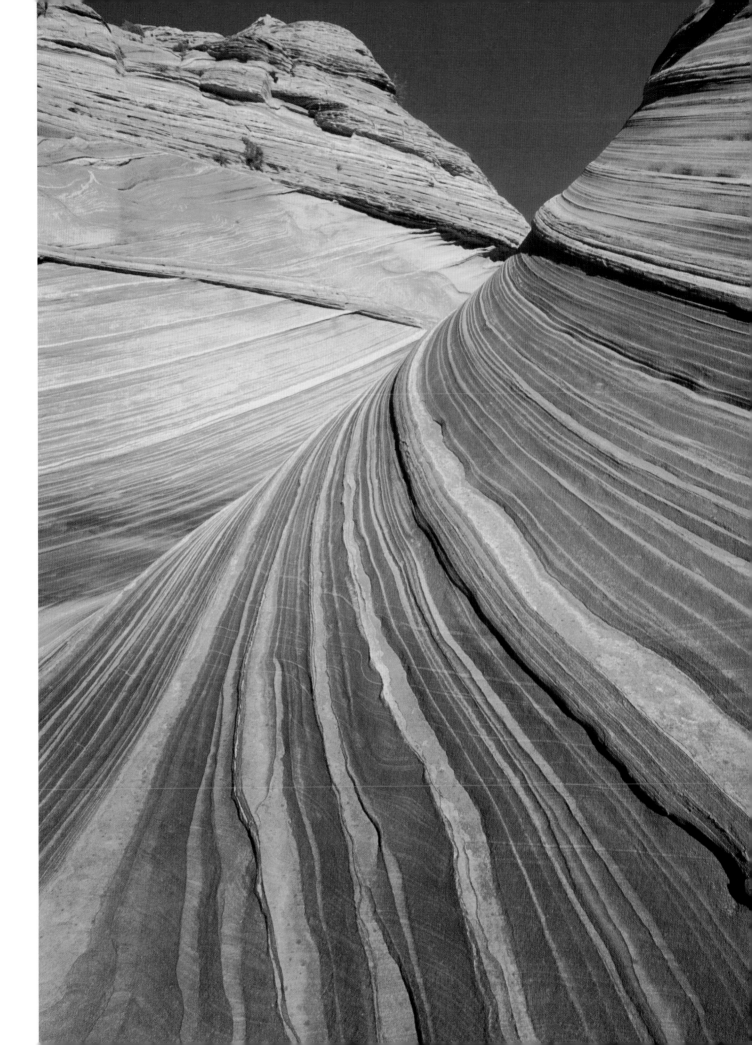

SHAPE

We identify many objects by their shapes alone, long before we've seen their color, texture, or other details. Shape is a fundamental element of design. Yet when it comes to making a photograph, it's surprising how photographers often forget to take the importance of shape into account, even when many shapes are present in a scene.

Shapes possess strong symbolism, and the shapes that dominate your photographs will dictate their tone or feeling. Squares and rectangles represent stability and structure. We don't often see a square or rectangular object in the natural world, except, perhaps, in crystal and rock formations. In the man-made world, however, squares and rectangles are ubiquitous, in office buildings, packing boxes, tractor-trailers, and barns—they're everywhere. When a photographer includes a square or a rectangular shape in an image, the photograph can express a sense of structure.

Triangles represent strength and endurance. A mountain is one of the few natural structures that has a triangular shape. Wide at the base and pointing heavenward, it represents stability and focused energy. Steeply angled sand dunes can appear as triangles, too.

Circles, composed of single, unbroken lines, represent wholeness. The earth is surrounded by its circular atmospheric boundaries, and a pond is a circle retaining water within its edges. The planets, the sun, and the moon are the most powerful circular shapes in nature, but sand dollars, dewdrops, berries, and flower blossoms are circles, too.

Shapes become visible when you frame a composition. These shapes may be rectangular, triangular, or something more organic. All the sky that sits at the top of your image of a landscape is a shape once it's defined by the edges of the frame. The green field below the sky is another shape, as is the barn in the scene. You can modify them by altering your position or the angle of the camera. When making a landscape photograph, try tilting the camera down, and the shapes of the sky

VINEYARDS AND OLIVE GROVES, PROVENCE, FRANCE. *Aerial views often give you a wonderful study of the landscape. The view from the high road was a fascinating grouping of shapes in the fields below, defined by the lines of the dirt roads.* 70–200mm lens at 176mm, f/9 at 1/50 sec.

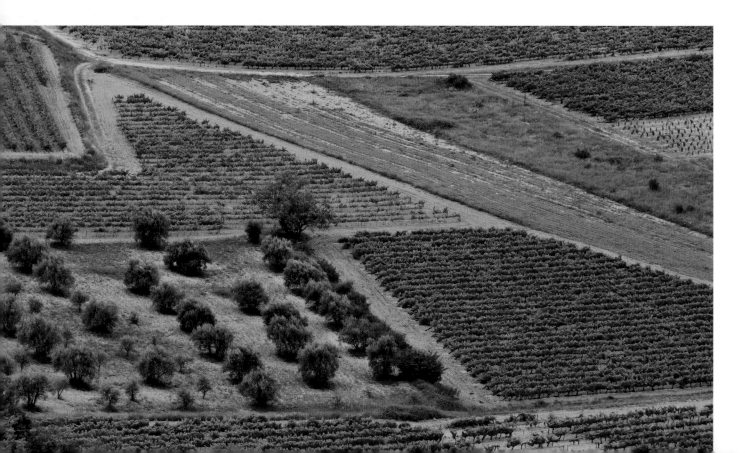

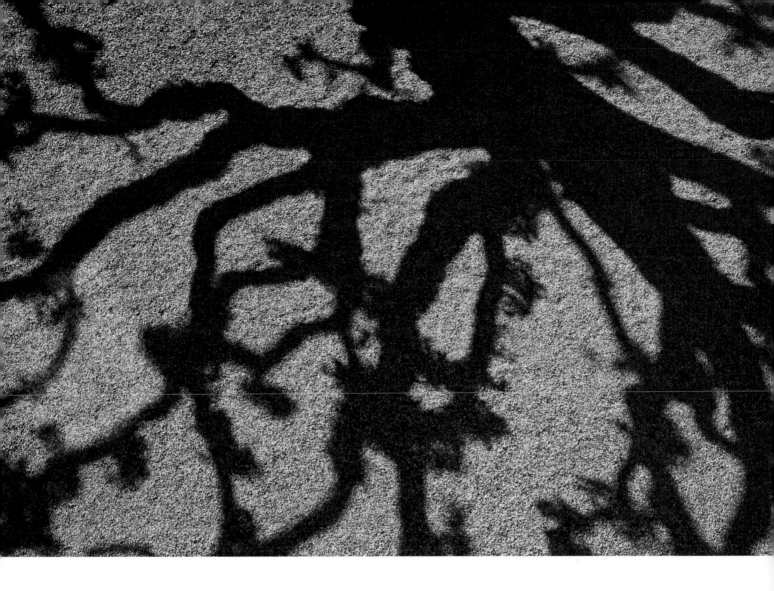

ABOVE: **TREE SHADOW, ITALY.** *As I threw open my windows in my third-floor room, I saw below me this incredible shape of tree shadows! Though jet-lagged, I could not pass up the opportunity to compose a picture. The next two days were cloudy, so I was very glad I made the picture when I did!* 24–70mm *lens at* 55mm, f/14 *at* 1/100 *sec.*

RIGHT: **SAILBOAT, MAINE.** *I love to photograph around harbors, and I especially like boats. With very little form showing in this picture, what jumps out are the various shapes made by the boat, the rope dividing the water area, and the reflection. The frame edge further defines these shapes.* 70–200mm *lens at* 170mm, f/11 *at* 1/15 *sec.*

and land will change, with the shape of the land becoming dominant. Tilt the camera up, and the shapes will change again, with the shape of the sky now becoming dominant. The negative and positive spaces of your pictures are actually shapes, too, just as important as the shape of your subject. Even the implied shapes created by the way the eye moves between objects in the frame are significant to the impact of the picture. To see shapes, you must get beyond what they are literally. A pond is more than just a pond, it's an organic, rounded shape, for example. When you learn to see shapes, you can control the balance between them, creating a stronger composition.

Remember, backlighting will define the shape of objects and allow you to produce a graphic study of their shape, perhaps even in silhouette.

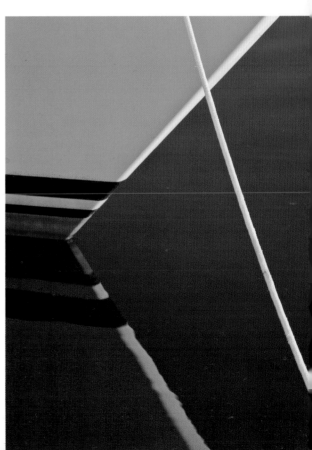

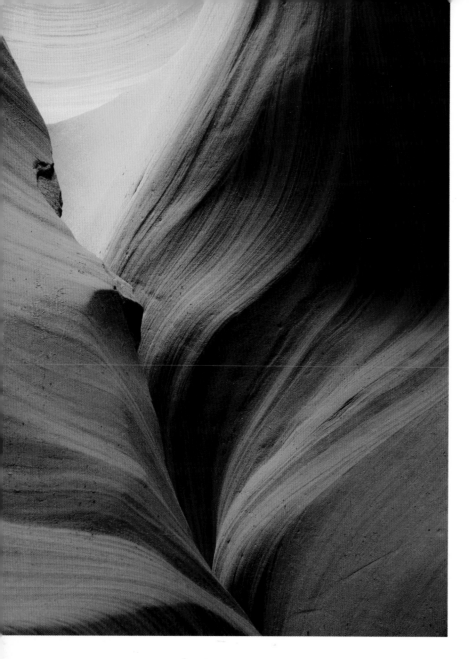

FORM

ABOVE, LEFT: Slot
Canyon, Northern
Arizona. *The diffused
bounce light illuminated the
form in the swirling folds
of these sculpted rock walls.
24–105mm at 85mm,
f/22 at 2 seconds.*

ABOVE, RIGHT: Sand-
stone formation,
Arizona. *Strong afternoon
sidelight defined the form of
this unusual rock formation.
By taking a low position, I
increased the sense of its height.
17–40mm lens at 24mm,
f/16 at 1/15 sec.*

How do you know the form of an object? The light defines it. For example, the light illuminating a tree from the side defines its round form. The gradual shift of tones from highlight to shadow gives dimension to the tree. Without that gradation of light, or *shading*, the tree might appear to be nothing more than a flat cardboard cutout of a tree. This is why front light is usually not very desirable in a photograph. It renders things too "nondimensional."

Strong sidelight is usually best for illuminating form, but even in diffuse light, you can show enough shading to define form. When the light is very low in contrast, shadows and shading can disappear, however, and with them the suggestion of the form of an object. As an exercise to learn how to see shape and form more readily, select something like a tree or large boulder and photograph it under specular and then diffuse light, using all three directions of light (see pages 28–33). The next time you head outdoors to photograph, make it a point to notice different shapes and forms in what you are photographing.

PATTERN

Pattern is everywhere in the natural and man-made world. Take a moment and look around you. How many patterns do you see right now? Probably many.

Pattern forms when such elements as shapes, lines, or colors repeat, amplifying the significance of each individual element. By definition, when you have three or more similar elements in your image, a pattern emerges. But I've never found that just three of any object creates a strong pattern, even if they are identical. By the same token, an image filled with a variety of different patterns can lose impact. But an image of, say, autumn leaves on the ground with similar shapes and colors repeated in your frame can be a very strong pattern.

A pattern grows in visual strength when it fills the frame, as the mind's eye assumes that it continues beyond the edges. If I photograph a small area of leaves on the ground in a desert wash, I compose it so that the leaves extend beyond the frame, implying there is more than meets the eye, to make it more powerful. I am less concerned about extending a pattern beyond the frame for a landscape image— one that may include some pattern—as the pattern is not the subject.

Any focal length lens will work to photograph patterns. I use everything from a wide-angle to a macro lens. When I want a pattern that is part of a distant scene, such as a hillside of trees, I'll even use a telephoto lens.

WILDFLOWERS, TUSCANY, ITALY. *Pattern exists on a large scale, not just in details. A frame completely filled with red poppies and white wildflowers appears as a never-ending "sea" of pattern and has a strong visual impact.* 100–400mm lens at 310mm, *f*/18 at 1/8 sec.

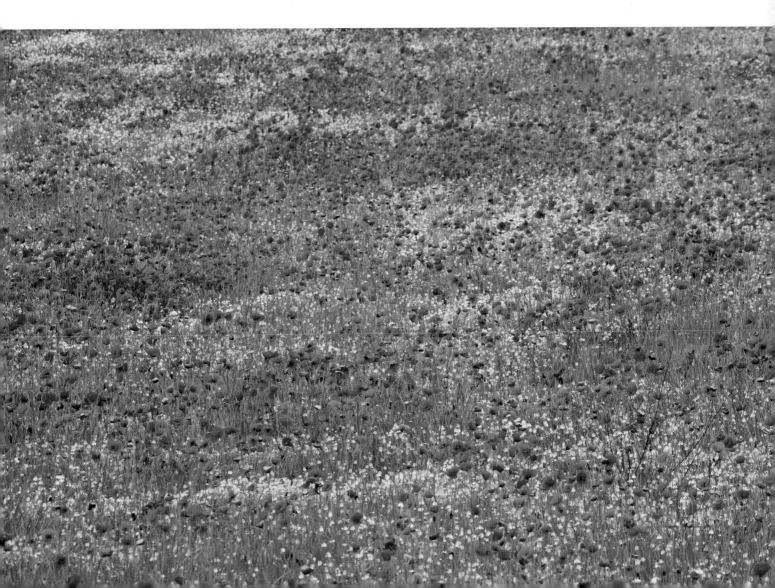

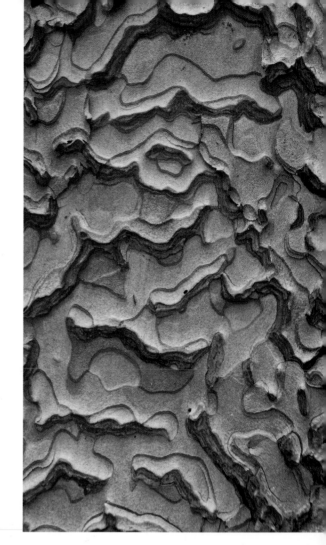

An image of a solid pattern can have impact, but the eye can tire of viewing a pattern. If you want to avoid having the eye move around "endlessly" in the frame, include some element to break up the pattern. The anomaly provides a point of contrast and a place for the eye to rest.

True pattern is random, and the eye doesn't follow a set course when viewing it. However, wide-angle lenses can create a feeling of direction, since objects appear to decrease in size as they recede toward the background, making it seem that the pattern has a direction. When pattern begins to take on a true direction or implied movement, it can create rhythm in the scene.

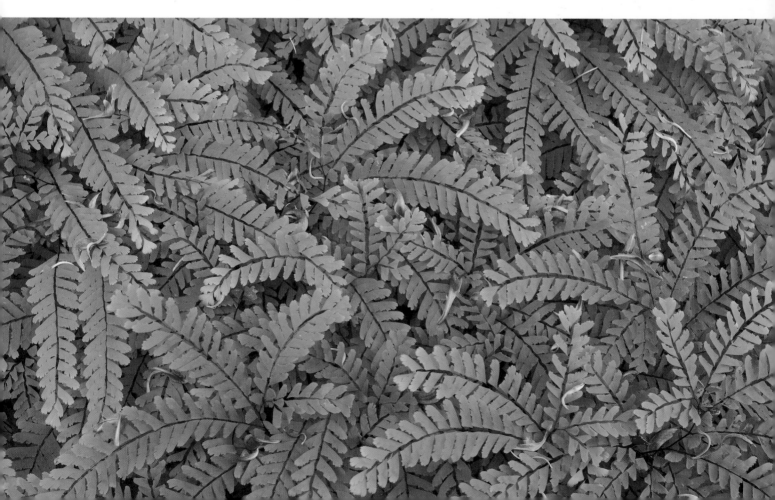

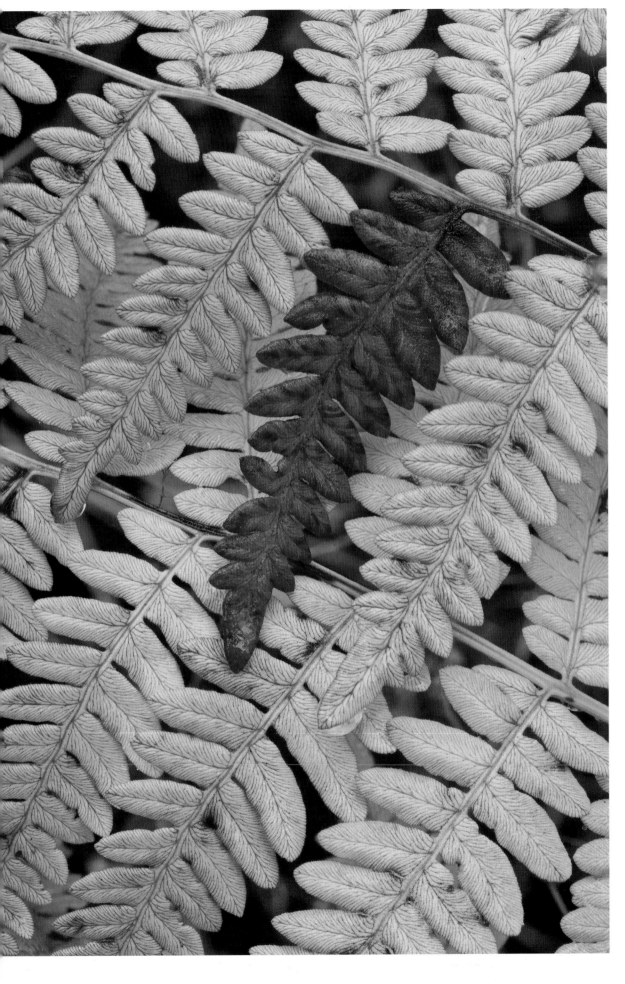

AUTUMN FERN,
YOSEMITE NATIONAL
PARK, CALIFORNIA.
*A friend and I challenged each
other to photograph this area
that a year earlier had been badly
burned. As I walked around
through the ferns that had grown
back, I discovered a golden frond
with just one piece turning
brown. Anomalies like these can
make a good pattern image even
stronger.* 100mm macro
lens, f/16 at 1 second.

TEXTURE

Touch is an important human experience. The memory of how something feels can reside indefinitely in our minds. As children, we learn about texture while touching everything around us. We walk and crawl on wood, carpet, and concrete. We touch fabric, such as the flannel of pajamas and the satin of dresses. We play with sand and mud, and learn what "wet" and "dry" feel like. We all recall certain textures, like a mother's hair or the fur of a favorite pet. It's no wonder that a photograph of something with texture can evoke a strong response.

You need the contrast of light and shadow to record texture. Light striking a subject from an angle accentuates the surface, defining all of its bumps, hairs, or ridges. If the light is strong and at a low angle to the subject, the texture will be more pronounced. By using this type of light, you can show the roughness of sandstone or the coarseness of weathered wood to create a photograph with a greater

TOP: SAND DUNE TEXTURES, DEATH VALLEY NATIONAL PARK, CALIFORNIA. *The sand dunes in Death Valley are always good for patterns and textures after a windy night. By positioning myself so the light came from the upper left, I was able to get the morning light to skim across the surface of the dune, emphasizing the texture sculpted into it the night before. 20–70mm lens at 70mm, f/20 at 1/10 sec.*

BOTTOM: OLIVE GROVE AND VINEYARDS, ITALY. *I climbed onto the roof of the villa I was staying in to get this image, when I saw how the sidelight had brought out such nice texture in the landscape. 24–70mm lens at 55mm, f/8 at 1/25 sec.*

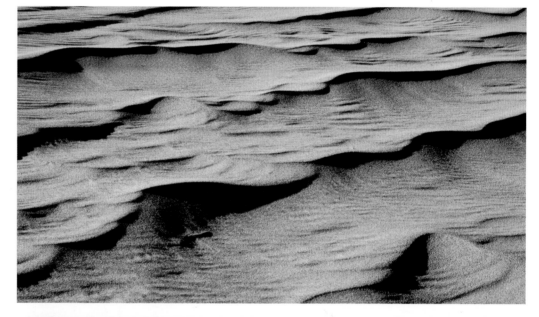

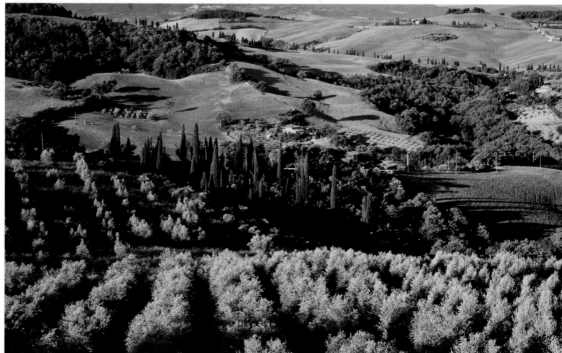

RIGHT: DRIED MUD PATTERNS, NORTHERN ARIZONA. *By incorporating a plant into my composition, I was able to create an anchor point for the eye in a sea of pattern and texture.* 24–105mm lens at 24mm, ƒ/16 at 1/25 sec.

BELOW: WILDFLOWERS AND LAVENDER ROWS, PROVENCE, FRANCE. *Abandoned lavender fields never give up blooming. With the mounds of lavender surrounded by other flowers, the scene had a soft textural feel to it, brought out by diffused light and a telephoto lens.* 70–200mm lens at 200mm, ƒ/22 at 1/30 sec.

visual dimension. You can express visually what the dried mud *feels* like.

Diffuse light can also bring out texture, but it often works better for softer types of texture. If you want to express the softness of a meadow of grasses, for instance, you should probably choose "soft" light. Stronger light may bring out too much contrast and reduce the soft texture. There is an appropriate light to emphasize each type of texture, and by noticing how different light affects textures, you'll arrive at the right way to photograph them.

You can also imply texture in a photograph. When I look at an aerial photo with good side lighting, I can almost *feel* the ridges and valleys of the land.

You can produce the effect of texture digitally with special filters but it's always great to find the textures as they exist

in our world. By now you're probably seeing lines, shapes, patterns, and textures everywhere, and that's the first step to creating photographs that contain strong visual design.

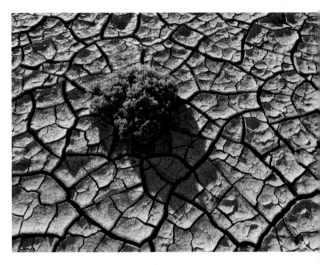

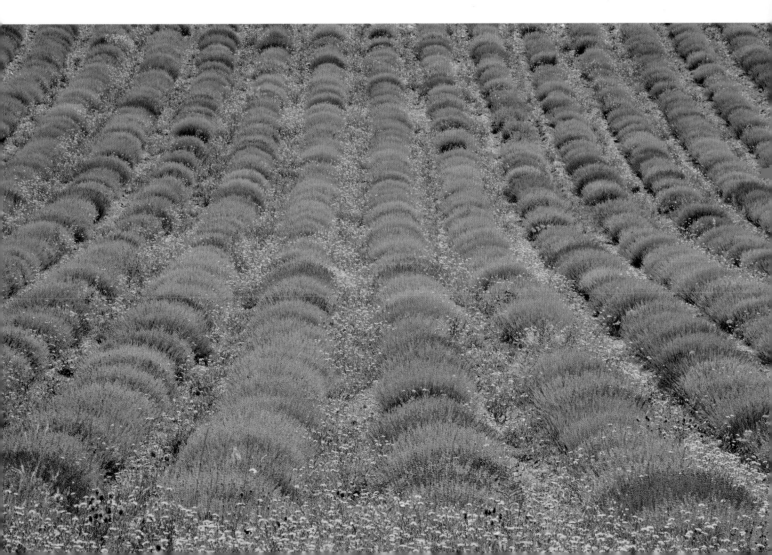

CREATING VISUAL DEPTH

"As photographers, we must learn to relax our beliefs. Move on objects with your eye straight on, to the left, around on the right. Watch them grow large as they approach, group and regroup as you shift your position. Relationships gradually emerge and sometimes assert themselves with finality. And that's your picture."
—AARON SISKIND

HAVING GOOD LIGHT AND INTERESTING DESIGN elements does not ensure you'll make a good photograph. You must figure out how to get that light and those design elements arranged in a pleasing composition that has depth and drama. If you're not in control of perspective, your image will lack depth. If you don't create a strong composition, your image will consist of chaotic, confusing elements. And if you don't know your lenses well, you may not utilize their potential to help you present your scene in the most dramatic way. The goal is to create powerful images without having to consciously think about composition and perspective. With practice, this becomes intuitive. The next two chapters will help you master perspective and composition and teach you how to use your lenses to their best advantage.

CLARE ISLAND, IRELAND. *The cliffs of Clare Island are high and dramatic, with waves crashing at their base. In spring, the sea thrift blooms, creating lovely color in the meadows along the cliff edges. Using a moderately wide angle of view, I placed the flowers near the bottom of the frame and let the cliff edge bring you through the scene. With the ever-present low clouds hanging over the hills beyond, this picture captured the classic beauty of western Ireland. 24–105mm lens at 34mm, f/14 at 1/25 sec.*

GAINING PERSPECTIVE

BELOW: CYPRESS TREES AND DRIVEWAY, TUSCANY, ITALY. *This is a common and classic view in Tuscany. Because of the vanishing-point perspective, there is a feeling of distance, even with a rather normal 60mm angle of view. 24–105mm lens at 60mm, f/18 at 1/20 sec.*

SPREAD ON PP. 66–67: MONUMENT VALLEY, UTAH. *I loved this piece of old wood and the sand textures around it. I got close and low with my camera, to exaggerate the wood with my wide-view, and created a strong near/far relationship that expressed the vast space of the valley. 17–40mm lens at 17mm, f/16 at 1/100 sec.*

Perspective is defined as the way objects relate to one another spatially, and a good part of that is also how they relate to the viewer, in this case the camera. Images that incorporate perspective have greater visual impact. Use of perspective can make objects in the foreground appear to be closer than those in the background. In short, perspective suggests depth in a photograph, though this depth is only an illusion, since a recorded image is two-dimensional.

The only way to alter perspective is to change your position, or point of view. If you view a scene through six different focal lengths without changing your position, the perspective, or relationship of objects in the frame, remains the same, although the angle of view is wider or narrower depending on the focal length of the lens. When you change focal lengths,

you are simply changing the framing, not the perspective. To see how changing your position changes perspective, try the following exercise: Find a scene that has an object you can get close to and a background with a mix of elements. For example, you might choose a friend sitting on a park bench. As you move closer to your friend, notice what happens to the relationship between the person and the objects in the background: Your friend appears much larger, while the background shows little change in size. However, note that the background objects have changed position in relationship to your friend, and each other, because you altered the perspective as you moved into the scene.

Take the results of this exercise and apply it to a landscape. Imagine a meadow with interesting boulders in it and mountains in the background. As you

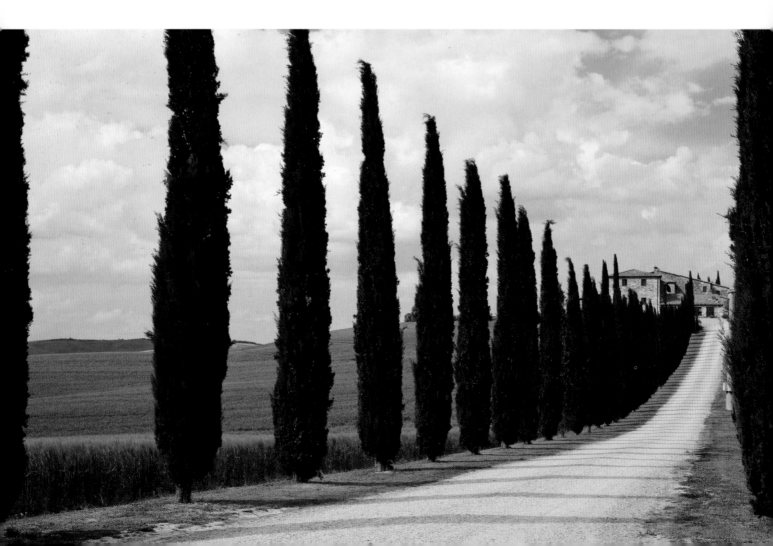

BRISTLECONE PINE, EASTERN CALIFORNIA. *This pair of pictures shows how by moving your position and getting in closer, you can create a more dramatic photograph of the relationship of two objects. The wider view photograph (below, left) doesn't pull you in to the scene, nor does it emphasize one tree as more significant than the other. I'm just using a wide-angle lens to capture the whole scene, but not creatively. But in the other image (below, right), I got up close to one tree, making it dominant, and created a relationship between it and the background tree. This point of view also puts the viewer in the scene. 17–40mm lens at 21mm, f/16 at 1/60 sec.*

move around the boulders left to right, or get in closer to them or back away, they will take on a different importance in the frame. They will also relate differently to each other. As you move forward, the boulders will get larger, but the background mountain will remain relatively the same. This closer position emphasizes the boulders and makes them your subject, while creating a suggestion of depth by their relationship to the background.

To express the depth you want your photograph to have, you need to find the best point of view for your composition. When you arrive at a location, walk around your scene with one eye closed (that's the way the camera sees) and watch how dramatically the relationship between objects and the background changes. Get higher or lower, if possible, to see what this

does to those relationships. At some point, you'll feel the scene come together, and you will have found the best position for what you want to emphasize.

I always prefer to take time to get to know a landscape I am photographing.

Over the years I have come up with a certain way in which I approach any scene. I ask myself what I find most interesting and how I can bring that out. The answers help me to find my point of view (position) and angle of view (focal length) more quickly. For example, it might be an unusual rock formation, or a beautiful patch of purple flowers, or both. It's an intuitive process that is built from the practice of getting in touch with my emotional reaction to a scene. As mentioned earlier in the book, getting clear on what you want to express is essential for making a good photograph.

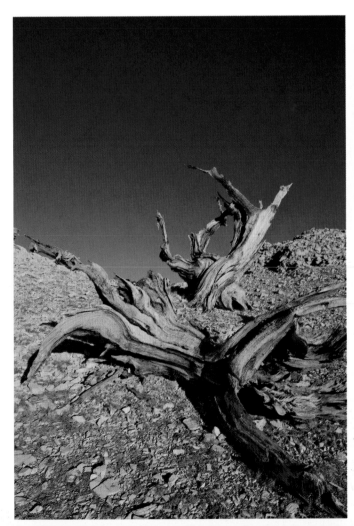

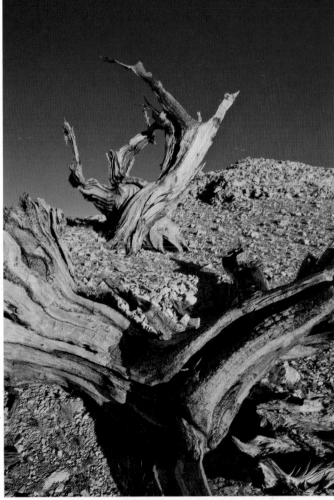

DEFINING DEPTH WITH SELECTIVE FOCUS

RIGHT: EUROPEAN POPPY AND LAVENDER FLOWERS, PROVENCE, FRANCE. *By selectively focusing on the poppy and using a shallow depth of field, I created a feeling of depth. Even though f/10 is a rather small aperture, the long telephoto created a shallow depth of field. 100–400mm lens at 400mm, f/10 at 1/30 sec.*

BELOW: TRANSLUCENT ICEBERG, INSIDE PASSAGE, ALASKA. *By using selective focus and a shallow depth of field, I was able to create a near-far relationship between this translucent piece of ice and other icebergs in the distance, which expressed depth in the scene. 70–200mm lens at 190mm, f/5.6 at 1/160 sec.*

You can alter apparent perspective, or the appearance of depth, by using selective focus on your lens. A sharply focused subject will appear closer than anything that is not sharp in the picture.

Telephoto lenses make this easier, but you can also use a wide-angle lens to selectively focus when the subject is close to the lens. The degree to which your background will be out of focus depends upon camera distance to the subject, subject distance from the background, and the aperture being used. This is when the depth-of-field preview button is critical. It stops the lens down so you can see what's in focus and what's not and check how the background looks. If you don't have a depth-of-field preview button, you can magnify the image on the LCD to see how your background looks.

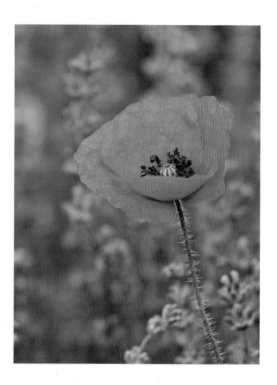

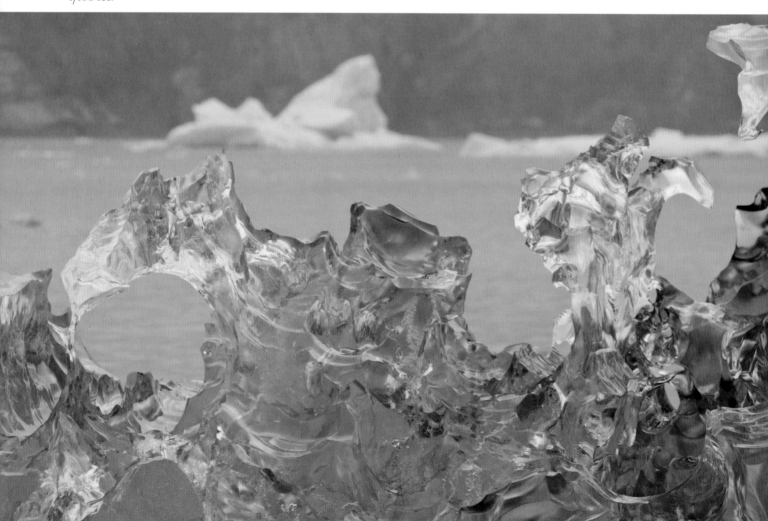

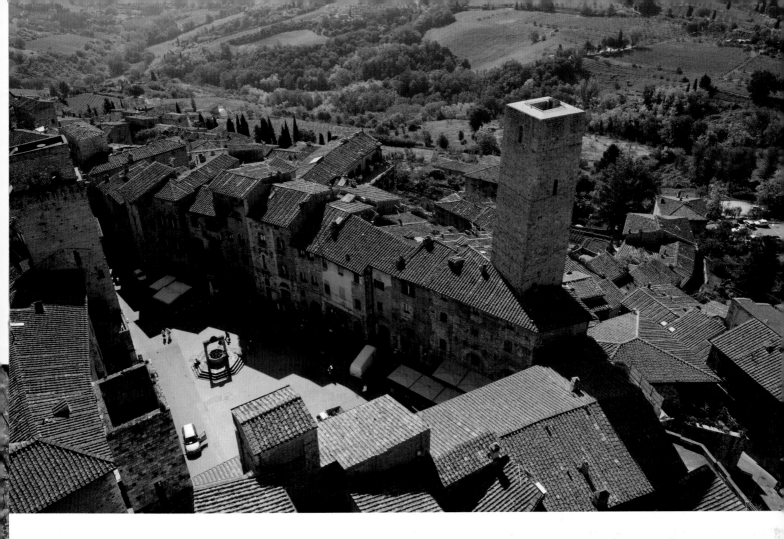

A Different Point of View

SAN GIMIGNANO, ITALY. *I always like to try for a different point of view when I travel. I had to wait until 9:30 A.M. before I could climb up the tower to get this view. In spring, the angle of the sun was still low enough to create long shadows of the tiny people below. This view is what a bird would see flying over the village. 24–105mm lens at 24mm, f/8 at 1/60 sec.*

Have you ever considered what a chipmunk's view of a meadow would be? What might an eagle's view of a valley or meandering river be? How does the world look from the height of a two-year-old child? Each of these viewpoints offers a whole new way to see the world, and you can create expressive images that highlight these points of view.

Of course, this approach means you'll have to give up any vestige of self-consciousness. Get over it! I've been on the ground in dozens of places around the world, and it's worth it. Whenever I travel, I try to get overhead views from bell towers or mountaintops. I take scenic flights to create aerial points of view. Aerials provide a great establishing shot for slide shows, travelogues, and magazine stories.

The next time you're "in the field," unleash your imagination and see what a new point of view can do for your photographs. Your results are limited only by the extent of your curiosity and your willingness to try new ways of seeing.

To create more dynamic outdoor photographs, use the characteristics of perspective to describe relationships of size and depth. Move in close on an object to exaggerate its size in the frame compared to the background elements. Try framing a background subject with a foreground element to give your image a greater feeling of depth. Once you understand the power of perspective, and how to alter it, you have another creative tool for giving your images greater impact.

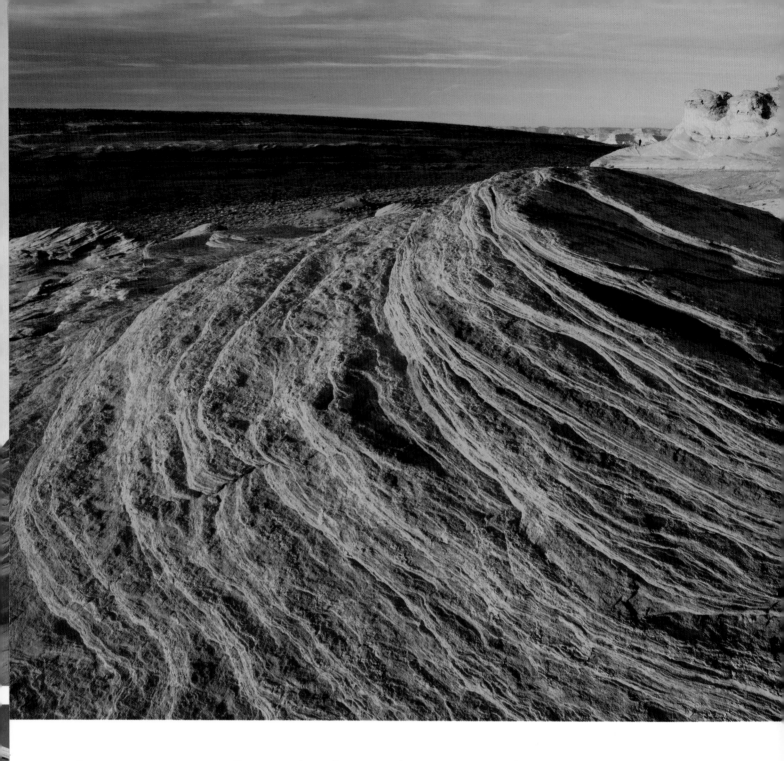

SANDSTONE FORMA-
TION, NORTHERN
ARIZONA. *This layered
sandstone formation created an
interesting foreground for my
landscape. The low angle of late
afternoon light created great
texture out of the layered stone,
and my position made the forma-
tion loom large in the frame.
24–105mm lens at 24mm,
f/16 at 1/4 sec.*

Because wide-angles can emphasize objects close to the camera and still take in a broad scope of background information, they can dramatically present a subject in the landscape. If you bring your lens close to an object, but above it, and tilt the camera downward toward that object, you can create an exaggerated viewpoint of it, and it becomes a visual stepping-stone, inviting the viewer to become more involved in the scene. This is a classic way to create expressive landscapes,

ones that not only show off interesting foreground objects but also express great depth. Study the work of master landscape photographers and you'll see the effectiveness of this approach using wide-angle lenses.

One spring morning, while traveling the country roads of central Italy, I saw a great cloud formation occurring overhead. This is when you scramble to find something to put beneath that great sky, yet you want the sky to be the real story. I

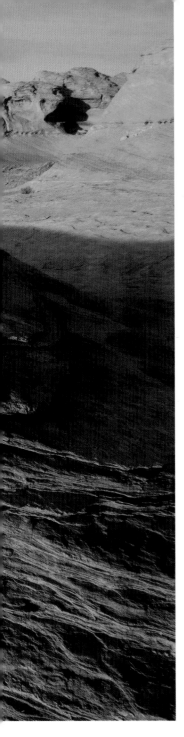

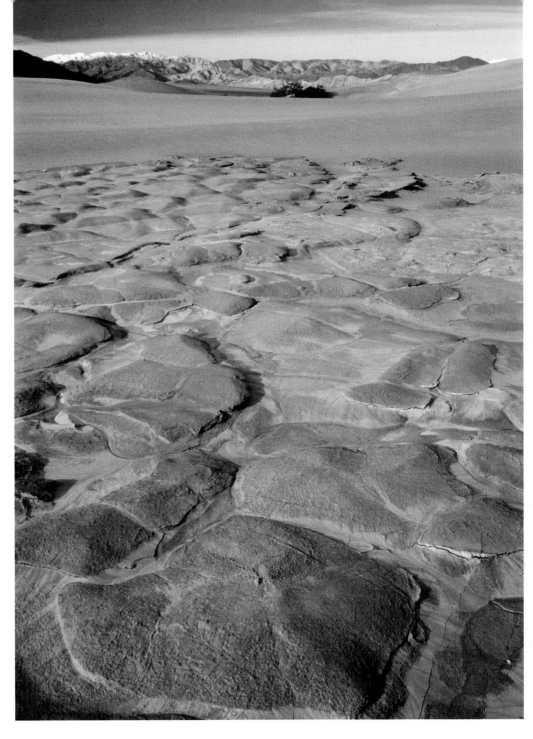

DEATH VALLEY NATIONAL PARK, CALIFORNIA. *Using a superwide-angle lens, I moved in close on the hardpan in the dunes, exaggerating their size. The lens optically pushed the mountains away, and created an expansive feeling to the landscape. 20mm lens, f/16 at 1/60 sec.*

found an old abandoned farmhouse, and the dirt lane leading to it. Using a 24mm focal length, I framed the scene vertically. The wide angle of view accentuated the sweeping clouds, which drew you to the farmhouse. I used a small aperture of f/16 and set my hyper-focal distance on my lens for best depth of field. (Note: Even though a wide-angle lens has great depth of field, it still makes sense to set the hyper-focal focus to get the most depth of field possible from the situation. Since most

zoom lenses don't have hyper-focal marks, I now pack along a small hyper-focal chart as a guide.)

If you can't get both foreground and background in focus, you'll have to choose which you want to emphasize. For most landscapes, it's more pleasing to the eye if the foreground is sharp and the background falls into softness, as that is the natural way the eye would see the scene. When I'm assigned an environmental portrait, I often use my

LEFT, TOP: BODIE STATE PARK, CALIFORNIA. *I was attracted to this half-buried wagon wheel in the field, yet I wanted to relate it to the surroundings of the ghost town. The relationship of the wheel to the buildings suggests space and makes you feel the emptiness of the place.* 24–105mm lens at 31mm, *f*/16 at 1/6 sec.

wide-angle to get in close to the person while emphasizing their surroundings, too. Having the person up close creates a sense of intimacy while having the background in the frame tells more of a story. Yet it doesn't have to be entirely in focus in this case, just enough to express the environment around the person. You can use this same technique with nature subjects, such as a particular flower that you want to show growing in a garden.

With a wide-angle, you can frame a background object with a foreground element such as a doorway, or emphasize a bridge railing or fence while keeping both the foreground and the background in focus. The near-far relationship will express depth. You can also take advantage of a wide-angle's ability to distort and use it to accentuate leading lines—whether it's a trail, a planted field, or a fence—and visually draw your viewer into the scene.

The best way to learn how a wide-angle lens "sees" is to put one on your camera and begin looking through the lens. Move in, out, up, down, and around your scene to see the potential the lens has to offer.

LEFT, BOTTOM: FIELD AND HOUSE, WHIDBEY ISLAND, WASHINGTON. *The bright green planted rows were lit by beautiful late-afternoon light. They take your eye all the way back to the farmhouse and tractor. It was all about leading lines in this composition.* 70–200mm lens at 200mm, *f*/20 at 1/3 sec.

NORMAL LENSES

Normal lenses are called "normal" because they render a scene much like the way the human eye sees it, with spatial relationships appearing realistic and objects appearing as their normal sizes in relation to each other. Normal lenses range from 45mm to 65mm in focal length for 35mm cameras. Over the years, many photographers have tried to make outstanding pictures with normal lenses. Unless they applied the concepts of perspective and good composition, however, most made mediocre pictures, giving the normal focal-length range a bad reputation. Many creative photographers today will tell you that the 45–65mm range produces boring pictures. This is really not true! Henri Cartier-Bresson used only a 50mm lens, and his images are not boring at all. It's how we see, as visual artists, and where we choose to position ourselves to make the picture, that matters, no matter what the focal length.

While normal lenses are limited in their ability to exaggerate perspective, you can still create strong compositions if you learn how normal lenses "see." To prove that you can make wonderful pictures in the normal focal length, dust off your old normal lens or tape a zoom lens into the normal range, and spend an entire day using only that lens. Push yourself to make interesting compositions. You can do it.

TELEPHOTO LENSES

There is magic in bringing in closer the details of distant and inaccessible scenes, or in bringing wildlife visually closer without putting yourself in danger. I'm always delighted when I look through "long" lenses, as they offer a view that can't be seen with the normal eye. Using telephoto lenses, I've had the wonderful opportunity to see a hummingbird weave a spider web thread into its nest. Once I thought an elk was charging me, but when

GRIZZLY BEAR CUB AND MOM, ALASKA. *My 500mm with a teleconverter enabled me to feel up close and personal with this bear cub and mom, from a safe distance! I love using long lenses with wide apertures: They can create a wonderful softening of the background. 500mm lens with 1.4x, f/6.3 at 1/500 sec.*

I took my eye away from the viewfinder, he was a hundred feet away and his interest was in a female elk near me! It's the chance to capture wildlife and action sports that makes telephoto lenses popular with outdoor photographers. I also like to use them to extract details and textures from the landscape.

Within telephoto lenses there is substantial difference in focal lengths: Any lens in the 100mm to 1,200mm range is considered a telephoto. The shorter the focal length, the wider the angle of view and the less optical compression there is. With a 100mm lens, for instance, you have less optical compression than you would with a 400mm lens. A 100mm lens is a great portrait lens—it does flatten the optical perspective just a bit, which flattens the appearance of facial features slightly, but with a pleasing effect. The longer the focal length, the narrower the angle of view, and the stronger the optical

compression, flattening the appearance of depth. Trees at the edge of a forest can look very close together, when in reality they might be 30 feet apart. The longer telephoto lenses (300mm or longer) can make a flock of 200 flamingos look like a thousand by visually "stacking" the birds tightly together—if you fill the frame with nothing but birds. While this may not be realistic, it is *artistic*.

When you optically compress elements with a telephoto lens, graphic patterns can develop. You can photograph the pattern of birds in flight or a mosaic of autumn-hued trees on a hillside. The narrow field of view isolates the pattern from its surroundings and can create a graphic composition. Telephotos lenses are also wonderful at wide apertures for photographing wildlife and bird portraits when you want the background to become a soft wash of colors, with the animal standing out in the image. Depending

SIERRA RANGE,
BISHOP, CALIFORNIA.
*The layers of rocks in this area
behind Bishop, California,
are truly beautiful. In late
afternoon, I like how the rabbit
brush glowed with backlight-
ing, and the rock formations
and layers of ridges repeated
into the distance. Even the light
blue sky created a shape. At f16,
I captured as much in focus as
was possible within the depth of
field for this focal length.
70–200mm lens at
153mm, f/16 at 1/60 sec.*

upon the magnifying power of the lens, the optical compression can also eliminate any suggestion of depth between the elements, at smaller apertures, resulting in a tapestry effect.

After many years of photography, I can see with my eyes the potential a scene offers for using a telephoto. Nonetheless, I am always fascinated when I look through the lens and see what I'll get. I often put one on the camera just to have a look around, because the effect a telephoto lens has on a scene can be a wonderful surprise.

A final word about lenses: Many photographers who use zooms don't have a clue which focal length they used to make their photograph. Does this matter? Yes, to a degree. In order to respond quickly to

changing conditions, you need to choose the right lens from your bag right off. Knowing what focal length you need— and not having to guess at which lens to use—can make the difference between getting a photograph and missing it. Even when choosing a zoom lens, you'll want to be able to select the right zoom range. Luckily, information about focal length is stored in the EXIF data for every digital image. If you review this data for all your pictures, you can determine what focal lengths normally worked best for certain situations. This builds a reference "library" in your mind and helps you anticipate what focal length ranges will be useful in a given situation when you're out in the field.

Depth of Field: A Practical Definition

Depth of field (DOF) is the area in front of, and behind, a focused subject that appears sharp in the final photograph. In any situation, you must choose the aperture that will give you the sharpness you desire. It may be a lot of sharpness (called a *large depth of field*) or very little (a *shallow depth of field*). The sandstone formation on page 72 is an example of lots of depth of field, while the image of the red poppy amidst lavender flowers on page 68 is an example of only a little depth of field. The choice is yours and depends on the type of photograph you are making. Typically, when working with a landscape, the goal is to have everything from the foreground to the background sharp. However, with close-ups and portraits, you may want to limit the sharpness so the background does not compete with your subject. There are exceptions, but generally this is what works.

DOF extends from 1/3 in front of the point in focus to 2/3 behind it. In other words, you will have twice as much DOF behind your subject as in front. This matters only in terms of understanding that you have a range of what will be sharp in front of and behind your focused subject. To effectively utilize the range, you will want to set your focus using a hyper-focal distance setting.

Hyper-focal distance is the closest point of focus in the scene at which infinity still falls within the depth of field at a given aperture. For a landscape or scenic photograph, this is an important fact. For example, if we choose a 35mm focal length and set the aperture at *f*/8, depth-of-field programs will show that the hyper-focal distance is 16.9 feet. If you set your focus at that distance, everything from half that distance, roughly 8.4 feet to infinity will be in focus. This is great if your rock in the foreground is 10 feet or more away from the camera. If it's closer, then you'll need to use a smaller aperture to increase your depth of field.

Many depth-of-field charts circulating among photographers show rough calculations of these settings. Depth of Field Master has a great software program to help you calculate hyper-focal distance, which you can download to your phone or PDA for use in the field. With this, you can find the right aperture to include all the elements you want sharp within the depth-of-field range. You can also choose a larger aperture to throw the background out of focus if you want. Using a DOF chart, *along with your depth-of-field preview button,* is essential to getting the DOF you want. You might ask, "How am I going to figure all that out when the lion is about to pounce on the gazelle?" Truth is, you can't in the moment. But with practice, you'll just "know" when you want, for example, a wider aperture to minimize focus on the background. And for a landscape with a fleeting rainbow, you'll know that you probably want the smallest aperture you can get to maximize the depth of field in the scene.

If I've lost you at this point, you're not alone! These concepts have long confused photographers. Being more an artist than a technician myself, I learned what I needed to know to master my craft. But to explain it is another matter! There are many helpful tutorials on the subject of depth of field, as well as photographers who love to have technical discussions about all of this. (See the resource section for references to good explanations of depth of field and hyper-focal distance.)

While on the subject of lenses and depth of field, I must include a discussion on the digital crop factor due to different sensor sizes. I use full-frame cameras for much of my work, but many popular cameras have smaller sensors, which change both the angle of view of a lens and

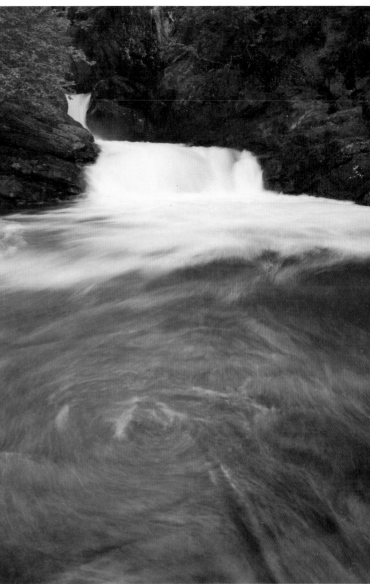

the resulting depth of field. First, the angle of view: A 24mm on a full-size sensor is still a 24mm. But on a camera with a slightly smaller sensor, a "crop factor" goes into effect. The factor varies—for Nikon, it has been 1.5x; for Canon, 1.6x; and for Olympus 2x. So, 24mm on a Nikon would be equivalent to a 36mm angle of view. On a Canon, the equivalent would be 38mm, and on an Olympus it would be 48mm. Many photographers buy camera bodies with "crop factors" for photographing birds, wildlife, and sports, giving their existing lenses a little more telephoto power. The trade-off is in the wide-angle end. To obtain a true 24mm angle of view on any of the crop factor cameras, you would need to use a lens within the range of 12–16mm.

Note: On 35mm cameras with a smaller sensor, commonly referred to as a digital crop factor, there is a slight difference in depth of field and the hyperfocal distance settings you would use, compared to those for cameras with a full-size sensor. There are charts available for your camera type that will help you determine the proper distance setting for the lens you are using. They are indispensable to achieve the best depth of field for any scene.

CREATING EFFECTIVE COMPOSITIONS

"Anybody can make the simple complicated.
Creativity is making the complicated simple."
—CHARLIE MINGUS

W HY DOES ONE PHOTOGRAPH HOLD YOUR ATTENTION when another elicits only a passing glance? Part of the answer lies in the composition, the way in which all the lines, shapes, and colors are arranged in the picture. The right lens, point of view, appropriate *f*-stop, and correct exposure are important factors, too, but they are only tools to help you bring all the creative elements of your picture together in a compelling way.

Composition is the art of presenting your vision in an uncluttered, clear arrangement. A great piece of music relies on the thoughtful arrangement of sound and silence. A great photograph relies on the thoughtful arrangement of objects and space. No matter how visually interesting your subject matter is, a chaotic composition will diminish its impact.

As I mentioned in the chapter on learning to see, if you don't know what you find important in the photograph, how is your viewer going to know? The first step in composing a photograph is to develop a clear vision of what you want to express.

BUTTERMILK ROCKS, BISHOP, CALIFORNIA. *The unusual shapes and forms of the rock formations in eastern California are a source of endless fascination for me. Here, the low-angled sun creates great shading that brings out the rocks' rough texture. The yellow bush grabbed my attention right away, so I placed it in the frame as the focal point of the composition, while the rock formation forms its counterpoint in the background. 24–105mm lens at 28mm, f/16 at 1/4 sec.*

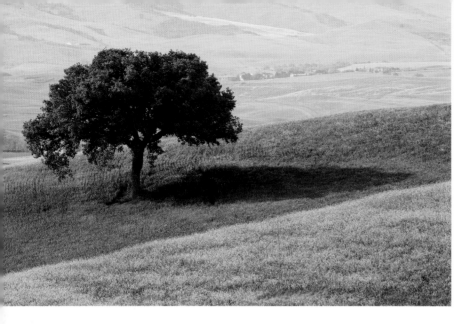

ABOVE: OAK TREE AND FIELDS, TUSCANY, ITALY. *This large oak tree in central Tuscany is a favorite of mine. In early morning, the tree is sidelit and creates a great shadow to its right. It just felt right to place it in the upper left and let the shadow spill to the right. Along with that, the triangular shapes of the crisscrossed slopes added a graphic element to the scene.* 70–200mm *lens with* 2x *teleconverter at* 400mm, *ƒ/*14 *at* 1/50 *sec.*

RIGHT: YOSEMITE FALLS, YOSEMITE NATIONAL PARK, CALIFORNIA. *It's always interesting to me how things just "fall" into the right position! When I framed this scene of Yosemite Falls, the cascading water ended up very close to the right imaginary line in that rule of thirds grid.* 17–40mm *lens at* 30mm, *ƒ/*14 *at* 1/50 *sec.*

Once you have determined that, you can organize the elements in your frame to support your vision. The purpose of composition is to lead the viewer through an assortment of elements and objects that, when combined, tell the story you want to tell. You might want to show us an interesting object or an unusual perspective, or convey a mood or impression.

The human mind craves structure and order, and good composition creates order from visual chaos. As a photographer, your role is to organize your scene with just enough structure to effectively articulate your vision. Good composition is the foundation of every successful artistic image. It's not as simple as pointing the camera straight at your subject. It's not enough to just routinely place your subject off-center in the composition. You have to think about what's dominant in each scene you encounter, and whether you can create a composition that is balanced. You have to consider whether the proportion of objects and spaces is correct.

I can hear you exclaiming, "Gosh, if I have to spend time thinking about all of these things, the elk will have moved on to a different meadow!" This may be true at first, but an increased awareness of these important composition ideas will have you seeing differently, and, before long, seeing in a new way becomes an intuitive process—but only if you first develop the habit of considering these points. When you apply the following ideas of dominance, balance, and proportion, you'll find your compositions becoming simpler yet stronger statements of your own creative vision.

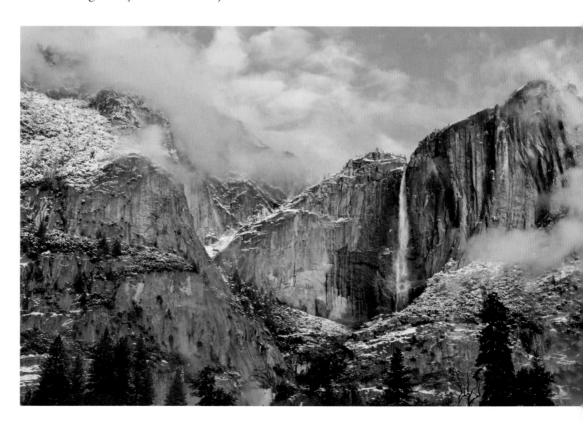

the rule of thirds

The phrase "rule of thirds" is used to describe a guideline for composition. Photographers took this rule from painters who had determined that pleasing compositions resulted from dividing the picture space into a 2:1 ratio—for example, two-thirds land to one-third sky, and that it brought order and stability to a picture. The formula of asymmetrical division evolved to become a standard in photographic composition, and you can use it to help make your photographs more harmonious.

Divide your 35mm photograph into thirds with two equally spaced imaginary lines, both horizontally and vertically, like a tic-tac-toe grid. This creates nine equal spaces in the picture. Place points of interest, objects, or elements on or near where the lines on the grid intersect, or anywhere along one of the imaginary lines. This placement commands attention and directs the eye away from the center of the frame, creating a more dynamic composition. For example, place a horizon line one-third in from the top or bottom of the frame aligning it near the imaginary horizontal line in that area. Place a vertical line, such as a flagpole or tree, one-third in from the left or right side of the frame. The intersecting points are the strongest positions within the frame; however, where you place your subject depends on the rest of the elements in the scene.

How the viewer enters the picture space can be an important factor in your deciding where to place your main subject. In Western cultures, we tend to read from top to bottom, left to right, so we are used to entering a frame from the upper left. If you place your subject on the upper right or lower right, the eye will have to travel across the picture space to get to it and will see whatever else you intended it to see in the process. If you place your subject on the left, in that nearest intersection to that entry point, the eye will get to it right away, and unless you have other things that will draw the eye into the rest of the picture space, the visual weight will sit at that top left area and the picture will not be well-balanced. Using that position usually requires lines to lead the eye elsewhere or other objects that let it visually jump to other parts of the frame. You have to think of both the positive and negative space in the frame when determining the best placement of your subject.

Though this formula provides a helpful guide for creating interesting compositions, don't follow the rule so strictly that your compositions become predictable and static. It's still important to evaluate what arrangement works best for your photograph, based on other factors that affect composition. As Ansel Adams once said, "There are no rules for good photographs. There are just good photographs." Know when to bend the rules to build dynamic tension in your image. Even though the brain seeks balance and structure, we are more stimulated by visual tension.

ASH AND MUD FORMATIONS, UTAH *Subject placement will often end up adhering to the "rule of thirds" area because it makes sense. This image is asymmetrically composed, using the lower right "power point" in the grid, but all the lines lead us from the top down to the little hoodoo, the hardened mud formation, making good use of the frame. 70–200mm lens at 127mm, f/16 at 1/6 sec.*

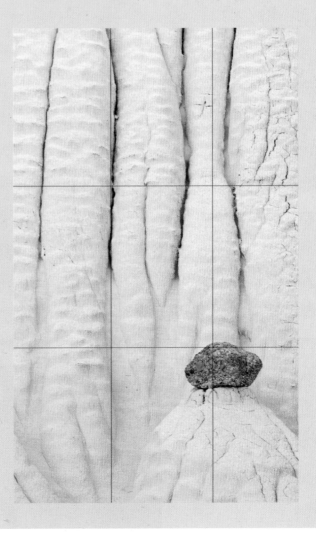

DOMINANCE

If you've ever heard yourself saying, "I don't remember seeing the fence post," or, "The lion was bigger in real life," there's a good reason. The human brain scans a scene, focuses on what it finds interesting, and subconsciously disregards the rest. Depending upon your personal likes and dislikes, your brain enlarges or reduces objects and colors. The camera, however, doesn't selectively extract information, so you end up with everything that was in the viewfinder, not just what you thought you saw. Elements you didn't even notice may later draw attention away from your subject.

Many years ago, I was thrilled to witness a humpback whale breaching. I shot numerous frames of it as it threw itself out of the water. However, when I got my slides back from the lab, my "giant" whale was only a "raisin" in the overall photograph. My emotional reaction to being anywhere near such an event had caused my mind's eye to enlarge the whale. Unfortunately, the camera captured the reality of the experience!

My whale experience provided me with one of my first major lessons in composition: Make sure the subject is large enough to be dominant. There are many ways to do this:

- Move closer or use a telephoto lens to increase the size of the subject and let it fill the frame. A frame-filling portrait of a bear is powerful because we think of bears as large, strong creatures. When the bear becomes the dominant element, the photo suggests a thrilling face-to-face encounter. You can even have the bear go off the edge of the frame to emphasize its size even more.

- Select a camera position that isolates a subject from a messy or merging background. Photographing an object from slightly overhead and angling downward can eliminate an otherwise distracting background, while photographing from a low viewpoint can isolate the object against the sky or some other simple background.

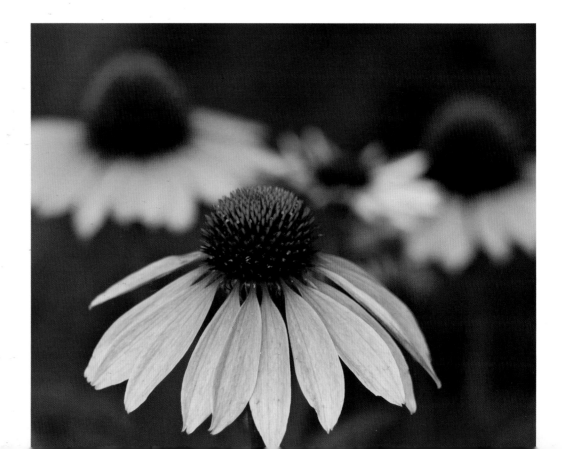

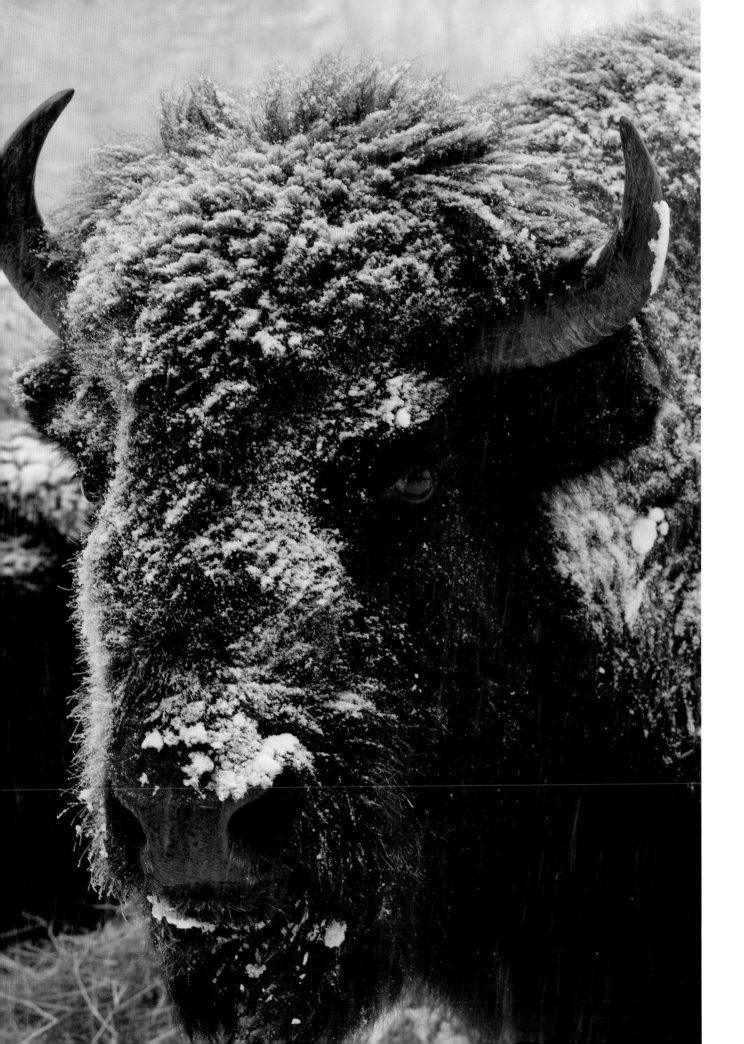

CAMEL, EGYPT. *These two pictures show how repositioning yourself, or waiting for a different moment, can make all the difference. Even framed tightly, with the camel sitting, I had a cluttered background with too much contrast. But when the camel stood up, I could fill the frame with its head and get a clean background. The upward viewpoint helps express dominance. 70–200mm lens at 130mm, f/8 at 1/160 sec.*

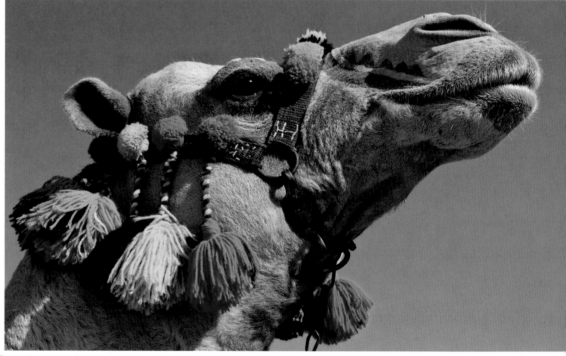

- Use selective focus, with an aperture that minimizes depth of field, to make the subject stand out from the background.
- When photographing a landscape, place an interesting element in the foreground to create a dominant focal point.
- Compose your scene so other elements support or draw attention to the main subject.

As you work with composition, you'll probably be surprised to notice the many ways various elements affect dominance. For instance, a small object will appear dominant in a field of larger ones, and an object that breaks up a pattern will also become dominant. A dominant color can draw attention away from the main subject, and since the eye is drawn to the brightest areas of a scene, an area of brightness can dominate any scene.

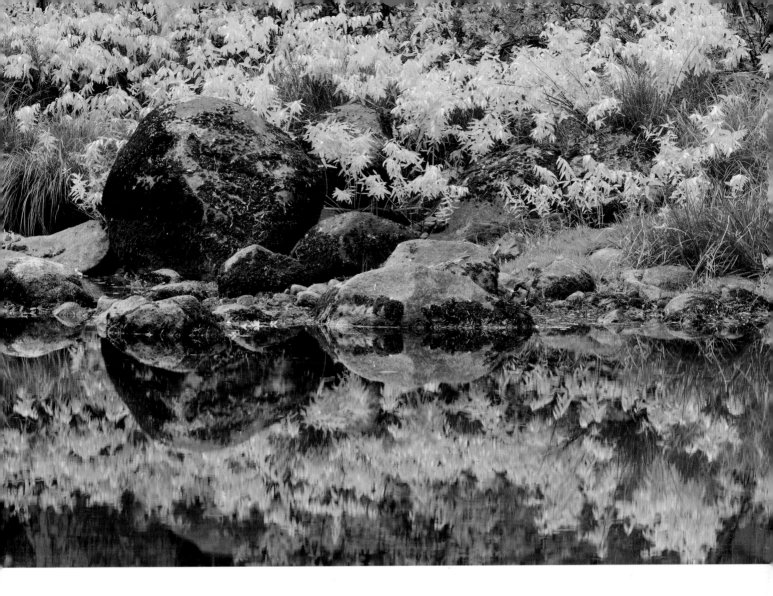

Balance

Balance is harmony, or a sense of equilibrium. If you thoughtfully arrange the elements in a scene—keeping in mind that every object or element in a photograph has a particular visual weight determined by size, shape, location in the frame, color, and other properties—you can create a balanced photograph. But do you always want that? Would you really want an image of white-water rafting to be perfectly balanced? Or would you prefer a little imbalance, some visual tension, to convey the excitement of the moment? While the eye seeks harmony and equilibrium, providing the opposite can be stimulating.

There are two types of balance: symmetrical and asymmetrical. With symmetrical balance, everything is oriented rather evenly around the center of the picture. Imagine a scene reflected in water, composed with the water's edge centered in the frame, with "reality" above the center and the reflection below. This is a symmetrical composition. In a picture that is too equally balanced, a visual stasis can occur, and the resulting photograph can lack impact and beg for an element that breaks up the monotonous order. I rarely create a totally symmetrical composition, though on some occasions the scene is stunning enough to be worth it.

Asymmetrical balance provides the articulated energy that I want my photographs to possess. With asymmetrical balance, elements of

different size or proportion offset, or counterpoint, each other. To achieve artful asymmetry, you can balance a small object with a large one or a dark object with a lighter one, or offset negative space with space that is visually "full."

The eye and brain like odd numbers of objects, in keeping with this asymmetrical concept. Three or five leaves as a subject is often more dynamic than two leaves. With just two elements, you have potential visual tension with neither one "winning" as the main subject. If you have only two objects, consider having them overlap or put them very close to each other, as this can make them appear as one, which helps.

Visual tension develops from the interaction of elements in a photograph. One object may be more dominant, but another object can command enough attention to force you to look at it. The resulting tension stimulates the eye, as it keeps moving between the objects in the image. For example, a red tulip amid a field of yellow ones will create visual tension.

The yellow tulips may dominate the composition spatially, but the eye will still be drawn to the red tulip by its contrast to its surroundings.

The term *negative space* refers to an area within the frame that is empty of detail, such as a solid blue sky or a blank wall. The proportion of empty space to your subject and other elements is a delicate balance that you have to work out with each situation. If the negative space is too large, the eye is drawn away from your subject. Light areas really pull the eye, yet even neutral tones can create an imbalance if they are too large in proportion. You can also have too much dark space, such as a shadow without detail, which creates a visual vacuum that draws the eye away from the subject. Yet too little space can make the subject appear to be crowded in the frame. Just becoming aware of the negative space in your composition will help you develop your own intuition about how much "feels" right for every situation.

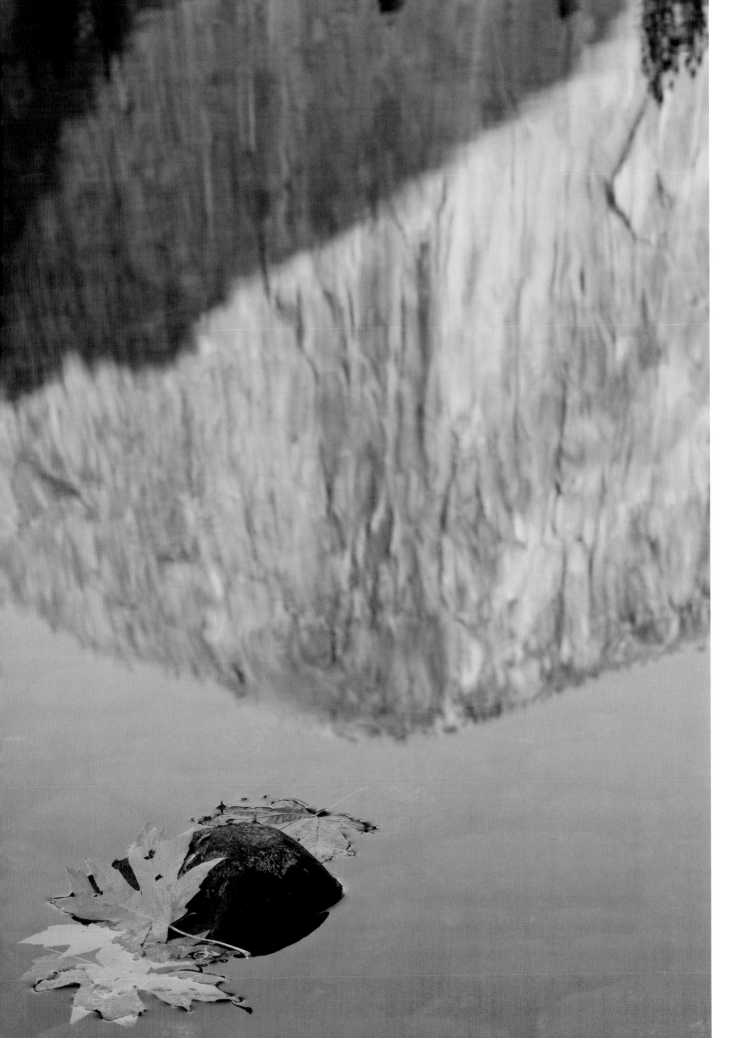

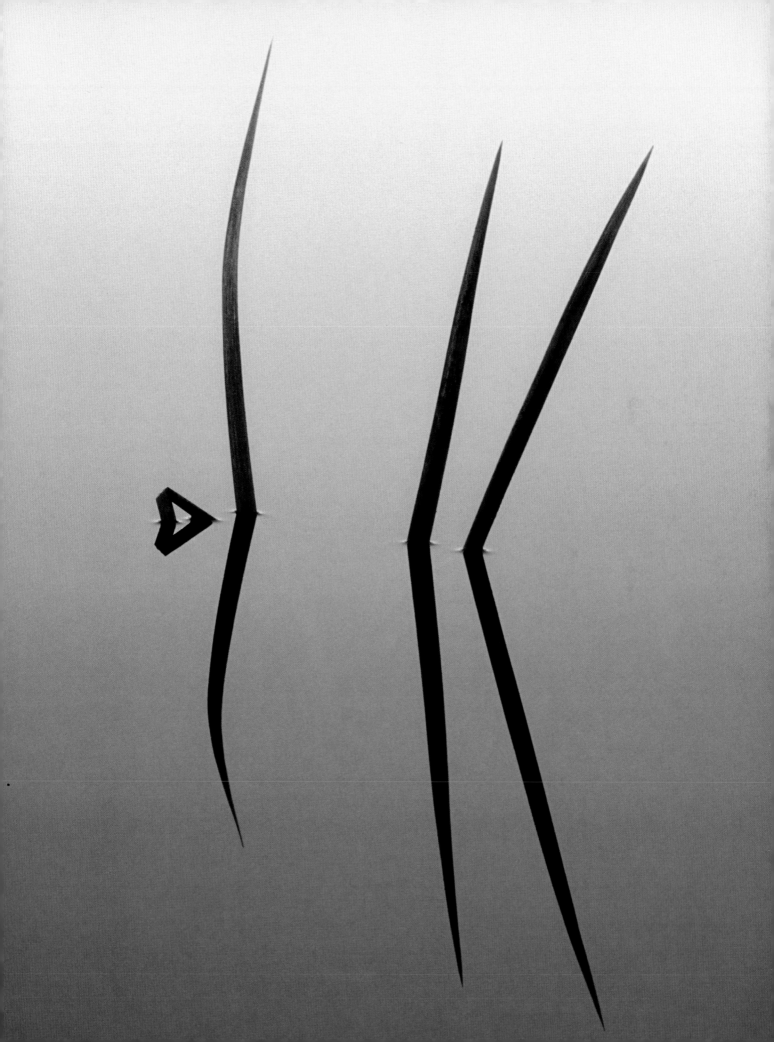

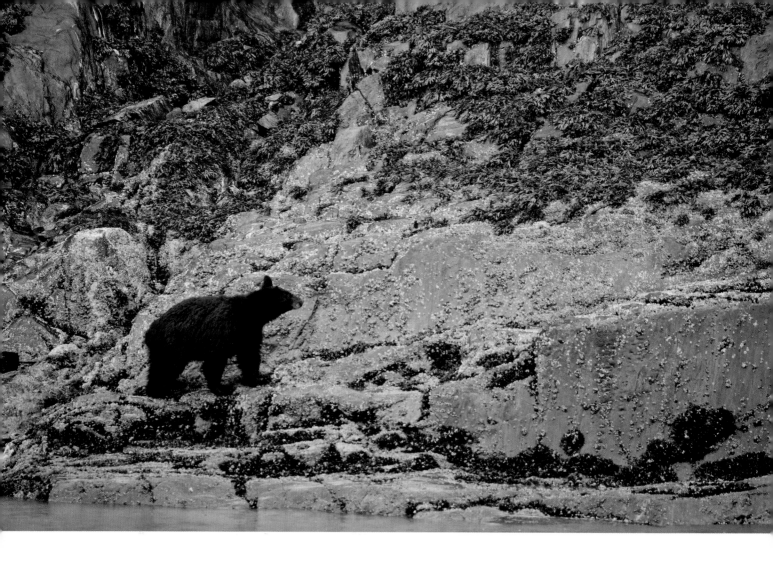

Proportion

Proportion can help you express symbolism. A frame filled up with pumpkins, squash, and gourds suggests the variety of the harvest. A photograph of the same subjects arranged so they stretch far into the background suggests the abundance of the harvest. A sense of how to use proportion derives from what you want to say about a scene. Is it the sky that's screaming for attention, or a cluster of giant columbines at your feet? Is it the size of something that you want to express? Once you decide that, you can create a proportional relationship of the elements to articulate your idea.

An object doesn't have to be large to command attention. In fact, the smaller a subject is in relation to any surrounding objects and the more contrast it has to those objects, the more dominant the subject can become.

I regularly use proportion to establish relationships that express my ideas. I emphasize an object or element by making it larger in the frame, but I do so purposefully and make sure that overall balance with other objects remains.

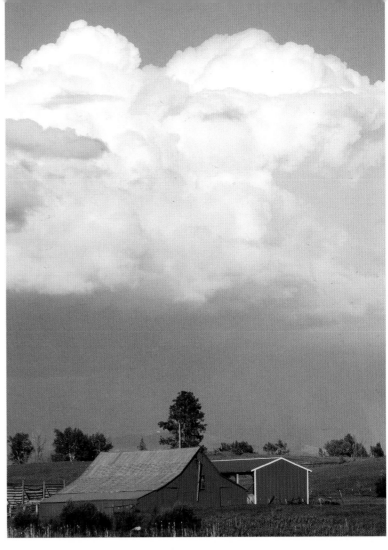

RIGHT: BARN AND CLOUDS, OREGON. *Although normally the red barn would dominate a scene like this, by keeping it smaller and having the white clouds above it, the balance changes a bit, and visual tension occurs. 70–200mm lens at 200mm, f/16 at 1/100 sec.*

BELOW: CABIN IN THE SMOKY MOUNTAINS, TENNESSEE. *The old cabins in the Smokies often housed families of nine or twelve people. They stand as sentinels to days past and the rugged life of those times. I tried to show this small homestead against the larger space of nature surrounding it. 70–200mm lens at 169mm, f/16 at 1/3 sec.*

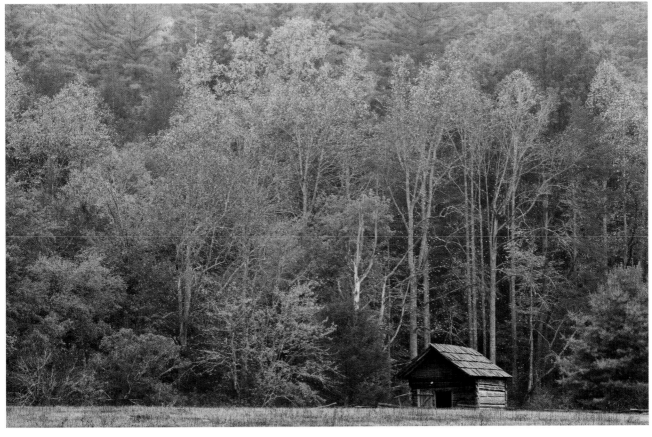

Scale

Scale, meaning the difference in size between various objects, is conveyed by the exaggerated proportional relationship of objects in the scene. Scale depends upon proportion for its effectiveness. If you want to show something is small, you'll want to keep it small in the frame in proportion to other elements.

Scale can express the height of a cliff or the smallness of a flower. When photographing the mountains in Denali National Park in Alaska, I was thrilled to see a woman in red walking up the trail. I photographed her along the trail, with the scenery behind her. But it got even better when she turned away from me and sat down to take it all in. I got a picture that expressed the vastness of the park when compared to her. Even though she's tiny in the frame, she stands out because of that red sweater.

**GOLDEN GATE
BRIDGE, CALIFORNIA.**
*Photographing for a visitor guide
cover, I had to make a "powerful"
photograph of the Golden Gate
Bridge. Using a 500mm lens, I
composed tightly on the tower.
This made the bridge dominant,
and powerful. But the picture
really came together when a
small group of people walked
out on the overlook and a man
pointed at the bridge. Their
size, in contrast to the bridge's
size in the frame, gave the scale
that expressed the strength of
the bridge. I was so lucky that
two of them were wearing red,
and it didn't hurt that I had the
moon in the frame, either. Good
things come to those who persist.*
500mm lens,
ƒ/16 at 1/125 sec.

LESS IS MORE

Unlike painters who begin with a blank canvas, photographers start with a full scene and have to eliminate the things they don't want in the picture. The goal is to simplify. When you include too many ideas or elements in a composition, you end up with a disorganized collection of subjects and your main subject becomes lost in the chaos. Frequently, the real picture is within the picture that you made. Your viewfinder contains a highly competitive world of objects, and you must get rid of all that are nonessential or distracting. As photographer Pete Turner once said, "Ultimately, simplicity is the goal—in every art, and achieving simplicity is one of the hardest things to do. Yet it's easily the most essential." Repeat after me, "Simplify, simplify, simplify!"

If you doubt the wisdom of this imperative, take another look at your photographs and see how many could have been improved by simplifying the composition. How often do you crop your images afterwards to improve them? Learn to crop in the camera first. Your challenge in making a good photograph is to reduce the visual clutter, to get rid of everything extraneous. You want to have one main subject or idea in your composition, and you need to eliminate anything in the frame that does not support that subject. Nothing in an image is neutral. There's nothing wrong with composing in the camera with the intent to crop later to, say, a panorama or square format for printing. But that's a conscious plan, not an attempt to save the picture later from poor composition.

Use your feet to reduce or eliminate areas of clutter in your picture. Yes, your feet—use them to move closer to your subject. As you move in, your subject becomes larger, which increases its

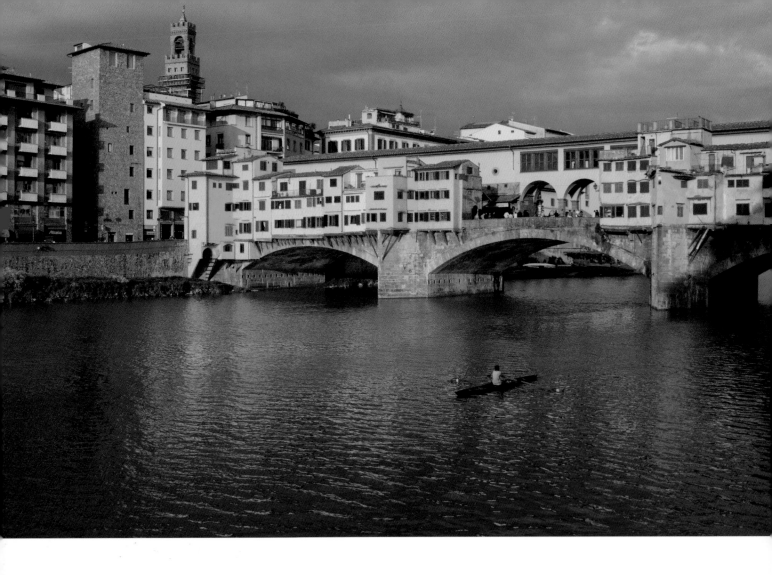

WORKING THE SITUATION

ITALY. *Late afternoon was partly cloudy, but I headed to the river in hopes of capturing some golden light at sunset, and got lucky. I knew that later the breeze would calm down, smoothing out the water, so I waited, as I wanted to capture the bridge and reflection with those moody clouds at twilight.* ABOVE: 24–70mm lens at 24mm, *f*/10 at 1/100 sec. OPPOSITE: 24–105mm lens at 40mm, *f*/16 at 10 seconds.

Photographers often don't get the most they can out of a situation. They make one or two pictures, and think they're done. As an exercise, the next time you're in a well-photographed location, challenge yourself to see what's around you in a different way. Make the "predictable image" first, if you must, but once you're past that, get into the scene. Zoom with your feet, not just your lenses. Try different focal lengths and different points of view. Return at a different time of day or night, if possible. Pay attention to the light of the day and decide if it could be better earlier, later, or at twilight. If the light is great and the location is great, you have the main ingredients for dynamite photographs. Spend a little extra time to make the most of it.

When I'm on assignment, I need to make as many good compositions as I can, until the light—or my memory cards—runs out. That doesn't mean that I run around frantically. Well, okay, sometimes I do get a bit frantic, but I still work a composition carefully to make the best image I can before I move to the next point of view. Since I submit pictures to stock photo agencies, I will try to make several good compositions, starting with the one I feel is the best. For photographers wishing to develop their vision, exploring the subject is essential. When you review your pictures, you'll see where you started, and what you ended up with, and the results will be very educational.

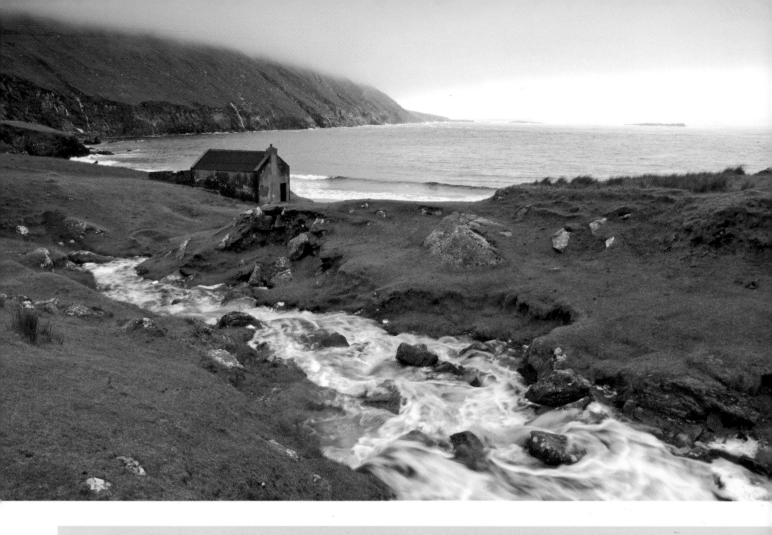

composition checklist

- Walk around with your camera and explore through the lens to find the best spot for making the picture. Don't settle for "first choice." The first place you stop is usually not the best.

- Think about what you're trying to emphasize and find the best angle of view and point of view you can to do that. Be willing to bend and stretch for your point of view. Don't be lazy!

- Utilize design and perspective.

- Preview the depth of field, and check for background distractions through the viewfinder.

- Do a "perimeter check"—scan the edges of the frame for extraneous "stuff." Your viewfinder may show you less than what you get on the sensor, but you can check that on the LCD if you make a quick "snap." While you can certainly crop that little bit later, it's good to get a "clean" composition in-camera if you can.

- Check for similar tones (or colors) that overlap and may not separate enough to stand out from each other.

- Watch for bright areas such as sky, sunlit patches, or reflections. They can create a strong distraction as the eye is always pulled toward bright areas of a scene.

- Watch for "the hand of man" in your nature landscapes—telephone poles, road signs, or airplane vapor trails that can cause distractions or visual clutter. And don't forget about the visual clutter you can remove—bits of trash, dead leaves, twigs—anything that is distracting.

- Watch for small distractions in macro compositions— pollen "dots" on petals, bright highlights from water drops, stray threads of cobwebs, moving bugs.

HORIZONTAL OR VERTICAL?

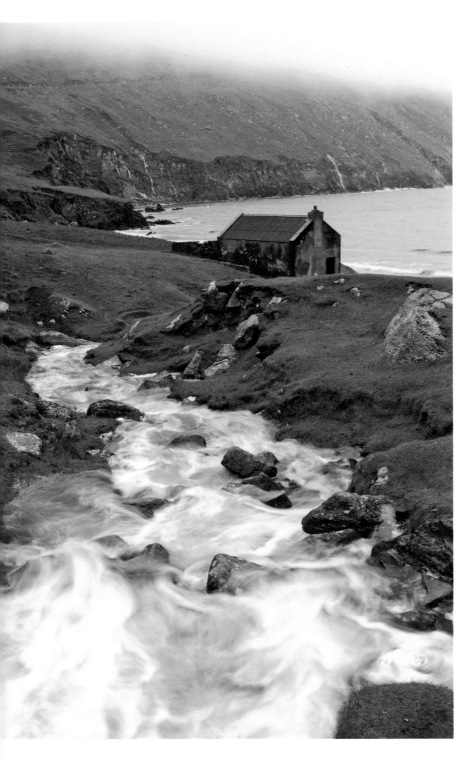

The next time you review your pictures from a field trip, examine the ratio of vertical images to horizontal ones. You'll probably discover that many are horizontals. I make a lot of vertical images, yet I am still surprised by how many horizontal images I create versus vertical ones.

Does this matter? Only if an image would be stronger if you were to compose it vertically rather than horizontally. As a general guideline, horizontal framing accentuates the width of the scene or a subject, and vertical framing emphasizes the height of it. Framing can have an emotional impact on the image, as well. Sitting empty on a page, a horizontal rectangle is more peaceful, because the longer two lines dominate the space and suggest a feeling of calm. A vertical rectangle expresses more vitality, as the longer two lines are upright and suggest strength. When you compose a scene, pay attention to the dominant subject and its orientation. Generally, vertical objects, such as trees, express more strength and energy if framed vertically to accentuate that attribute. But there are always exceptions, and it's a great idea to look at both vertical and horizontal compositions of your scene or subject, before settling on the first one that came to mind.

When I find a good location with great light, I try to find ways to create exciting photographs with both orientations. I use design, perspective, and composition techniques to make both images visually arresting.

ACHILL ISLAND, IRELAND. *When framed horizontally, the stream brings you through the scene in a relaxing manner, and you feel the depth of the scene. When the image is framed vertically, the rushing stream becomes dominant, its energy pulling you to the background. Since it serves as a visual pathway through the scene, it connects the foreground and background together and also expresses depth. Both orientations work, yet express different qualities.*
LEFT: *24–70mm lens at 25mm, f/20 at 1/6 sec.*
OPPOSITE: *24–70mm lens at 38mm, f/18 at 1/3 sec.*

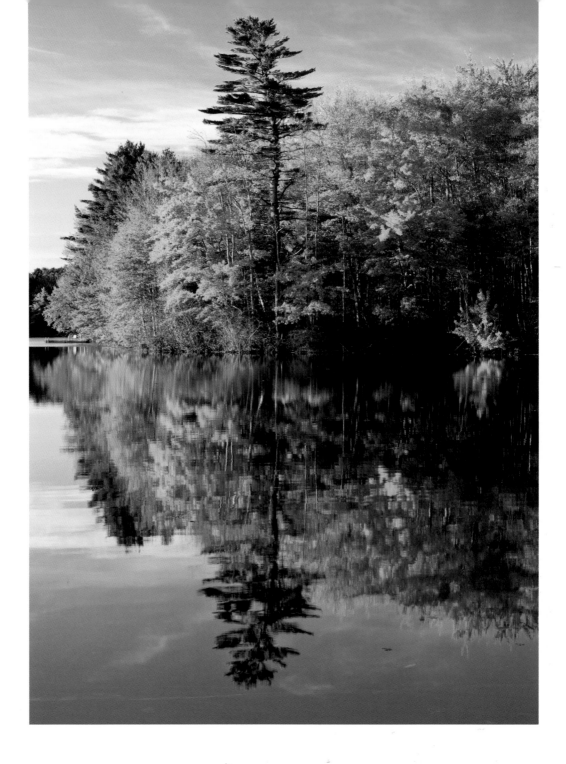

dominance. Any extraneous elements close to the edge fall away outside the frame. It's amazing how much this simple exercise can improve a photograph. If you can't move closer to the subject, use a longer focal length lens to eliminate some clutter, as it narrows the field of view, which can help to simplify the scene.

Keep an eye out for lines that may be leading the eye away from the main subject to other elements in the photograph, or to the edge of the frame. Color, too, can draw the eye away from your subject, if too bright or light.

As you integrate the ideas of dominance, balance, and proportion into your photography, an intuitive sense of composition will develop, freeing you to concentrate on other aspects of the process. The goal is to make a well-composed photograph that's as dynamic as possible. Between visual design, perspective, and composition, you now have many tools at hand to help you do that.

CREATING RHYTHMIC COMPOSITIONS

RIGHT: ARCHWAYS IN FLORENCE, ITALY. *The repeating archways created a strong rhythmic pattern. By filling the frame, I emphasized the rhythm, suggesting to the mind's eye that it continues outside of the picture space.* 100–400mm lens at 400mm, *f*/29 at 1 second.

BELOW: HANGING FERN, NORTHERN CALIFORNIA. *The gentle S-curves of these fern leaflets repeat from left to right in the frame, creating rhythm in a very simple composition. Here, too, the mind's eye assumes this repetition continues outside the frame.* 24–105mm lens at 75mm, *f*/4 at 1/13 sec.

OPPOSITE: ALASKA. *A rhythm developed from the repeating shapes of the wake pattern, a measured "beat" even though it appears to get compressed in the distance.* 100–400mm lens at 250mm, *f*/11 at 1/200 sec.

If you listen long enough to someone tapping out a rhythm, you'll be able to pick it up and tap along in time, even if you don't know the song. You probably wouldn't be able to pick up the rhythm with just two or three taps, though, because rhythm is established over time.

The same thing happens with rhythm in photography. You can begin to establish a rhythmic feeling with just three or four similar objects repeating in your frame, but the rhythm will be stronger if you have more. Whereas time is needed in music for rhythm to develop, in photography space is needed for the repetition to repeat enough times. Those repetitions also need to be in a measured beat—which in photographic terms means the objects are a relatively equal distance from each other in the field. While visual rhythm is often equated with wavy or curving lines, a row of trees can express rhythm if the repetitions create a *measured* movement for the eye to follow, as seen in the picture on page 64. If you compose so the repeating elements extend beyond the frame, you strengthen the effect, as the mind assumes the repetition continues and so the rhythm flows on, too.

You can use any focal length to create rhythm. A wide-angle lens provides lots of space to develop the repetition and it may be too much space for the amount of repeating elements. A telephoto lens gives you less space, but you can optically compress, or "stack," objects to establish rhythm more quickly. Creating rhythm still requires you to consider all the other factors of composition, perspective, and design, yet it can be the final crescendo in a well-designed photograph.

WORKING WITH COLOR

"In my photography, color and composition are inseparable. I see in color."
—WILLIAM ALBERT ALLARD

COLOR TOUCHES US ON A DEEP LEVEL AND EVOKES an emotional response. It has the power to create mood in a photograph. Pictures made in the blueness of twilight convey a mood of tranquility and calm. Photographs of bright yellow objects convey a mood of cheerfulness, or aggression.

Each color has its own attributes and visual weight. Warm colors tend to advance and cool colors to recede. Red feels heavy, whereas blue feels lighter, even deep hues. Think of how we respond to colors in nature. The earthy brown, beige, and ochre hues of a meadow in autumn represent a return to the earth. In spring, in the very same meadow, the lime-green hues of new shoots and leaves represent rebirth and growth.

You can employ these attributes to give impact to your photographs. Color is an element of a creative photograph, just like line or shape. You can emphasize or de-emphasize colors by your choice of point of view, focal length, and composition. You can visually arrange colors in your frame to create harmony or tension. You can use contrasting colors to accentuate your subject, or make color the main subject of your photograph. If you develop an awareness of the properties of color and how colors relate to one another, you can make better color photographs, no matter what your subject matter.

IRIS, CALIFORNIA. *The vibrancy of this iris drew me in one morning as I was having coffee in my kitchen. Violet and yellow are complementary opposites on the color wheel.* 100mm macro lens, *f*/8 at 1/30 sec.

THE PROPERTIES OF COLOR

The gestalt of colors comes from our experiences with these colors—for example, our experiences with fire, sun, sky, water, and snow. These experiences define how we respond to color, regardless of subject matter.

Yellow, the brightest of all colors, radiates light in a photograph, especially when set against darker colors. It advances visually when set against any other color except white. Yellow is emotionally vigorous and somewhat aggressive, yet often cheerful. It radiates warmth, and at the same time suggests we use caution. Think of flames, and the worldwide use of yellow in caution signs. Because it is so strong visually, yellow can dominate a composition, even if only a small portion of the frame. This is true even when yellow is darker in value than other colors.

Red is bold and expresses energy, power, passion, and vitality. Blood is red, and so are stop signs and extreme danger signs. Bright red roses almost seem to pulse when they are in a bouquet. When set against cooler colors, such as green or blue, red advances visually and has a kinetic energy. Like yellow, red can dominate a photograph depending on its proportion of the frame. But used carefully, red can be a great focal point—as in a red boat, or a barn.

Blue is not as active as yellow or red and is often referred to as a quiet color. Blue has a distinct coolness, sometimes even a cold quality to it. But it can also feel ethereal and express a tranquil mood. Blue can easily dominate other cool colors, but it stays in the background when warmer colors such as yellow and red are around.

The secondary colors—green, violet, and orange—also have emotional attributes. Green is the most prevalent color in nature, and its attributes and symbolism come from this association. It expresses growth, and expanding from that it also communicates progress and hope; fresh yellow-greens, rebirth and youthfulness. The lush green of a rain forest generates a feeling of growth and bounty.

Violet, less common in its pure form, expresses mystery and is often said to have properties of healing; a similar color,

purple, has rich associations with royalty and religion; and orange, like the yellow and red it's derived from, expresses heat and energy, as in fire. The orange light of sunrise evokes a feeling of warmth and energy.

The individual properties of color can be used creatively but must be managed carefully in your compositions. For example, if you have too much yellow in the frame, it will weaken any other colors. If you have a warm color juxtaposed by cooler colors, the warm color will stand out, even if small in the frame, due to the more aggressive properties of warm colors. Colors will also take on a different look according to the colors they are next to.

Red is perceived as very different when against yellow as opposed to green. Color therefore can define your composition and make it more interesting, if you are aware of these facts.

Many colors may exist simultaneously in a scene. Recognizing the visual weights of colors can help you select the proportion of each color element to use. For example, red is visually heavier than blue, so an image that has a lot of blue on the bottom and red on top may seem improperly weighted. Blue and green are fairly equal in visual weight; yellow is visually less heavy than other colors. Varying intensities of each color will produce different effects, too. For

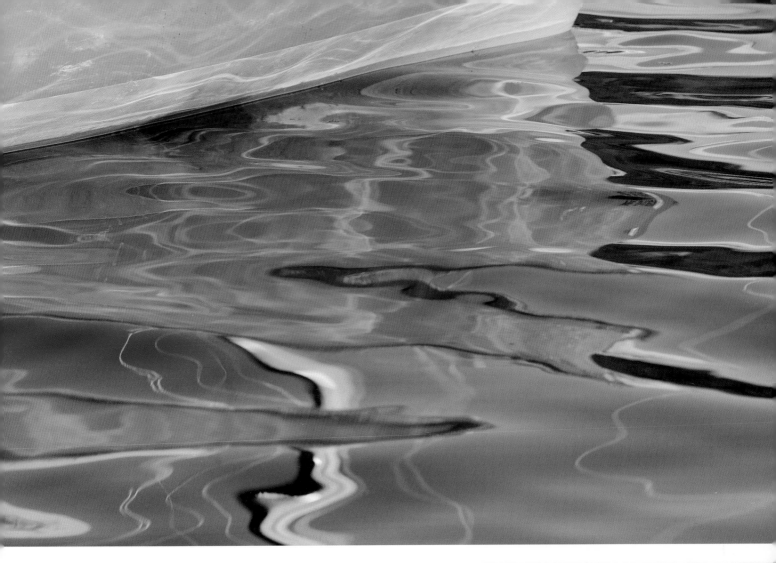

ABOVE: RED BOAT AND
REFLECTION, MAINE.
*The red is very strong on this
boat, and since red is visually
heavy, I didn't want too much
of it at the top of the frame. Its
proportion, coupled with the
larger area of multiple colors in
the reflection, creates a balanced
frame. 70–200mm lens at
200mm, f/9 at 1/60 sec.*

RIGHT: AUTUMN TREES,
ZION NATIONAL PARK,
UTAH. *Yellow dominates,
even with other strong colors
around it. This wall in Zion is a
favorite area of mine. The trees
somehow get enough soil to live
on for years on the small ledges
and crevasses of these rock walls.
70–200mm lens at
189mm, f/16 at 2 seconds.*

example, pink is a lighter, more delicate
hue than a heavy red. Pink and red both
express energy, but in different ways.
Pink is a ballerina; red is a floor-pounding
flamenco dancer. So you can see that
strong colors will be more energetic, while
pastel colors will present a gentler view of
the world.

 To find out what your personal color
palette is, review images you have made.
Try to discern whether you favor bold or
pastel hues in your photographs and what
colors attract you and in what intensities.
This can be the beginning of your
discovering your personal style.

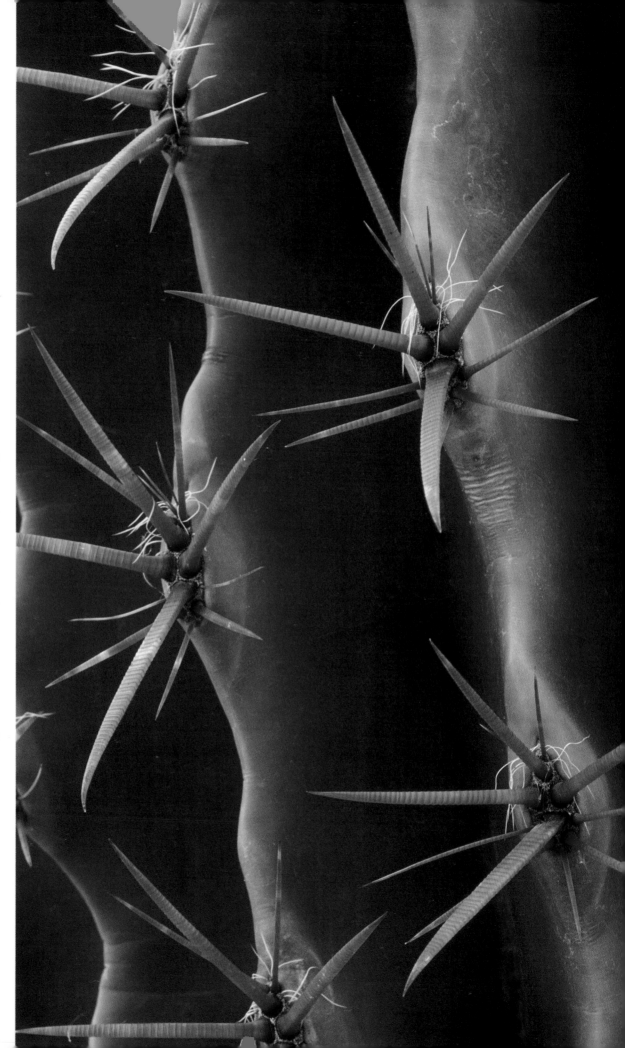

RIGHT: CACTUS, ARIZONA. *The brilliant contrast of the red spikes against the green flesh of the cactus made this a stunning subject to photograph. I diffused the light with a translucent panel close to the cactus, and the colors just glow as a result.* 100mm macro lens, *f*/16 at 1/2 sec.

OPPOSITE, TOP: WATER ABSTRACT, CALIFORNIA. *Sunset's colors and blue sky are all reflected in this motion blur of a rushing river. The natural color pair of orange and blue, even with other similar warm hues mixed in, makes this an eye-pleasing abstract.* 100–400mm lens at 350mm, *f*/13 at 1 second.

OPPOSITE, BOTTOM: MONO LAKE, CALIFORNIA. *The soft pink above the mountains and the blue sky directly overhead created a pleasing warm-cool contrast to this scene. I enhanced them a bit with the polarizer, to bring out this contrast.* 24–105mm lens at 32mm, *f*/16 at 25 seconds, Singh-Ray Gold-N-Blue Polarizer.

SPREAD ON PP. 112–113: GRAND PRISMATIC SPRING, YELLOWSTONE NATIONAL PARK, WYOMING. *The blue and orange contrast of this geothermal pool makes it visually interesting.* 70–200mm lens at 190mm, *f*/16 at 1/25 sec.

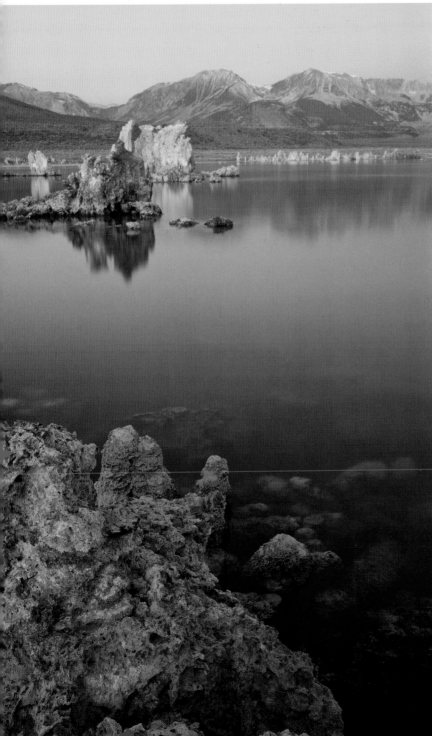

COLOR HARMONY

Have you ever noticed how stunning red berries are against green leaves? Or how pleasing red-orange sandstone is against a cobalt blue sky? Color harmony is important in photography, even if we don't always get to choose the colors of our scene. For every color, there is an opposite color, and the two form a complementary pair. On the color wheel, orange sits opposite blue, violet sits opposite yellow, and green sits opposite red.

Of course, photographs that contain only reds, oranges, and yellows can be wonderfully energizing, and photographs that contain only blues, purples, and greens can be soothing to the eye and uplifting to the soul. The contrast of cool and warm colors in a picture, however, creates the natural balance the eye seeks and often results in an emotionally pleasing picture.

I use these color fundamentals in my photography, and I watch the way colors affect my images carefully. If there's a red or yellow object in the scene that isn't the subject or part of it, I position it carefully and control its proportion so it won't dominate the frame. I might even choose to eliminate it. However, if I need to add scale to my scene, I try to have a red or yellow object that will draw attention against a color-contrasting background so it stands out. I love to photograph scenes in which complementary colors are present, but I've also learned to work with the colors that are there in any situation.

Try this exercise. Pick a color, then spend a day photographing that color everywhere you encounter it. Look for its complementary color as well. For example, if you pick red, look for situations in which you can contrast it with green. As you make your photographs, experiment with the concepts of dominance, balance, and proportion with relationship to that color.

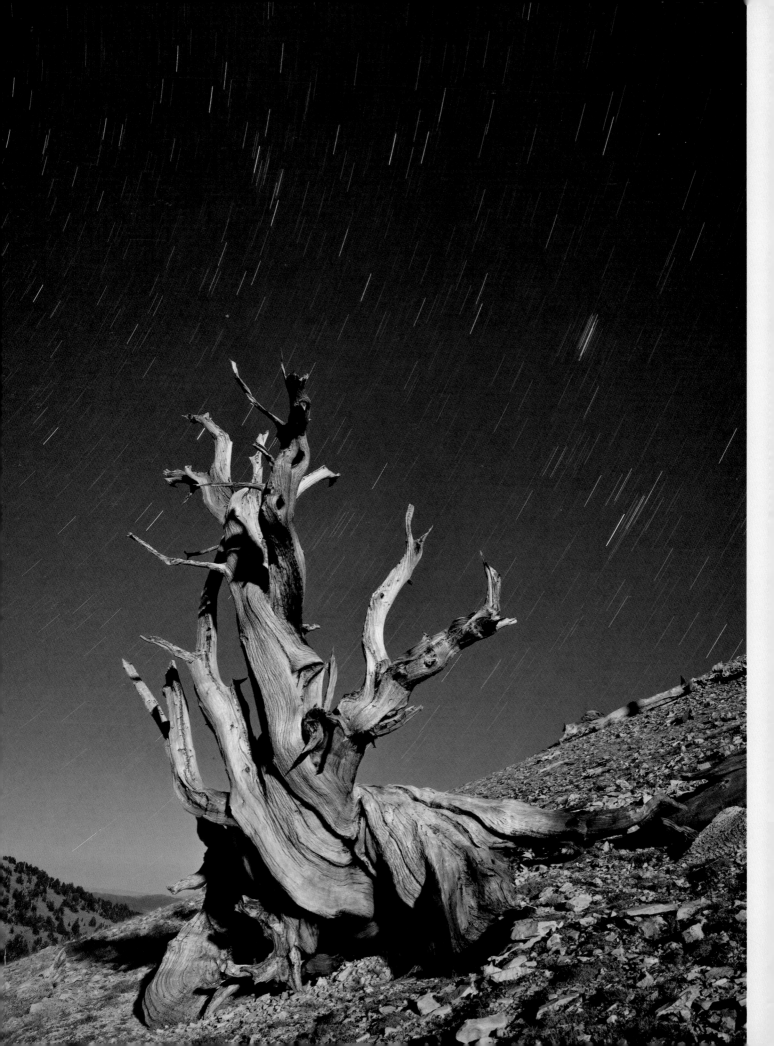

THE EXPRESSIVE IMAGE

"The creative act lasts but a brief moment, a lightning instant of give-and-take, just long enough for you to level the camera and to trap the fleeting prey in your little box."
—HENRI CARTIER-BRESSON

PHOTOGRAPHS HAVE INCREDIBLE POWER TO convey the mood of a situation, whether it's joy, horror, tranquility, or festivity. Photography can also reveal the moments and gestures in both the natural and the man-made world.

When we look at pictures of people engaging in sports, we can feel the energy of the action and any moments of triumph and despair that were captured. When we see wildife photographs, we feel the same energy in a photo of, say, a running gazelle. When we view photographs of moments in time of any kind, we respond according to the story they tell and the emotions that are expressed in the picture.

As photographers, we have a great opportunity to see and capture motion, moments, gestures, and mood in the world around us, making our images resonate with energy and meaning. Use the camera as your license to be curious, to get closer, and to explore more deeply.

As you read on, you will learn how to incorporate this ability to capture energy in ways that will make your pictures more expressive.

BRISTLECONE PINE AND STAR TRAILS, EASTERN CALIFORNIA. *Even at 800 ISO, I needed 6 1/4 minutes to capture enough trailing of the stars. I turned noise reduction on, used my remote release with the locking button, and pressed the release. It was incredibly peaceful up at 12,500 feet. 24–105mm lens at 24mm, f/8 at 637 seconds.*

CELEBRATING MOMENTS

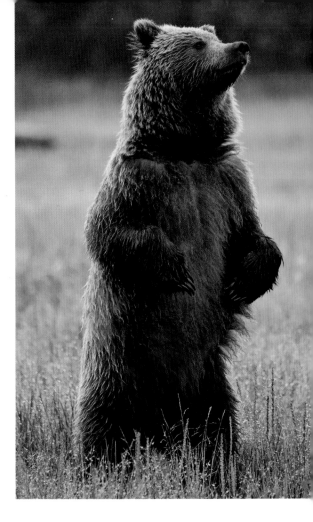

RIGHT: LAKE CLARK
NATIONAL PARK,
ALASKA. *Grizzly bear
checks out the territory.*
100–400mm lens at
400mm, ƒ/5.6 at 1/200
sec.

BELOW: BREACHING
HUMPBACK WHALE,
ALASKA. *These whales are
amazing to see, yet not easy
to capture. They suddenly
appear, hurtling their bod-
ies into the air. Fast shutter
speeds are required: 1/800
just made it. Keeping shutter
speeds high while searching
for whales helps you be pre-
pared for the action.* 100–
400mm lens at 300mm,
ƒ/5.6 at 1/800 sec.

A whale breaching, a bird taking flight, a child laughing—all of these express a unique moment in time. Candid moments, those spontaneous actions in nature and of humans, can help to create an expressive photograph. For an outdoor and nature photographer, candid moments are the icing on the cake. For all the research and planning that might go into a trip to photograph the wildebeest migration in Africa, you still can't predict what the animals will do once you're there.

Since candid moments are so unpredictable, it might seem impossible to apply ideas of visual design or good composition to them. Just capturing the moment is often thrilling enough for some photographers. But a great moment in nature doesn't guarantee a great photograph. Capturing the moment is a combination of technical and artistic skills. If you hone your reflexes, you'll respond more quickly to capture a fleeting moment; likewise, if you've developed your artistic vision, you stand a much better chance of capturing a moment creatively. You have to be ready for a situation when, suddenly, right there in front of you, "it" happens. Chance favors the prepared mind, as Louis Pasteur put it.

The key is to hone your timing. Parks are great places to practice. Dogs are running and leaping, and adults and children are playing. You get wildlife action and people moments within one contained area. And many dogs, such as retrievers, will fetch until exhausted, so you'll have plenty of opportunity to practice your timing. Whether it's people or animals, capturing moments is an exciting part of photography for me.

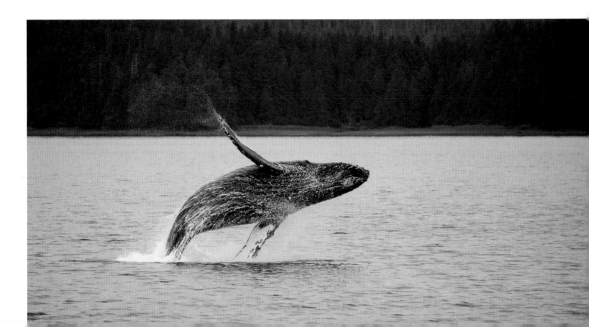

Capturing Gesture

Gesture often defines a moment in a photograph and adds to the expressive nature of a picture. A smile almost universally signals happiness or friendliness; hands folded in prayer generally represent a desire for connection with a greater spirit; hands held high at the end of a race signify empowerment, a "Yes!" gesture. We understand the gestures of many animals, too—stretching, yawning, play fighting, stalking, nurturing. Consider, too, some of nature's more dramatic gestures—lightning bolts, volcanoes, calving icebergs, and rainbows. Even inanimate objects can express gesture, such as the way a flower nods or a tree reaches into the sky.

These poignant gestures breathe life into a photograph and make your images resonate with visual energy. To increase your ability to capture a gesture, you must develop your skills of observation. The

more you observe, the better you'll be at anticipating a moment of gesture. Practice making photographs in places where moments and gestures happen regularly, such as wildlife refuges, zoos, parks, or lively outdoor markets.

Many photographers today use their continuous frame mode to capture a series in the hopes they'll have captured the peak gesture or moment somewhere in there. But it still requires good timing and anticipation skills to know when to start the series, or you might miss the moment altogether. To become better prepared, develop an awareness of the moments or actions that tend to occur in certain situations that you like to photograph. Watching large flocks of snow geese, you'll learn that certain hawks or airplanes can startle them into taking flight en masse. Boaters tend to take a similar route down a rushing river, and after the first one or

two go by, you'll have a better sense of what to expect. If you just think about gesture in everyday things, you'll be more aware of them all around you.

Prepared with the knowledge of what can happen, you can go into a situation and be ready to seize the moment. I knew what to expect at an outdoor market in Bhutan, since I had been to farmers' markets near my home. Photographing running dogs in a local park prepared me to capture race horses in western Ireland. However, on my first trip to Alaska many years ago, I hadn't had any experience with whales and was failing miserably at capturing the peak moment when they surfaced to breathe. I couldn't tell where they were going to pop up, so I was usually pointing in the wrong direction. A helpful naturalist taught me how to see changes in the surface tension of the water that indicate where the whale is about to emerge. What a difference that made!

Many photographers talk about having a sixth sense when it comes to capturing moments, and that's been true for me. If your observation skills are strong and you are attuned to what's taking place around you, you can often sense the moment before it happens, perhaps because you are subconsciously familiar with the situation. I'd love to say that I always sense the moment and capture it, but I don't. It's a lifelong goal, so every trip into the wildlife refuge, a village, or a festival is an opportunity for me to continue to try for those instances when light, design, and gesture all come together in one fantastic moment.

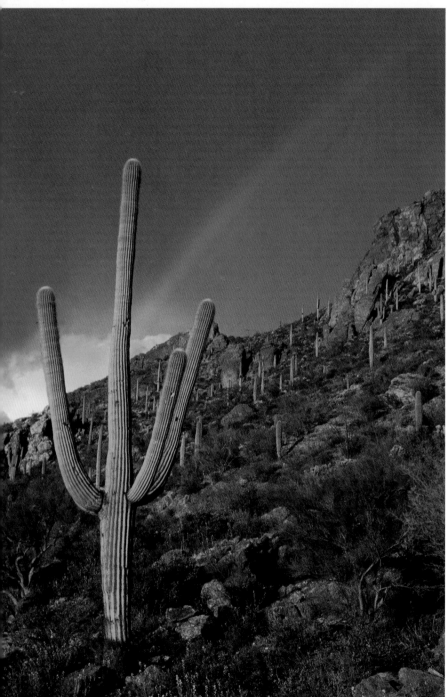

TOP: GRIZZLY BEARS, ALASKA. *When the cub climbed on Mom's back, I knew I had a cute photograph! I took several, but in this one, all three of them seemed to be looking in the same direction.* 500mm lens with 1.4x, f/6.3 at 1/500 sec.

LEFT: SAGUARO NATIONAL PARK, ARIZONA. *I waited out a rainstorm because I knew there was a chance for a rainbow and great afternoon light, with the clearing on the horizon. Nature makes her own great gestures at times with rainbows!* 24–70mm lens at 55mm, f/18 at 1/40 sec.

Expressing Motion

THE CAMARGUE, FRANCE. Fast action requires fast shutter speeds. If you're trying to freeze motion, it's usually best to go one stop higher than you think you need, to make sure you get the shot. Since the horses were coming toward me, I could keep the shutter speed a little lower and go for more depth of field with a smaller aperture. Skill at this develops with practice and evaluation of results. 100–400mm lens at 275mm, f/10 at 1/500 sec.

In this constantly moving world, it only makes sense that we would try to show the motion that we see and experience all around us, even when using still cameras. Of course, a still photograph can provide only an illusion of motion; nonetheless, an image can be quite effective in creating a sense of speed or portraying the fluidity of movement. In a photograph of a car driving along a dusty road, the trailing dust cloud tells us the car is moving. The split-second shutter speed that captures a bird in midflight, and the long exposure that records water flowing over rocks, each express motion, in very different ways. Both, however, capture the magic of motion.

To photograph motion, you can freeze it, let the action move through your still scene, or pan with the movement. Each situation calls for a different technique.

First, ask yourself what effect of motion you want to bring out, then use that answer to decide which technique will give you the best results.

FREEZE FRAME

Freezing motion is aimed toward capturing the *peak* moment of action, a view we never experience with our own eyes as we watch a moving scene. When you use a high shutter speed to freeze the action, you can seize that peak moment. You can also create visual tension in freeze-frame moments. Imagine a hand reaching toward the volleyball but not yet touching it, or a bird plunging toward the water, captured in-camera just before impact.

A shutter speed of anywhere from 1/250 to 1/2000 can stop most fast

action. To determine how fast your shutter speed should be, you have to factor in the distance from camera to subject, the focal length you're using, the direction your subject is moving in relation to the camera, and the speed at which they are moving. The closer you are to your subject or the longer the lens, the faster the shutter speed will have to be to freeze the motion; in a narrow field of view, the time it takes for your subject to travel through the frame is very short and the motion is amplified. If the path of movement is parallel to the sensor plane, you'll need a faster shutter speed than if the movement is perpendicular or diagonal to the sensor plane. Huh? Don't worry, there are charts you can use as reference, to get you in the ball park. The rest comes from practice and evaluation of your results.

Remember the retriever playing in the park I mentioned earlier in this chapter? He's still out there. Master your timing by photographing him leaping for a ball, and you'll be ready when the cheetah pounces on its prey on your African safari.

MOVIN' AND SHAKIN'
Another terrific way to express motion is by panning. I love the look of this technique. Panning enhances the action and shows the "choreography" of the motion. You can still feel the excitement and tension in a slow-shutter panned image of white-water rafting. Elements overlap in the scene, their hard edges becoming softer as they blend together, and the blending of the background often "cleans" up the clutter.

To get the full impact of the movement of your subject, choose a shutter speed that allows for enough blurring yet retains enough detail to define the subject. This tip may sound vague, but there is no formula for panning with slow shutter speeds. Situations vary greatly, and the surprise factor makes it fun and challenging. Generally, a faster shutter speed will record less movement in the subject, and may make the background more distinct than you desire. Again, the results will be affected by the speed and direction the subject is traveling in relation to your camera and the focal length you're using.

If you want a smoothly panned background, put your camera on a tripod. This only works if you use a tilt/pan type of head, however. A ball head, once loosened, is like not using a tripod at all. With all panning techniques, the only real way to develop a sense of what works is to experiment.

Finally, remember the importance of composition when photographing motion. If you don't put enough space in front of a moving object, blurred or not, the image will appear crowded and off-balance, with too much visual tension.

GOING WITH THE FLOW

Even with a still camera we can capture the series of movements that constitute action. Imagine a quiet forest with a stream running through it. You will want the scene to be still, but not necessarily the water. You might want the blur of horses running through a beautiful meadow, with the meadow still and sharp. To get any environment around your moving subject to remain sharp when using slow shutter speeds, you'll need to use a tripod. If the light level is too bright to get slow enough, even when using small apertures, a variable neutral density filter can "dial in" more density, which then allows you to slow the shutter down even more.

The shutter speeds necessary to capture different amounts of blurred movement vary widely and depend upon the speed your subject is moving. The faster the subject is moving, the faster the shutter speed will have to be, to a degree, to show the blur. For instance, if you try to capture the blur of a dog running through your still scene using a 2-second exposure, you may see nothing on the frame! The slower the shutter speed and the faster the movement, the more transparent the object becomes. A 1/2 second might be a better solution for this. Remember, too, that the focal length will affect your shutter speed choice, as will the distance between camera and subject and the direction of movement.

Reference charts can be very useful here, too, but it's also great fun just to try it and learn through experience. When I do something that works, the memory of how I did it gets stored in my mind's "library" for later reference.

I love to photograph moving water and prefer a soft effect to convey its fluid and ethereal qualities. When water moves through the frame, the light reflecting off of it can "paint" across the sensor, creating an artistic interpretation. When you paint with light like this, you never really know how the image will look until you try it. You will be creating one-of-a-kind results, which is part of the excitement as you try for the "right" effect. Experiment by varying your shutter speeds within a certain range, and you'll be assured of getting something that works from the exercise. For swiftly moving water, I usually set the shutter speed between 1/8 second and 2 seconds. That's a pretty wide range, but with practice, you'll learn that a rushing river takes a certain shutter speed to blend it together, and a swirling eddy in a stream takes another. Wider angles of view require slower shutter speeds and telephoto ones require slightly faster ones to capture the blur, due to the time it takes for motion to traverse the frame in the different focal lengths. Review the picture on the LCD and vary the shutter until you get what you want.

BELOW, LEFT: GOLDEN REFLECTIONS, MERCED RIVER, CALIFORNIA. *A shutter speed of 1/25 second stopped the movement enough to create a metallic surface reflection.* 100–400mm lens at 400mm, *f*/11 at 1/25 sec.

BELOW, RIGHT: ST. GEORGES RIVER, MAINE. 70–200mm at 200mm, *f*/16 at 1/2 sec.

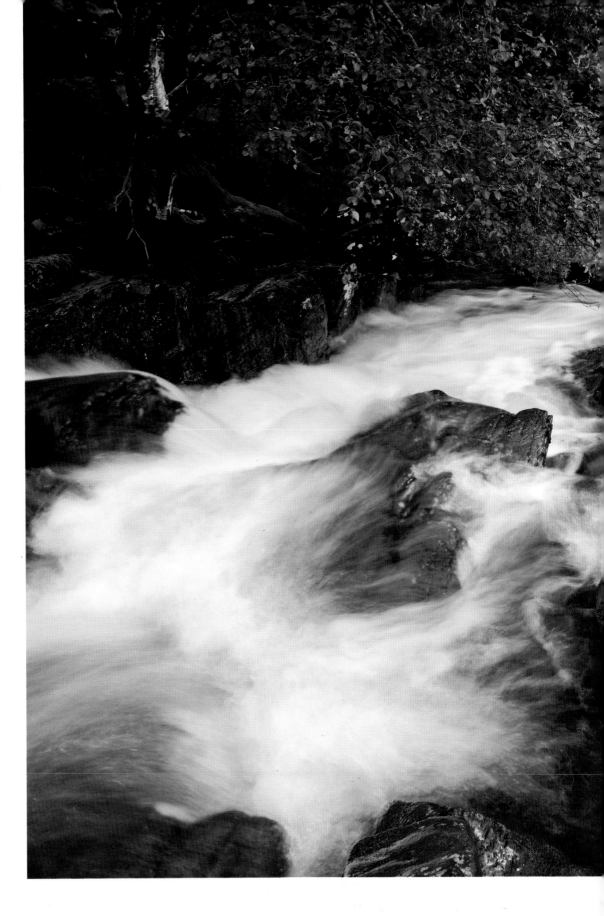

WESTERN IRELAND.
*Capturing this peaceful scene,
I positioned myself so the water
flowed away from the camera,
taking the viewer on a visual
journey to the background.
I used a tripod to render the
overall scene sharp, and a slow
shutter speed to let the water
blur softly. Overcast light was
perfect for bringing out details
in this scene. 24–105mm
lens at 40mm, f/11 at
1/3 sec.*

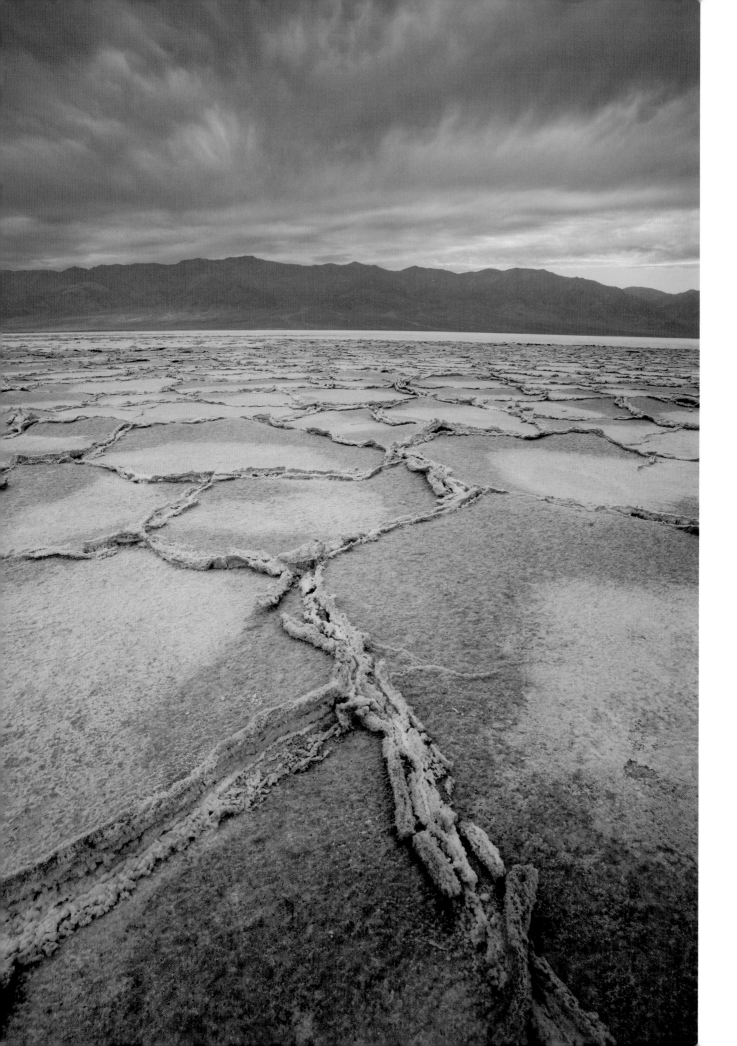

OPPOSITE: THREATEN-
ING SKIES, DEATH
VALLEY, CALIFORNIA.
*Stormy skies often mean rain,
but not always for Death
Valley. Still, this particular
morning looked quite promis-
ing for rain. To accentuate the
sky, I merged three exposures
with Photomatix software into
an HDR image, then adjusted
it to emphasize the stormy
mood.* 16–35mm lens
at 16mm, *f*/16 at
1.5 seconds.

RIGHT: MARSHALL
POINT LIGHTHOUSE,
MAINE. *Twilight is a won-
derful time. The blue hues of
the coming of night are tran-
quil yet mysterious. When I
saw this view from the porch of
the light keeper's house, I knew
I had a great mood-evoking
image.* 24–70mm lens at
60mm, *f*/16 at 1/2 sec.

BELOW: CHAPEL,
YOSEMITE NATIONAL
PARK, CALIFORNIA.
*During a rare midautumn
snowstorm, I took my work-
shop group out to photograph
in the valley. The chapel is a
classic icon, and the falling
snow added a great mood to the
scene.* 70–200mm lens at
100mm, *f*/7.1 at 1/50 sec.

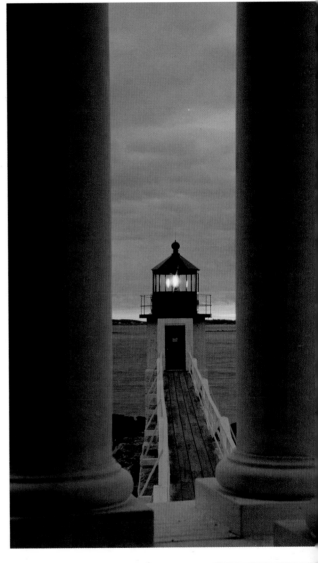

ARTISTIC INTERPRETATIONS

*"The less descriptive the photo, the more stimulating it is for the imagination.
The less information, the more suggestion; the less prose, the more poetry."*
—ERNST HAAS

THIS IS THE CHAPTER WHERE YOU GET TO TELL YOUR internal critic to take a hike while you play around with new ideas and experiment with abstraction and impression.

In order to get the most out of this chapter, you should release your need to have perfect results. Digital photography allows you to experiment freely: If you don't like it you can simply delete it! When you make a photograph that is highly interpretive (i.e., an abstract or an impressionistic work), there are no hard-and-fast rules. For some of the techniques I will discuss, there are basic steps you will need to follow to get the general effect, and then you get to experiment. Each panned image, multiple exposure, and montage will be a one-of-a-kind picture—and therein lies the magic and fun! The only limit to your experimentation is your imagination. Your willingness to abandon traditional approaches can expand and enhance your results.

Some special effects are now done on the computer, as my digital camera can't do some things that film used to do so well. I also use some wonderful plug-ins to Photoshop and other software applications that allow me to continue my creative vision once I have the picture in the computer. Let's get started!

AUTUMN TREES, CALIFORNIA. *I love to make painterly abstracts of nature. You can probably guess these are trees, but it was the blending of colors and the suggestion of trees that interested me the most when I made this picture.*
100–400mm lens at 400mm, f/16 at 1/3 sec.

PANNING

NORTHPOINT
HARBOR, MAINE.
*I thought I'd try panning
vertically on a harbor scene
one morning for something
different. The motion blended
together the pretty dawn hues
and blurred the boats to create
a dreamlike scene of the har-
bor. 70–200mm lens at
110mm, f/22 at 1/10 sec.*

Panning on a still scene allows you to blend the elements of the picture into a wonderful abstract of light and color, turning an ordinary static situation into a painterly one. By moving the camera up, down, or sideways, during a slow shutter speed, you blur all the details together and create a wash of colors through the frame. Trees, flower gardens, rolling landscapes, and sky are just some subjects for which this technique works. After experimenting a while with the same subject using different shutter speeds, you'll get a sense of what to do for the look you like. There's no formula, and every photograph will surprise—and hopefully delight—you.

As a guideline, the fastest shutter speed you'll want to use when panning is around 1/15 second. With speeds above that, you may not be able to complete enough movement in time. The shutter speeds I typically choose for panning range between 1/15 second and 1 second, but so much depends on the speed of my movement. If you want to control the movement in only one direction, use a tilt-pan style of tripod head that allows you to release only the vertical or horizontal axis for panning. To pan vertically on a ball-type head, you have to loosen the ball, and then the whole camera is loose, but you can still do it, and you'll get a wavy feeling to the motion.

I prefer to fill the frame with the movement, so I begin panning before I press the shutter, and continue it after it's closed, to be sure I was moving the entire time the shutter was open.

Do a few trial runs at panning to get a rhythmic feeling to your movement. Pan while looking through the viewfinder—you'll see how much area you are covering, which helps you decide whether to narrow it down to eliminate some distraction or to widen your swing. Finally, check your LCD to see if you got what you wanted, and keep working until you do. It takes practice to produce just the right effect, but the results are worth it. Think about doing vertical pans as well—they can be very exciting. And don't forget about rotating the camera while using slow shutter speeds, or move it in all directions to see what effects you achieve.

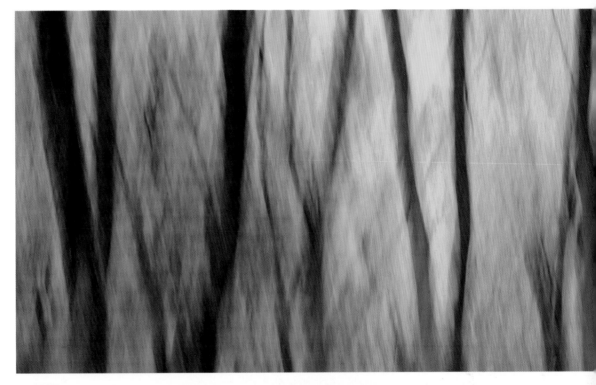

ZOOMING THE LENS

GREAT SMOKY MOUNTAINS, TENNESSEE. *Zooming a lens can turn an ordinary scene into something more creative. I try to find a subject, such as this nice S-curve road, that will give the zoomed picture some structure.* 24–105mm lens at 82mm, *f*/16 at 1 sec.

Zooming on a still subject during a slow exposure is another way to imply motion. To zoom effectively, you need to set the shutter speed slow enough to give you time to zoom. Stop the lens down to *f*/16 or *f*/22. This usually allows for a slow enough shutter speed to create a good zoom effect, around 1/4 to 1 second. This too is personal choice, depending on the look you like.

Once you have composed a scene that you like, take a few practice runs on the zoom control to be sure you have your timing down. To get a complete zoom effect, start before you press the shutter and continue zooming even after the shutter has closed. If you want the streaking in the photograph to be smooth, you need to zoom at a consistent speed. Varying the speed will create a choppier effect, but this isn't necessarily bad—it all depends on what you want to do. The more you practice, the easier this technique becomes. To experiment further, try zooming and panning at the same time, or zoom on a moving subject instead of a still one. Because a zoomed composition always radiates from the center of your frame, you might consider cropping to put the point from which the zoom radiates off-center.

CREATING MONTAGES

LEAF ON SALT FLATS.
This leaf was floating on a pond in Maine, until I "moved it" to Death Valley's dry salt flats! I like the color contrast, and the juxtaposition of the two. The reflection makes it appear that it's floating on a thin layer of water on the salt pan.

A montage is a composite picture that brings a number of pictures or elements together, like a collage in traditional art. The montage in photography has been around for a long time, beginning in the darkroom days, and film photographers have used it to make some wonderful interpretive photographs. Digitally, we can combine images, or pieces of them, using the computer. You can use just two image files, or as many as you want. The choice of images you might combine is limited only by your imagination—and the amount of RAM in your computer!

As a simple example, imagine you have a scene of birds flying in the sky in front of you, but you think it would look so much better with a moon in the frame. First, you make a picture of the birds flying by, remembering to leave space for the moon in the composition. Then, you make another picture of just the moon, positioning it in the frame so

that it will fall into the right spot when combined with the image of the birds. You can review your bird picture on the LCD to verify positioning before making the second picture.

If your particular camera model can put them together for you in-camera, you'll have an instant double exposure. If not, you'll have to use an editing program like Photoshop to blend these two files together to arrive at a final image of birds flying with the moon in the frame.

There are so many things you can do using the montage technique. I like to "sandwich" layers of textures over objects and scenes. Planning for these composites, I make photographs of just textures and store them in a folder labeled "Textures for Montages" on my computer. Sand grain, wood, rusting metal, and fabric are just some of the textures you might photograph and store for later use.

WILDFLOWERS,
CALIFORNIA.
*Multiple exposure created by
overlapping six image layers.*

OPPOSITE, TOP:
AUTUMN LEAVES,
ZION NATIONAL
PARK, UTAH. *Two
pictures combined digitally,
one in focus, one out of focus,
to make this glowing mon-
tage. 24–105mm lens at
90mm, f/11 at 1/4 sec.*

OPPOSITE, BOTTOM:
GERANIUM, VILLA
ROSA, ITALY. *I needed
only one picture to create this
look, using my diffused glow
technique. The soft glow
creates a feeling of a romantic
dream. Original base
photo specs: 70–
200mm lens at 115mm,
f/16 at 1 second.*

IMPRESSIONISTIC MONTAGES

I am fascinated by how a painter can overlap tiny strokes of color onto a canvas to create a wonderful *impression* of a scene, with all the light and shading necessary to perceive the content or story. Years ago, attempting to create a similar effect in my photography, I started creating multiple exposures—many photos on one frame—using film. When I switched to digital, I had to learn how to re-create this effect using the computer. It's a favorite of mine, and I'm excited that we can once again create impressionistic effects easily.

This technique works very well with subjects that have a lot of small detail, such as trees with foliage, gardens, and wildflower meadows, but it's always worth trying on other subjects. I get great results combining anywhere from six to sixteen. It's all about experimenting until you get something you like.

To create the stippled, impressionistic effect, you'll need to make multiple pictures of the scene. Let's take a wildflower meadow as an example. While hand-holding the camera, find an object or area you can use in the scene as a visual reference point. Reposition the camera slightly around that reference point for each exposure, in a random direction. Make six exposures. There isn't any right or wrong

direction, but don't move too far from your point of reference, or you won't get the stippled effect from elements overlapping closely. Watch out for any distracting bright or dark areas, which may still pose a problem when exposures are combined. Once you master the technique, you can create wonderful impressionistic scenes.

1. Once you've downloaded, convert your files from RAW to TIFF or PSD.
2. Using Photoshop, open all six of your image files.
3. Choose one file as the base layer.
4. Using the Move tool, click on the next image file, holding down the mouse, then press the Shift key, and drag that file over the base file. This creates a new layer. Do this for each file you have open, until you have all six in one multilayered file. The Shift places each layer in exact registration over the base layer in the file. Yet, because you moved the camera in the field, the elements within each layer will be overlapping. At this point, you'll only see the top layer.
5. Highlight the top layer, and reduce the opacity until you see the layer below it. The amount will vary for the look you want, but start with about 30 percent.

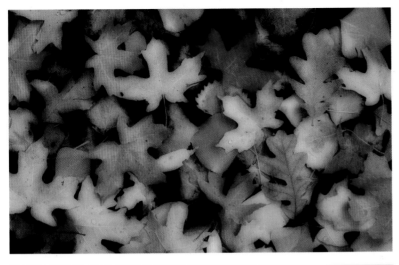

6. Highlight the next layer, and do the same. (Turn off the eye on the above layer each time or you will not see the effect.)

7. Do step 6 until you have arrived at the first layer above the background. You'll see your multiple-exposure image "developing" as you go. When finished, if you want, you can vary the opacity on each layer uniquely, thereby controlling the effect.

CREATING A DIFFUSED GLOW

Another favorite montage technique is a simple one that creates a glowing effect. The method I find the most satisfaction with uses one image file as below. This means I can choose any image I've ever made and apply this look. There are various methods on this technique, but here's how I create the look I want. Tutorials on other methods are accessible online. (See the resources section for information.)

1. Open your image file in Photoshop.

2. Copy the background layer (Layer Duplicate in the Menu Bar).

3. Change the blending mode on the duplicate layer. You have several creative choices here, and I'd suggest experimenting for the look you want. I often use Soft Light or Overlay, but at times, Multiply gives me darker results, and I may then lighten up that layer a bit, depending on the image.

4. Apply a Gaussian blur to the layer, in the amount you like.

5. Rename this layer Blur XX, with the "xx" the amount you used for blurring for later reference.

6. If you like the results, save it as a PSD or TIFF with open layers for further modifications; then flatten, size, sharpen, and save it for printing or Web sharing.

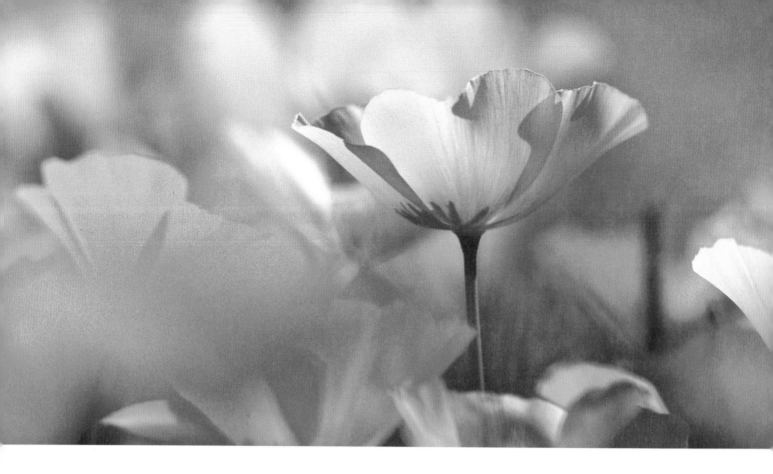

FOCUSING THROUGH OTHER OBJECTS

How does a rabbit view the meadow as it looks through the flowers at one luscious morsel just a few feet away? You can express this point of view by focusing on one flower in the meadow while looking through others in front of it, and letting all those closer to the lens go out of focus. The leaves or flowers closer to the lens will stay out of focus if you use a wide aperture, which transforms them into transparent washes of color and soft shapes that surround the in-focus flower. You can use this technique for focusing through glass, screened windows, leaves, grasses, and flowers for interesting effects. Picture autumn foliage, out of focus, creating a transparent wash of warm hues over a cluster of red berries.

To try this, use a lens in the 100–300mm range, and set up two groups of flowers or plants in pots or vases. Position yourself so the lens is very close to the first group of flowers, almost touching them, and focus *through* them to something in the other group. Most telephoto lenses don't focus closer than 4 feet, so any subject you want sharp will have to be no closer than the minimum focusing distance on the lens. If you back up to get it sharp, it may make your subject too small, but an extension tube used on the lens will allow it to focus closer.

The resulting effect is a transparent color wash that covers parts of the scene, with your subject still having enough clarity to be the focal point in the picture. The key to this technique is getting things up close enough to the lens so that they are completely out of focus and just a wash of color. Once you have that worked out, then setting the other pot of flowers where you want will be easier. It's pretty easy in the backyard using flowerpots to get the right distance between the two groupings. But in the field, it's more challenging. Gardens that are densely planted, wildflower meadows that are full of plants, and forests of deciduous trees are good places to try this technique.

SOFT-FOCUS EFFECTS WITH A LENSBABY

TOP: ORCHID, FLORIDA. *I pushed the lens around until I got the look I wanted while maintaining some sharpness on the mouth of the flower. Lensbaby, with +4 close-up lens, f/4 at 1/640 sec.*

BOTTOM: MARSHALL POINT LIGHTHOUSE, MAINE. *The Lensbaby gave me a different effect on this lighthouse, and the soft sunset colors added to the dreamlike impression. Lensbaby, f/4 at 1/60 sec.*

If you want to create a soft-focus effect, yet with a small area that is still in focus, the Lensbaby is a fantastic and fun way to do that. This unique lens is designed to give you control at creating selective focus in your picture yet still having a "sweet spot" that is sharply focused. The newest version operates like a ball in a socket: You push the front of the lens around until you get the effect you want, and it stays in position until you move it again. By inserting the supplied aperture ring of your choice, you can control depth of field, too. When I use the Lensbaby, the doors of creativity are opened wide, and I perceive images in new and exciting ways. My Lensbaby always comes with me. When I want a more unique effect to my image, I know I'll get it with this lens.

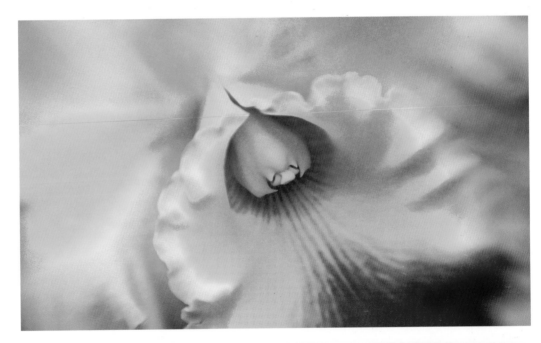

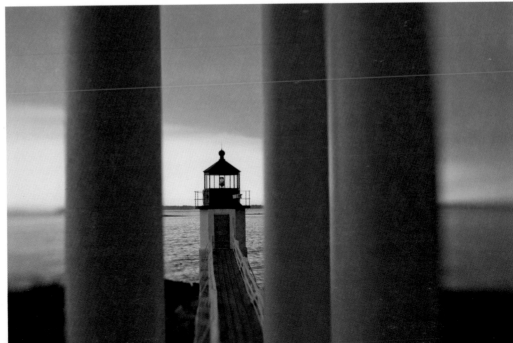

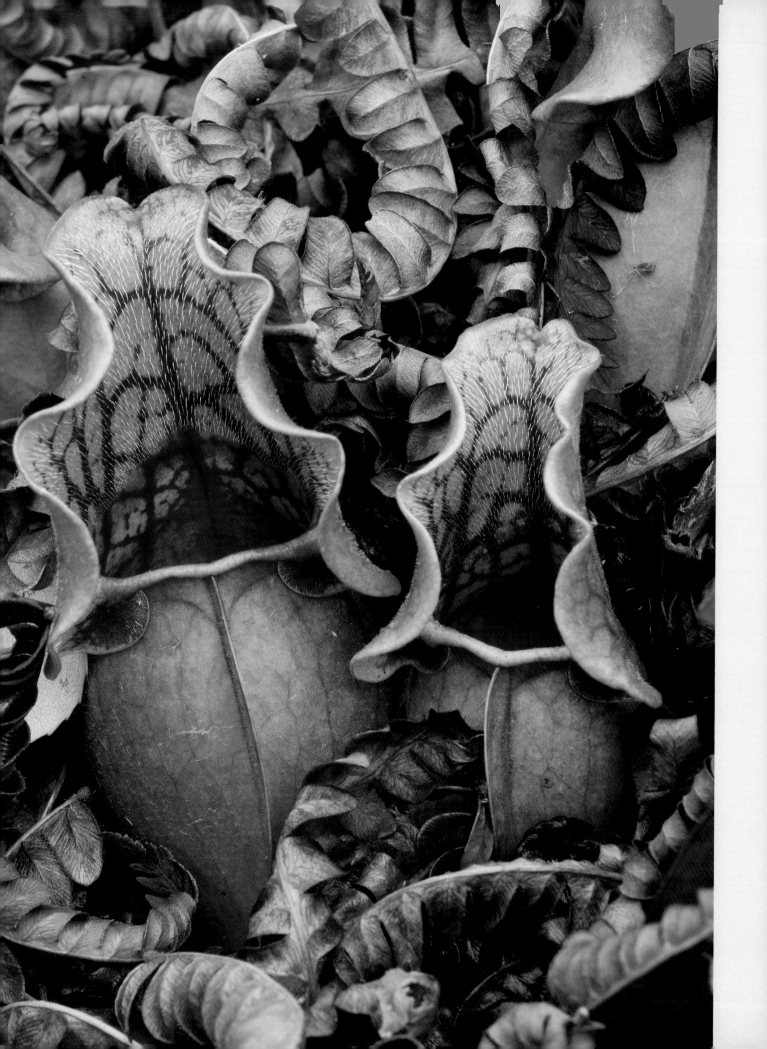

A DEEPER VIEW

"How often if we learn to look, is a spider's wheel a universe, or a swarm of midges
a galaxy, or a canyon a backward glance into time."
—LOREN EISLEY

YOU CAN PHOTOGRAPH A FLOWER, BUT CAN YOU
capture its personality? More important, do you think a
flower has a personality? Do you see spirits in rocks, faces in snow
banks? Is a calla lily sensual to you? When you look at something,
what you see depends upon how open your soul's "eyes" are. The
more open you are, the more deeply you can see from an emotional
point of view. If you want to photograph more creatively, let go of
your tendencies to define things, and look more closely at what is
there, not just what you think is there. Think metaphorically. Is the
dew-covered spider web nature's own necklace of jewels?

In the first chapter of this book, I suggested asking yourself what
you are trying to say with the photograph. Now take it a step further
and think about what the subject is saying to you, and try to use that
as your lead. The image that results from what you see in your mind's
eye can have more impact than a technically perfect photograph that
simply records the subject.

PITCHER PLANTS, NORTHEASTERN OHIO. *This pitcher plant "couple"—part of a colony, actually—was so
wonderful to find. Great color contrast and all the dried fern fronds made a great surrounding texture for these interesting plants.
70–200mm lens at 110mm, f/22 at 1/2 sec.*

A Closer Look

OPPOSITE: SEA FIG, POINT REYES NATIONAL SEASHORE, CALIFORNIA. *Selective focus can create wonderful impressions of flowers. It requires wider apertures, to keep the depth of field shallow.* 100mm macro lens with EF25mm extension tube, f/3.5 at 1/30 sec.

The intimate world of nature is full of little gifts to unwrap. Even with all the drama of the big vista, I'm often brought to my knees by the detail right in front of me. Thousands of details make up the larger scene, yet often that grand vista overwhelms the details that can make a terrific photograph, too. Once, while I was leading a photo tour in Utah, a participant who was interested only in the big landscape asked to see a macro image my co-leader had composed of a dried flower blossom emerging from the coral sand dune. "Hmmm," he said, "that's nice." He wandered off for a while, and when he returned, the co-leader was making a new macro image. After taking a peek at this one, he exclaimed, "That's art!" With that, he disappeared behind a dune. An hour later, when it came time to leave, we asked his wife where he was, and she replied, "What did you do?! He's out in the dunes on his hands and knees doing macro photography!" We laughed and said we didn't do anything except change his perceptions.

By definition, *macro photography* involves making images of things at life size or greater than life-size, whereas the term *close-up photography* refers to just that—a close view, such as an intimate study of shells on the beach, that might not be life-size but is still an interesting close-up of details. These terms are often interchanged when discussing this type of photography. For the sake of simplicity here, I'll refer to both as macro photography.

You can use everything from a designated macro to a telephoto lens for these types of pictures. I've used a 28–135mm lens to fill the frame with the colorful details of Alaska's tundra plants. I've used a 100mm macro lens to photograph a tiny hummingbird nest with eggs. To capture the luminescent close-up details of an iceberg, I've used an 80–200mm lens at various focal lengths. Each situation requires a different combination of equipment designed to give you the amount of closeness you need for your photograph. The following are my two favorite close-up accessories that I use with a variety of lenses:

Diopters, also called close-up lenses, look like filters, but these magnifying type lenses, when mounted on the front of any lens allow it to focus closer, thereby increasing the magnification of the subject because you physically can get closer. When you use them with a macro lens, you can get in very close, usually magnifying the subject greater than 1:1, or larger than life-size. I love to use my diopter on my 70–200mm, or my 100–400mm, on the long end, as the narrow field of view with those lenses gives me a simpler background to work with, and the close-up lens allows

RIGHT: FERN, CALIFORNIA. *This fern came from a gardening day in the front yard. When I saw the spores on the frond, and the way it glowed in the backlight, that was it. All gardening ceased (for a little while anyway), as I took the frond to the back yard, set up the tripod with camera and a clamp to hold the frond in place, and made my pictures. I used a white reflector to bounce a little light in on the shaded side, so we could see the brown spores and their texture.* 100mm macro lens, f/18 at 1/6 sec.

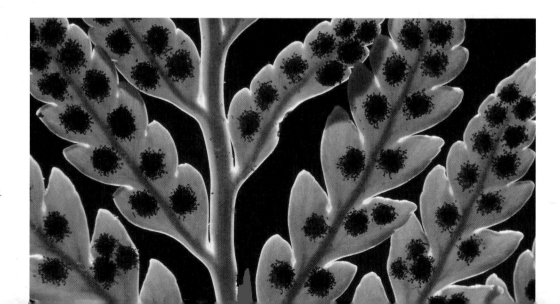

MORNING GLORIES, CALIFORNIA. *These flowers are big enough that, with three of them in the frame, I didn't need a macro lens to get a frame-filling close-up. I loved how the light came through the white part of the flowers, so they appeared to glow from within.* 24–70mm lens at 64mm, *f/*20 at 1/2 sec.

me to focus closer than those lenses would normally so I can move in on my subject more. When I travel, I can't always take a dedicated macro lens, and so my 500D diopter goes with me—everywhere—and it has allowed me to get closer and make pictures I would have otherwise missed. Because no light is lost through these glass lenses, they allow for faster shutter speeds at any chosen aperture, something that's important when working with magnified subjects. Top-quality, dual-element diopters are sold individually and come in specific diameters; most fit lenses with a 62–77mm filter size. I suggest buying it to fit your telephoto lens, and using step-down rings for fitting it to other lenses if necessary.

Extension tubes contain no optical glass. They just push the lens farther away from the sensor or film plane and, in so doing, allow you to focus the lens closer than it would normally focus. This means you can move in closer, and that increases the magnification of the image. The downside of extension tubes is that you lose light, requiring slower shutter speeds at whatever aperture you've chosen. Being in close, the slightest movements are magnified, so in even the faintest breeze, you can have trouble keeping your subject sharp. The upside is that you can use them with many of your lenses. I can put my 12mm EF tube on my 17–40mm or 300mm lens. Extension tubes are often sold in sets of three sizes, or you can buy individual ones made for your camera model.

The overall goal in photographing the world close-up is to share details others might have missed. Yet there are many different approaches to macro photography. Some photographers like to photograph an intimate view of a whole flower, while others want to get close enough to see whether the bug on the petal is carrying any luggage! Some prefer everything exposed at *f/*22, while others leave their lenses wide open to create abstract or impressionistic effects. The choice is totally personal. It all boils down to that now-familiar question: What you do want to say with your photograph?

This section is not designed to teach you specifically how to make macro photographs but rather to get you thinking about macro as a way to see. There are excellent resources available today to help you do that. I recommend Bryan Peterson's *Understanding Close-Up Photography* (Amphoto Books) for an in-depth how-to.

Following are some simple ideas that can give your close-up or macro photographs more impact:

- Work in diffused light, often the best type of photography for macro and close-up details, but also consider backlighting for dramatic effect.
- Go out after a rainstorm or ice storm and you'll capture some of the special moments of nature in detail.
- Head into meadows in early morning for dew-covered insects and spider webs.
- Try to compose simply for the strongest impact.
- Pay close attention to your background and try to keep it uncluttered.
- Look for harmonious color contrasts.

Even if you haven't yet mastered the technical aspects of macro photography, you can still learn to see subjects creatively. Think in terms of interpreting your subject instead of merely recording it.

FINDING THE ESSENCE

ROSE, CALIFORNIA.
Abstract interpretations of flowers are really fun to create—but not without challenge too. I used my 100mm lens and a 500D diopter. I wanted to get in close and let the petal edges of this beautiful rose blend and blur, just hinting at the essence of a rose. 100mm macro lens, f/2.8 at 1/400 sec.

What is the essence of a flower? Or of water? Can that essence be photographed? According to the dictionary, essence is "that which makes something what it is." So if we learn to look deeply enough, we can photograph what makes a tree a tree. For example, there are things that are specific to certain trees. The essence of a California oak tree might be its gnarled branches and classic overall shape. A birch tree's essence might be the papery, peeling bark.

Essence is sometimes difficult to put into words, but we intuitively recognize it in some things, and so we can photograph them from that perspective. When someone tells you that you've captured the essence of something in a picture, you've succeeded in expressing an idea that is widely felt or understood. At other times, the essence may simply be what you consider it to be but not so easily understood.

Ask yourself what the idea or object means to you. For example, what is the essence of autumn? What elements define that essence? It might be pumpkins, or autumn leaves, or geese flying in formation. If, for you, the essence of autumn involves a vision of glowing, colorful leaves, how can you photograph those leaves so they express that? Do you want them sharply focused and crisp, like the autumn air that surrounds them? Or should they appear as soft, blurry impressions in which the colors overlap and blend to create a palette of autumn hues? The choices are yours to make.

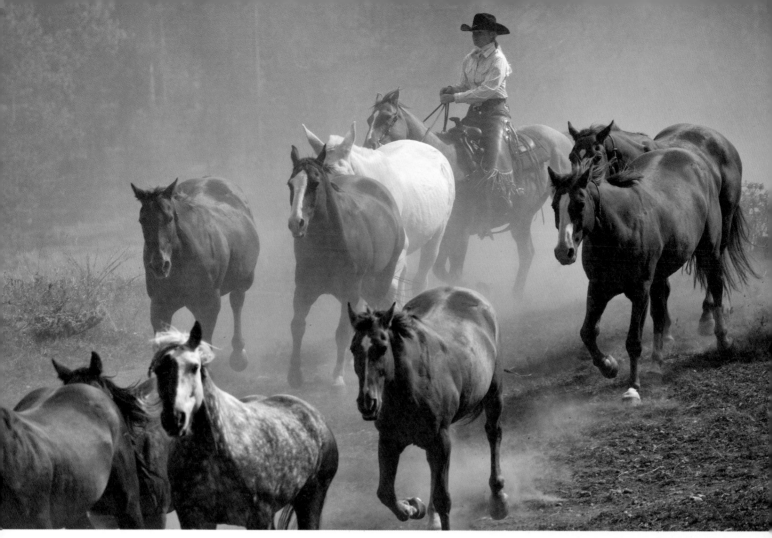

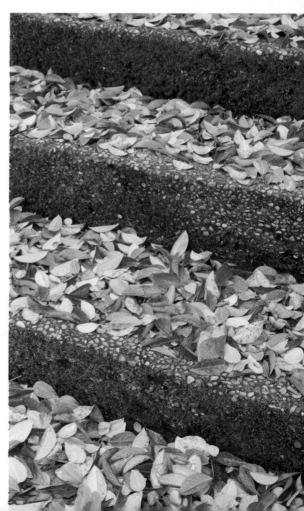

ABOVE: ROUNDUP, MONTANA. *I wanted this scene to seem timeless and to capture the essence of a timeless activity. I converted this color picture to black and white and gave it a sepia tone.* 100–400mm lens at 390mm, ƒ/10 at 1/500 sec.

RIGHT: STAIRS AND LEAVES, CALIFORNIA. *These stairs are just outside my home, and every autumn we are treated to this pretty sight. It's one of those pictures you can easily miss if you don't pay attention to what's literally right under your feet.* 24–105mm lens at 31mm, ƒ/16 at 1 second.

Everything has an essence, but to find it you'll need to open up your mind and throw out your need to be literal. To stimulate your mind and eye to think about essence, try photographing images that express the essence of:

- A season
- A flower
- Joy
- Family
- The West
- Death and rebirth
- A forest
- A place: wilderness area or village

This is just a short list of ideas, but it can help jump-start you on the path to discovering the essence you see—in everything. Once you get started, you may find your list goes on forever! Whatever you do, take some time to find the essence of things. There is magic in the discovery.

Being Open to the World Around You

You are open when you are willing to look at what is presented to you and when you respond to it and do not analyze it or try to define it.

When was the last time you picked up your camera and headed out the door with no specific plan or destination in mind? If it wasn't recently, it's time to get out there! It's great to go out without a specific plan and see what presents itself. A walk to the local park might provide you with all the photo possibilities you can handle in a day. For that matter, a walk into your backyard could do the same thing. It depends upon your openness to what's around you.

I've made some of my best photographs and had some incredible experiences when I didn't have a specific direction planned but just wandered out of the hotel or down the trail and let my eyes lead me. This doesn't mean you shouldn't plan and research a destination, whether it's a national park or a city. Having some idea of where you want to go when you get there makes good sense. But be loose with your schedule, so you can immerse yourself in the place and be receptive to pictures as they present themselves to you.

It pays to have a camera with you at all times. But the reality of that is that it's not always easy to carry a full complement of lenses or accessories. Yet even a compact digital is worth having, if photography for you is about capturing light and documenting moments and things along the pathway of life itself.

The point is really the process of seeing wonderful moments and beauty everywhere, and trying to make those moments stay by capturing them in our memory as well as on memory cards. A photographer's most important guide is his or her emotions, because you make a great picture with your soul, not your eyes. You can't make images that affect others if you aren't in some way affected while making them.

LEAF FROZEN IN ICE, CALIFORNIA. *The season was just turning cold, and a thin layer of ice had trapped this cottonwood leaf. I love how all the swirling lines in the ice lead you to the leaf, suspended in time as the pond freezes.* 28–135mm lens at 100mm, *f*/16 at 1/25 sec.

EXERCISING YOUR VISION

Writers can suffer from writer's block, and photographers can become visually blocked. I've had it happen. I've arrived at some popular place and thought to myself, "Why bother? So-and-so has a great shot of this, and I've seen a dozen similar images of this scene already." To silence those voices of resignation, I tell myself, "Yes, but there isn't a picture made by *me* yet!" All too often we forget that *our* vision, *our* point of view, is unique to us— viewed through those filters of life that I talked about in the beginning of the book. But to bring that vision out, you'll have to approach that all-too-familiar subject in a way that is different, personal, and ultimately pleasing to you.

I've had days when I've had a lot on my mind, and I can't seem to see creatively as I look around. Sound familiar? When this happens, I sometimes just keep the camera in the bag and walk around a little, to shrug off the mental baggage I might be carrying that day. Or, I'll take

my camera out, and rely on my list of ways to get "unstuck," shown below. I don't overanalyze whether I'm making good pictures or not. I consider these photos part of a warm-up exercise, and before long both my eyes and my mind are primed and ready to see again. The following exercises are designed to help get the creative juices flowing, to stimulate your mind and your eyes. Whether you're stuck or not, they push you to stretch your vision.

- Make no less than twenty different pictures of one object, from every angle and point of view you can find.
- Photograph concepts, metaphors, and contrasts. Here are a few to get you started: standing out from the crowd, cheerfulness, solitude, power, risk, strength, death and rebirth, big and small, fast and slow.
- Use your wide-angle lens to make close-ups.
- Use your telephoto lens to make landscapes.

SUNSET, MEXICO
Trying a fresh approach to photographing sunsets, I panned the camera on this vibrant sky, which gave me an abstract, almost airbrushed effect. 24–105mm lens at 105mm, f/20 at 1/6 sec.

RIGHT: TWIRLING FERRIS WHEEL, CALIFORNIA. *Amusement rides are great fun to photograph. I love how the motion created a pinwheel effect from the slow shutter speed and moving lights. The sharp supports are a graphic counterpoint to the blur of the wheel. 16–35mm lens at 20mm, f/22 at 4 seconds.*

BELOW: RIVER ROCKS AND DESERT HARDPAN (MIXED LOCATIONS). *I regularly photograph patterns and textures for "sandwiching" them with other images. This one worked really well when combined with an image of stones. Various lenses and exposure settings.*

- Select a 3 x 3–foot area and make at least fifteen images within that area.
- Photograph for a day from a low point of view.
- Photograph something or somewhere you've never photographed before.
- Go to a familiar location and make images with a fresh, new point of view.
- Photograph reflections.
- Make black-and-white images, even though your camera records color. Look for monochromatic scenes with contrast.
- Make compositions using selective focus and keep your lens on the widest aperture.
- Spend a few hours making pictures that work, yet are entirely out of focus. Yes, you read that right.
- If you always photograph in macro, spend a week using your wide-angle lens.
- If you always use your telephoto, spend a week using your wide-angle or normal lens.
- If you always photograph wildlife, photograph people, and vice versa.
- Tell a story about something in nature in four pictures. (Make only four pictures for this one—make each one count.)

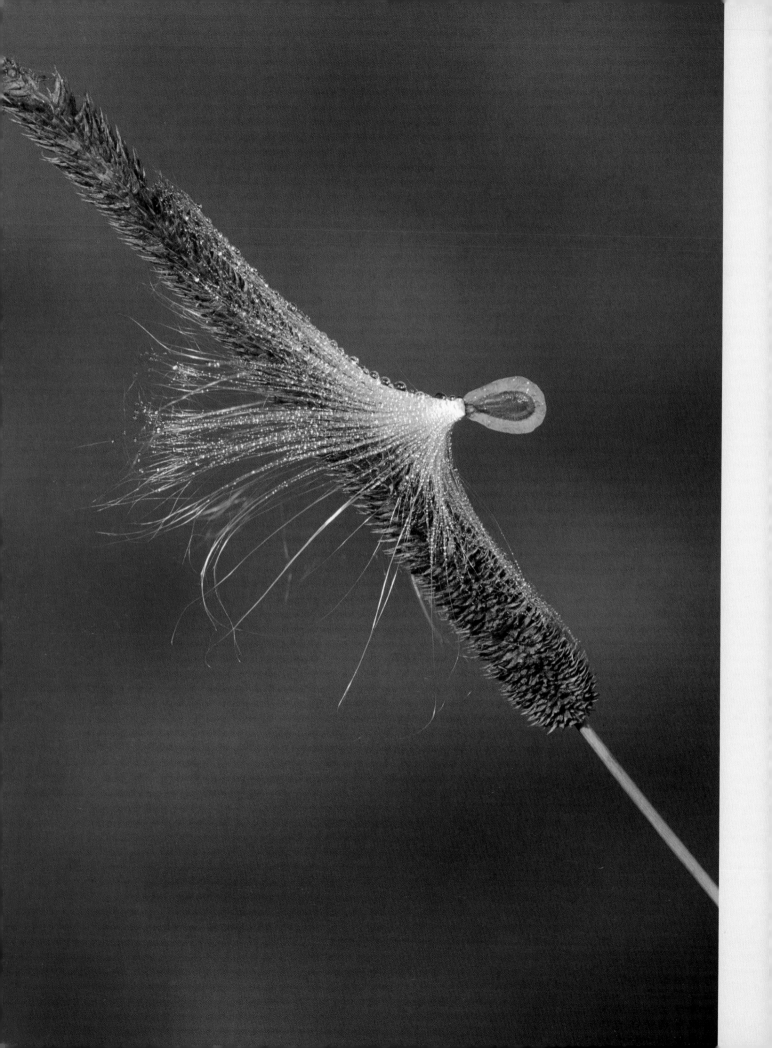

EVALUATING YOUR PROGRESS

"Your first ten thousand photographs are your worst."
—HENRI CARTIER-BRESSON

W HEN IT COMES TIME TO REVIEW PICTURES IN
workshops, the groans from students are audible. It's not
always their favorite time of the class, but it is mine because someone
invariably shows us all a new way of seeing. It's that eye-opening
experience that makes review sessions so wonderful.

If you want honest evaluations from other sources, don't ask
mom or family members! Unless mom or a caring sibling is a curator
or gallery owner, you'll likely get biased responses. How often have
you heard, "You should make calendars with these images," or, "You
should try to get these published," from a family member, who looks
at your pictures through "love-coated" filters. If you want a more
unbiased evaluation, ask friends whose taste or "eye" you admire; join
a camera club that has critique nights; hire a professional to review
your portfolio; or take a critique class with a local instructor. Find
someone whose work you respect and like, so that you'll trust his or
her opinion.

MILKWEED SEED, MAINE. *I love the little stories that nature tells. This milkweed seed had at one point been
floating aimlessly in the breeze, until it ran into this orchard grass stalk. Then the evening dew came. Now, until it dries out,
that seed's not going anywhere. But that gave me the opportunity to capture the magic of the jewel-like water drops stuck to the
gossamer threads of the seed. 70–200mm lens, f/5.6 at 1/250 sec.*

At some point, you'll have to learn to critique your own work to assess your progress. The key is learning how to separate from the emotional connection you have with your pictures. Never mind that it took 2 hours to climb the hill for a unique viewpoint of the village or that you lay on your belly for 4 hours to get the shot of the fox vixen by her den. We've all done hard things to make a picture. As Freeman Patterson once said, "Don't evaluate the pictures you thought you made, evaluate the ones you actually made." Does the photograph work? It's still the fundamental question, and you answer it by asking several other important questions. After you've put aside the obvious "woofers" from your most recent group of photographs, use a checklist of questions (right) to help you evaluate the rest.

Once you have decided the image works, congratulations are in order! But what if it doesn't work? Don't toss out that image just yet. Consider why it doesn't. Use your outcasts as a way of evaluating what you did wrong so you can get it right. Learn from your mistakes. And, with digital image editing capabilities, you can salvage some images. You can't solve poor lighting, focus, or lack of visual depth issues, but you can crop, adjust the color, eliminate the telephone pole in the middle of the picture, and correct for perspective and other less serious problems. It's pretty amazing what you can do to improve an image. However, unless it's a special and unrepeatable photo, it may not be worth all that effort to save it. I make my decision based on whether I'll ever be happy enough with it to make a print of it or put it in my portfolio or give it to my stock agency. If not, then it doesn't get saved.

It's a known fact that the photographs we make grow more dramatic (in our minds) while sitting on the memory cards, so when they finally get into the computer for reviewing, they can be disappointing given all the expectation we've built up

self-evaluation checklist

Begin with this list and add your own questions that may be specifically appropriate to what you like to photograph—say, for wildlife or aerial photography. Be ruthlessly honest, but also realize that while you may not have gotten the image you wanted, perhaps you made a better one.

- Does the photograph express your intent?
- Is the light appropriate for what you wanted to express?
- Does the photograph make interesting use of any existing design elements?
- Does the picture make good use of perspective to create visual interest?
- Is the image composed well, the arrangement dynamic?
- Are the exposure, focus, and other settings correct or appropriate for the subject?
- Could the photograph have been simplified?
- Is there something in the image that detracts from the main subject?
- Do the color relationships work?

around them. It's a good idea to wait a while to do the serious editing/sorting of your pictures. That allows the emotional experience to subside a bit, and the more honest critic in you to emerge. If you shoot RAW, remember that the pictures will never look as good as the scene did. I found initially that my reactions to my pictures were flat, because the photos themselves were flat and lacking saturation. But once I learned how to process my RAW files, I knew how to review the RAW pictures up front— mostly for content, composition, focus, and overall lighting and exposure—and evaluate whether they would "work" after processing.

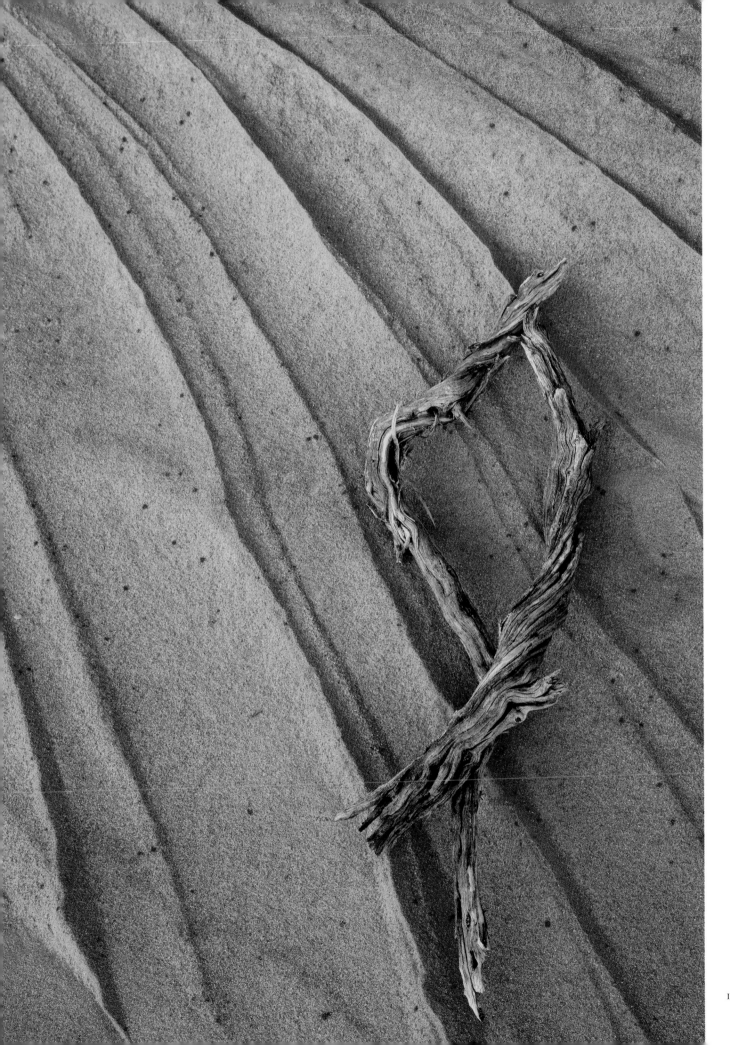

DISCOVERING YOUR PERSONAL STYLE

UPPER ZION NATIONAL PARK, UTAH. *In the upper canyon washes of Zion, I often find great lines in the rock formations. This wall had a wonderful S-curve running through it, as if it were an accent over the beautiful leaves below. 24–105mm lens at 58mm, f/16 at 1/2 sec.*

I am always amazed by the variety of images produced when eight people photograph the same subject or idea, or even the same scene. Everyone has a unique way of seeing the world, and most of us want to be recognized or remembered for that expression we call our *style*. Pete Turner once said, "A photographer's work is given shape and style by his personal vision. It is not simply technique, but the way he looks at life and the world around him."

When I am reviewing the portfolios of students, they often ask, "Do you see any style to my work?" It's a valid question.

Your photography may already have a style. To find out, gather a large collection of your prints or slides and analyze them carefully. Find the common factors in the photographs. Do you gravitate toward close-ups or landscapes? Are your landscapes only of natural subjects, or do you photograph man-made objects as well? Do you use your wide-angle or your telephoto lens most often? What type of light do you gravitate toward? Are people a regular occurrence in your pictures? Do your photographs portray a message? If so, is there a common message underlying your work?

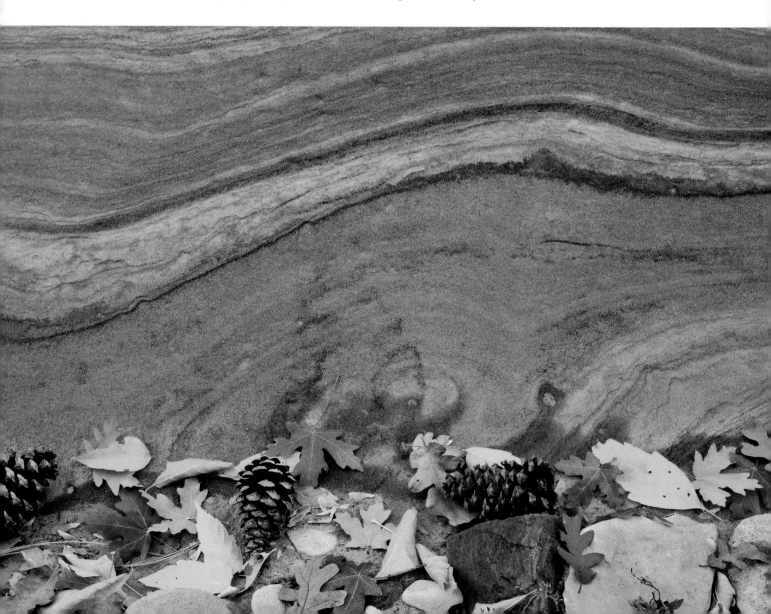

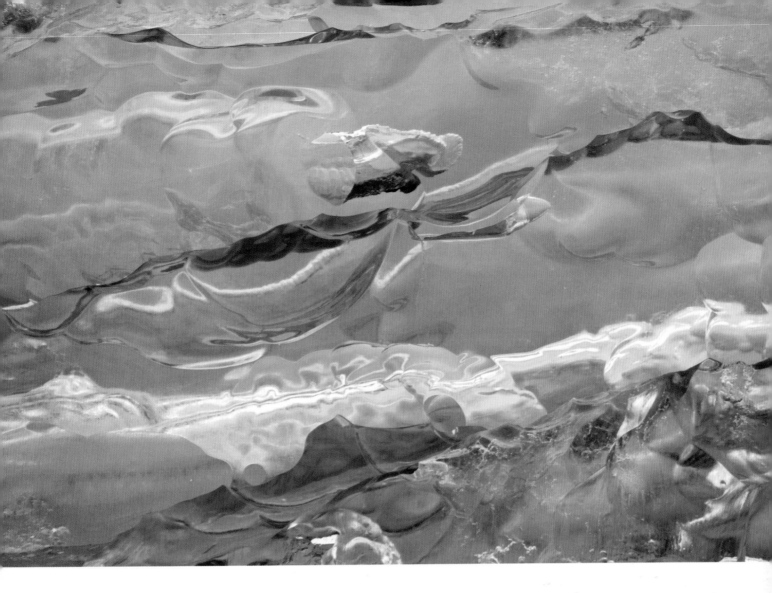

ICE ABSTRACT, ALASKA. *This piece of ice looked like crystal to me. It had calved off a glacier in Alaska and we were lucky to discover it. 35–350mm lens at 350mm, f/5.6 at 1/250 sec.*

Make a list of characteristics that stand out to you. Ask someone you trust if he or she sees a common denominator in your photographs. The process will also help you discover favorite techniques, viewpoints, colors, or subjects. You'll see where you've been and perhaps where you're going with your vision. Take photo workshops and go on tours where you can share your work with fellow enthusiasts. Join forums where you can share your work and get trusted feedback. It's a great way to see how others view your work and what similarities or differences they might see in your image collections.

Style evolves from constant self-expression. It's who you are, a combination of your emotions, experiences, and knowledge. You can't force style. If you are too intense about creating a "look" to your work, you may be seriously limiting your vision and your creativity. Loosen up and photograph what you love—with all the passion, artistry, and technical skill you can muster. Make many photographs, evaluate them, and study the masters whose work you admire. In time, your personal style will become evident. You are original, and your vision will express that. Stay true to it.

WHERE TO GO FROM HERE

If I've done a good job with this book, you are sitting at the edge of your seat ready to hit the fields, forests, villages, and coastlines to make new photographs! All the ideas in this book will help you, but the most important factor is your imagination. If you stretch your mind, ask that "what if" question, and then act upon your curiosity, you'll find an endless supply of things to photograph. If you dig deeper into your own feelings about what you love to photograph, you'll find the emotional connection that may be missing in your images.

What comes next? For some, simply making photographs is good enough. As amateurs, they share their photographs with friends and family and decorate the walls of their homes or offices with their wonderful images. Many belong to camera clubs and are members of online clubs and forums where they can share their work with fellow enthusiasts. I've judged for camera clubs, and the real meaning of amateur—"for the love of something"—rings true in these groups. The members are motivated by their love of photography. It often inspires me to see the pictures these people produce.

For others, it might mean getting into it professionally. But remember to keep the joy and passion for photography. If you do so, your images stay alive and vibrant.

Here are some ways to get your work out there to be seen and enjoyed by others. You can:

- Build a Web site for your pictures or become a member of sites where you can share your pictures.

- Participate in exhibits, both local and regional.

- Have your own exhibits in cafes, galleries, gift shops, libraries, and community centers.

- Give visual presentations. Many active adult communities and retirement homes eagerly welcome people who can volunteer to entertain their residents.

- Make your own greeting cards to send out.

- Donate your work to worthy nonprofit causes. Even though many large organizations hire professionals, most, especially smaller ones, don't have money budgeted for photography.

- Start a creative support group with other photographers and artists where you can all share your images and get feedback and ideas for developing your vision and your projects.

A great way to maintain your inspiration is to develop personal projects. For example, I have ongoing projects to photograph water, trees, and the Southwest. Create a collection of your impressions from a place or of a particular subject. It gives you something to plan for, to build on, and to be challenged by as you think of more ways to interpret your topic.

If you let yourself experience the world as a child does, full of wonder, you'll begin to see the world in new ways. Apply the concepts presented within this book, and remember to play and experiment, too. You are limited only by your imagination, so stretch, open your eyes and heart to what's around you, and you'll soon be a better photographer.

WHAT'S IN THE BAG

Gear can be addictive when the manufacturers offer up the latest and greatest camera, or lens. But as Sam Abell once said, "It matters little how much equipment we use; it matters much that we be masters of all we do use." It's not the gear that makes the picture, after all! I use Canon 35mm digital cameras, lenses, and flashes. They are top-quality, and are great for what I want to do. However, any 35mm camera can perform the basic functions that we need to create great photographs that don't require special effects. Choose a camera for the features it has, how it feels in your hands, and how the controls and menus are laid out.

Here's what I carry in my bag:

- *Cameras:* Canon 1DS MK III, and a Canon 1D MK III or a 5D MK II

- *Lenses and extenders:* 17–40mm F4, 24–105mm F4 IS, 90mm F2.8 T/S, 70–200mm F2.8L IS or a 100–400mm F3.5–5.6 IS, 1.4x and 2x teleconverters, a Lensbaby, two extension tubes or the Canon 500D diopter. If I am doing extensive macro work, I will add the 180mm F4 macro, but I often use the 90mm tilt-shift with an extension tube or the 70–200mm with the 500D diopter, for close-up work.

- *Flash equipment:* 580 EX II flash, off-camera flash cord, wireless transmitter equipment, Sto-Fen Omni Bounce diffusion dome, and the Flash X-Tender, a folding flash concentrator with Fresnel lens (the latter, if doing wildlife photography)

- *Filters:* A 3-stop graduated ND filter, circular polarizing filter, the Variable ND filter, the Color Combo, and a few other filters, all made by Singh-Ray

- A 32-inch fold-up diffusion disc and a soft gold/white reflector hangs outside of the pack

- Model/property release forms on index cards

- Macro kit, when doing a lot of it (paintbrush, hair clips, fishing line), and the McClamp (see the resources list)

- Spare batteries for cameras and flash, lens-cleaning cloth, sensor cleaning kit, eyeglass repair kit, strong bulb-type blower, Allen wrench

- Hoodman LCD Loupe
- Rain hoods to fit various longest lens/camera setups
- Leatherman Wave multipurpose tool
- Headlamp and mini flashlight with red lens for night photography
- Small notebook, pen, compass, remote shutter release
- Spare quick-release plate
- Depth-of-field chart

If I'm doing travel or street photography, I carry the following:

- One camera body (sometimes two)
- 17–40mm F4 L lens, 24–105 F4 L IS lens, 70–200 F4 L IS lens, and a Lensbaby
- Teleconverter
- Polarizing filters, the 500D diopter, a remote release for camera, and flash with Omni-Bounce diffusion and a wireless setup
- Lens-cleaning cloth, sensor-cleaning kit, eyeglass repair kit, spare batteries, Allen wrench, small flashlight or headlamp
- Model/property release forms on index cards
- Rain hood for camera/lens

I use carbon fiber tripods with Really Right Stuff ball heads. For mounting my 500mm, I use the Wimberley Sidekick, essential for balancing the weight load of that lens. I also pack a tabletop tripod. (Note: All my cameras and lenses are equipped with Really Right Stuff quick-release plates. They are well-designed, strong, and easy to use.)

RESOURCES

CAMERA EQUIPMENT

The manufacturers listed below make great products for photography. While others certainly exist, the ones listed here make the gear that I use, and I have found their products to be well-designed and highly functional.

Bogen Corp. www.bogenimaging.com
Canon USA. www.usacannon.com
Lowepro USA. www.lowepro.com
McClamp. www.fmphotography.us
Lensbaby. www.lensbaby.com
Really Right Stuff. www.reallyrightstuff.com
Singh-Ray Filters. www.singh-ray.com
Think Tank Photo. www.thinktankphoto.com
Wimberley. www.tripodhead.com

SPECIAL SOFTWARE

The following software products are ones I use and like:

Helicon Focus
www.heliconsoft.com.
Image stacking software that solves depth-of-field problems.

Lightroom
www.adobe.com.
Software designed to integrate image processing, editing, organizing, and showcasing your photographs.

Nik Software
www.niksoftware.com.
Easy to use software for creating black-and-white images, applying color filters, sharpening, and reducing noise. Works with Photoshop, Lightroom, and Aperture.

Photomatix
www.hdrsoft.com.
Software for merging exposures using High Dynamic Range technique, and for generating highly illustrative effects to your images.

Topaz Image Enhancing
www.topazlabs.com.
Software for enhancing your photographs and adding painterly effects.

SUGGESTED READING AND TUTORIAL PRODUCTS

Brandenburg, Jim. *Chased by the Light*. Creative Publishing International. This wonderful book documents a season, one photograph per day.

Burkholder, Dan. *Producer of Tiny Tutorials*, a set of instructional DVDs for creating a unique look with your fine art images. Also wrote *Making Digital Negatives for Contact Printing*. www.danburkholder.com.

Kemper, Lewis. *The Photographer's Toolbox for Photoshop*. A great set of instructional DVDs for processing and editing your photographs using Photoshop. They are very easy to understand and follow along, and highly recommended by this author.

Neill, William. *Landscapes of the Spirit*. Bulfinch Press. Beautiful images and inspiring text.

Patterson, Freeman. *Photographing the World Around You, Photo Impressionism and the Subjective Image*, and many others. Key Porter Books. These books cover design, composition, and color and present alternative techniques for expressing creativity.

Peterson, Bryan F. *Understanding Digital Exposure* and other books. Amphoto Books. These well-written books cover everything you need to make great pictures, no matter what your subject.

Sweet, Tony. *Fine Art Digital Nature Photography, Fine Art Flower Photography, and Fine Art Nature Photography: Advanced Techniques and the Creative Process*. Stackpole Books. Expressive images and the information you need to create your own.

Willmore, Ben. *Adobe Photoshop CS4 Studio Techniques* (Adobe Press), *Adobe Photoshop CS4: Up to Speed* (Peachpit Press), and *HDR and Beyond in Photoshop CS4*, New Riders Press.

USEFUL WEB SITES

www.betterphoto.com.
Great resource offering online courses in outdoor, nature, travel, people, stock, and portrait photography. Offers camera specific courses and Photoshop classes, too. Public forum, member galleries.

www.dofmaster.com.
This site has very useful depth-of-field charts for purchase.

www.Luminous-Landscape.com.
Great tutorials on every concept and technique in photography. Also features forums, columns, essays, product reviews, and more.

www.TheCandidFrame.com.
Offers inspiring series of informal podcast interviews of photographers.

www.tmelive.com.
The Mindful Eye. Daily critiques, articles on editing, podcasts, and more thought-provoking and insightful content.

www.lynda.com.
Great resource for lessons on using a vast array of software applications.

INDEX